ALSO BY LEE DURKEE

The Last Taxi Driver: A Novel

Rides of the Midway: A Novel

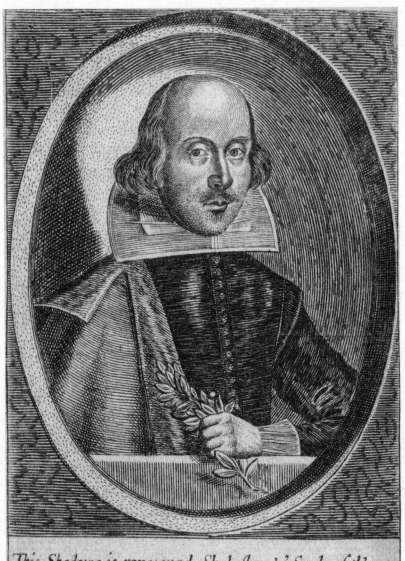

This Shadowe is renowned Shakespear's? Soule of th'age
The applause? delight? the wonder of the Stage .

STALKING SHAKESPEARE

A Memoir of Madness, Murder,
and My Search for the Poet Beneath the Paint

LEE DURKEE

SCRIBNER

New York London Toronto Sydney New Delhi

Scribner
An Imprint of Simon & Schuster, Inc.
1230 Avenue of the Americas
New York, NY 10020

First Scribner hardcover edition April 2023

SCRIBNER and design are registered trademarks of The Gale Group, Inc.,
used under license by Simon & Schuster, Inc., the publisher of this work.

For information about special discounts for bulk purchases, please contact Simon & Schuster
Special Sales at 1-866-506-1949 or business@simonandschuster.com.

The Simon & Schuster Speakers Bureau can bring authors to your live event.
For more information or to book an event, contact the Simon & Schuster Speakers Bureau
at 1-866-248-3049 or visit our website at www.simonspeakers.com.

Interior design by Erich Hobbing

Manufactured in the United States of America

1 3 5 7 9 10 8 6 4 2

Library of Congress Cataloging-in-Publication Data

Names: Durkee, Lee, author.
Title: Stalking Shakespeare : a memoir of madness, murder, and
my search for the poet beneath the paint / Lee Durkee.
Description: First Scribner hardcover edition. | New York : Scribner, 2022.
| Includes bibliographical references.
Identifiers: LCCN 2021056277 (print) | LCCN 2021056278 (ebook) |
ISBN 9781982127145 (hardcover) | ISBN 9781982127176 (ebook)
Subjects: LCSH: Shakespeare, William, 1564–1616—Portraits. | Dramatists,
English—Early modern, 1500–1700—Portraits.
Classification: LCC PR2929 .D865 2022 (print) | LCC PR2929 (ebook) |
DDC 704.9/42—dc23/eng/20220308
LC record available at https://lccn.loc.gov/2021056277
LC ebook record available at https://lccn.loc.gov/2021056278

ISBN 978-1-9821-2714-5
ISBN 978-1-9821-2717-6 (ebook)

See page 259 for image credits.

To Hayden, the only one who cared.
And in memory of Aaron Swartz.

But now farewell—a long farewell to happiness—winter or summer! farewell to smiles and laughter! farewell to peace of mind! farewell to hope and to tranquil dreams, and to the blessed consolations of sleep! for more than three years and a half I am summoned away from these: I am now arrived at an Iliad of woes.

<div style="text-align: right">

Thomas De Quincey,
Confessions of an English
Opium-Eater

</div>

Hideous Shakespeare

O sweet Mr. Shakespeare!
I'le have his picture in my study at the courte.
The Return from Parnassus;
Or the Scourge of Simony, 1601

Regarding the portraits said to depict the late Mr. Shakespeare, there are good reasons to be cynical. You could, after all, crowd the snail-shell Guggenheim with the four-hundred-year parade of counterfeit bards, each one prettier than the last, evolving Will by Will like some Darwinian ascent from the knuckle-dragging Droeshout engraving of 1623 to the superciliously upright Cobbe portrait recently embraced by the town of Stratford. Invariably the sagas of these painted poets have been tragic in nature, each in turn girded in gold, basked in bulbs, then whisked upon the shoulders of a scholar's reputation through London, New York, and Milan . . . only to find itself a short while later a laughingstock: debunked, denuded, holed up in a seedy motel, and eventually hung upon the wall of some dungeon museum as a curiosity, a cautionary tale, *a freak show.* Meanwhile a prettier yet Shakespeare, one with Fabio hair and a fly leather doublet, is hoisted aloft by the adoring crowd.

Throughout humanity's centuries-old search for Shakespeare *ad vivum*, a picture painted from life—one he sat for, one he paid for—no candidate portrait, however celebrated, has withstood the test of time. For the most part, Shakespeare ad vivum has been a history of artistic con men and starry-eyed scholars. During the eighteen years, following a divorce, that I was forced to live in arctic Vermont, I found myself readdicted to this search every winter. And Shakespeare ad vivum is in many ways a wonderful winter addiction, an unsolvable puzzle that constantly makes you feel as if you are about to conquer it. But nobody ever has.

So welcome to the Shakespeare Funhouse, where four centuries of frauds stare out at you from inside warped mirrors. A bit dizzied and intimidated, I reminded myself I had one big advantage over the countless academics who had failed in this search. At the time I began my hobby, museums had just started creating virtual galleries online. These galleries often displayed portraits that had been hidden inside storehouses for decades or even centuries. During the day I inventoried the facial anomalies unique to Will Shakespeare and began to master software capable of comparing these anomalies. At night I put on my black mask and became a virtual art thief who had taught himself to disassemble, steal, and then sew back together high-resolution portrait jpegs from online museums.

But how, I wondered (as I turned dazed circles), was a novice like myself to decide which portraits to begin investigating? Following some discouragement, I soon hit upon a strategy, a path less taken I hoped might lead me to my hero. Since it seemed obvious Shakespeare had been getting prettier by the century, I decided to ignore those boy-toy bards so popular with modern scholars and home in on the more neglected candidate portraits, the wretched-refuse Shakespeares, the homeless, homely, and tempest-tossed mutts nobody wanted to depict our Soul of the Ages. This decision seemed logical in that the Droeshout engraving from the 1623 First Folio, our one avouched likeness, had revealed a poet burdened with an encephalitic head containing two froglike eyes swollen, it has

been suggested, by the blossoming of syphilis. Why look for such a Jack among the jet set?

And so I went to work. Any portrait that interested me—the uglier the better—got bookmarked and filed. My court favorites were special ordered or torn out of books. Soon I started paying museums to photograph obscure portraits. As the bills piled up, I began papering the walls of my Vermont fishing camp with the mug-shot bards only a mother could love. (Trust me, my Shakespeares can beat up your Shakespeares.) In the depths of my despair with seasonal depression, these mangled poets consoled and befriended me, and eventually, usually around the third blizzard of March, their eyes began to follow me as I paced my office devising and discarding some very peculiar theories about William Shakespeare.

There was more to my strategy, however, than courting ugliness. Every winter I became more fascinated with the technologies that allow us to time travel back through layers of paint. To that purpose, I became adept at pestering curators into plumbing their would-be Shakespeares with spectral technologies. And by *spectral technology*, I mean the black magic of *infrared reflectography*, which fires an IR beam through paint layers until it is absorbed by any carbon-based underdrawings; *X-ray examination*, which thrusts electromagnetic light up through the paint layers and imprints their history onto a radiographic film thereby exposing underportraits, extirpations, retouchings, and counterfeitings; *dendrochronology* tests wood panels to establish the general age of a portrait's backing; *pigment analysis* can determine original color, establish date of composition, and help identify the artist; *raking light* angles a beam across the portrait's surface to reveal an ocean pitch of texture; and *ultraviolet examination* uses black light to darken both new paint and old varnish while making the whole portrait resemble a haunted house caught in a lightning storm.

My hope was that these technologies might help me discover not just what Shakespeare had looked like but who he had been. Censorship of all art forms ran rife throughout both Elizabethan and

Jacobean England, and I couldn't help but wonder what scandals and heresies might lurk beneath four hundred years of overpaint.

We tend to project our own culture backward onto history and paint ourselves over dead tribes, but in approaching Shakespeare's generation of wits and writers, it's important to recall they were much smarter than we are—and far more conceited and ruthless. They employed spatial memory systems that allowed them to access entire libraries of inner guile. Vainglorious, superstitious, and hyper-paranoid, they lived among ghosts, demons, poisons, codes, witches, spies, pen names, and plagues. They were obsessed with bloodlines and caste systems, but perhaps their most defining characteristic was a fear of death, or oblivion, so chronic it gave birth to an insatiable thirst for fame—and not just any fame, but the eternally flickering candle called immortality. To this purpose, portrait painting became an Elizabethan fetish so in demand it jumped the caste system to spread from the nobility down into the upstart merchant class.

As to my own motives for joining this ancient search for a lost portrait, I doubt you should trust any explanation I offer. Sure, my admiration for the Elizabethans had a lot to do with my fixation. They'd forged the language we use to think with, and in that sense they were our creator gods. But I had some unsavory motives as well. I, too, pined for immortality, however jaded, and longed to be whisked away from my bartending job to London, New York, and Milan—or, for that matter, any place warmer than the state of Vermont, where I had promised myself I would stay until my son was old enough for college.

When I began this intermittent project, I vowed to approach it with no preconceived notions. Let the bard cards fall as they may, I said. I had studied the Elizabethans for decades, and the more I'd learned about this eccentric tribe, the less I felt I knew about Will Shakespeare. During my search I'd had him in my grasp any number of times, had my hands wrung around his ruffled neck, but he kept changing shapes, tricking me, and slipping away. He was Ovidian:

a white rabbit, a murdered spy, a decadent earl, a castaway actor, an infinity of typing monkeys . . .

It's not a pretty story what follows, but it's an honest one. Although my years of exploration have produced a tale filled with sorcerers, demonic possession, royal scandals, portrait switchery, Adderall addiction, incest, madness, ghosts, shark tanks, and two sordid murders, that was not my intent. What started off as a dilettante's hobby took over my life during those endless winters I could not abide. Inside that frozen landscape the disgruntled portraits of Will Shakespeare befriended and bewitched me. My research became something magical and demented, intuitive and haunted. In the end it changed the way I look at history, art, politics, and myself. It certainly changed the way I look at William Shakespeare.

A Mind of Winter

1

White Rabbit Shakespeare

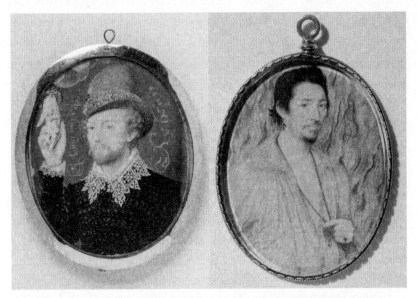

Two portrait miniatures by Nicholas Hilliard. *Left: Unknown Man Clasping a Hand from a Cloud*, 1588 (Victoria and Albert Museum, London). *Right: An Unknown Man*, circa 1600 (Victoria and Albert Museum, London).

The first time we drove through Malletts Bay I told my wife I wanted to live there. We were on Lakeshore, where the road dips down to split the marina, and it was night out with a full moon out and all the stars you can't see in Burlington out, and suddenly it felt like we were driving through a forest of birch, only it wasn't trees it was masts, aluminum and wooden ones swaying in the wind making that sad-belled night noise, and I turned to my new wife

and said, "Hey, I wanna move here. If we gotta live in Vermont then I wanna live here."

It wasn't until after the divorce that I moved to the bay. Back then Malletts Bay had so many redneck boat people it reminded me of Mississippi, except in winter, of course, when the wind would leap howling under the doors and through the cracks in the glass making the windowpanes shudder and the chimney scream its long ghost whistle night after night and to step outdoors was to be near about denuded by wind. I remember one evening shortcutting across the frozen bay to the local tavern where not one car was parked in the lot—nothing but snowmobiles. I liked watching those things at night, too, their headlamps moving spooky and serpentine across the bay, whole packs of them, like something predatory, like wolves. Come morning I'd sip coffee and stare out at the crop circles they'd carved into the powder wondering how many fishermen were sifting along the lake bottom, how many cheating lovers and murdered landlords.

It was while living on the bay that I became addicted to Elizabethan portraiture. That was my nature, obsessive—what women call "passionate" at the beginning of a marriage and "psychotic" by the time they kick you out. This particular obsession began when I wandered into a used bookstore in Burlington and picked up a big red hardback written by Professor Erna Auerbach that cataloged the portrait miniatures of the Elizabethan painter Nicholas Hilliard.

What's this? I thought as I removed the dusty hardback from the shelf.

I had a soft spot for the Elizabethans due to Dr. Leo Van Scyoc, a military flying ace who got me hooked on Shakespeare while I was an undergrad at the University of Arkansas. Slouched in the back row, safe from the spittle he let fly whenever he quoted a play, I learned in his classroom that Shakespeare had used portrait miniatures as props, *Hamlet*'s incestuous closet scene reaching its climax when the prince fondles the portrait of the evil Claudius pinned to his mother's bosom and then compares it to the poisoned father chained around his own neck.

I purchased Auerbach's book and late that night, while sipping tequila, began my study of the Elizabethan portrait miniature.

Usually oval in shape, these tiny paintings were designed to be worn on hats, doublets, or chains often as feudal badges of loyalty. Soldiers sent back miniature ambassadors of themselves to their wives or mistresses so as not to be forgotten (or God forbid cuckolded). Travelers presented them as gifts to hosts, and beauties shipped fetching miniatures of themselves to foreign lands in hopes of becoming royal brides. Elizabeth I once dispatched Hilliard to paint the Duke of Anjou—a man she would nickname her "frog"—to surmise whether he was pretty enough to marry. (Um, no.) The queen was an avid collector of miniatures and kept them in a custom-made cabinet that served as a courtly Facebook.

They were so fragile, these miniatures, the playthings of the rich and idle, so easily lost, damaged, and given to whim that it seemed a miracle to me any of them had survived. The tantrums of unrequited love must have been the death of many a masterpiece. Spoiled, theatrical bastards that the Elizabethan nobles were, they likely smashed them through lattice windows, splashed them into chamber pots, or tormented them to death like voodoo dolls. These, at least, were the nightmare scenarios I conjured up late that night unable to sleep.

As I kept turning pages I began to wonder why so many of Hilliard's sitters remained unidentified. Who were these lost Elizabethans? It irked me we didn't know, and I kept recalling the first words of *Hamlet*.

"Whofe there?"

Whofe indeed. Then I turned another page and found myself confronting an oval portrait of a man posing before a wall of fire that was also reflected in his frantic eyes. Professor Auerbach, after noting that this miniature had been painted onto the back of a playing card, the ace of hearts, described its sitter as a symbol of forlorn love pining after a mistress whose likeness, in the form of another miniature, he held facedown against his heart. The portrait had an

odd effect on me, as if I were gazing into a pocket mirror at my own heartbreak. I downed another shudder of tequila and kept wondering who this courtier had been, and why he had posed stripped down to his linen shirt before a burning ring of fire.

I also found myself wondering why Nicholas Hilliard wasn't more famous. That he painted most of his portraits the size of turkey eggs seemed to have disqualified him from the greatness we bestow on less gifted artists. This would have shocked Hilliard because during his prime, paintings "in little" were held to be among the most elevated of art forms. At the height of his powers, when he was the court painter to Elizabeth I—who famously told him to leave out the shadows—only nobles were deemed worthy of the liquefied silver leaf he anointed on the backs of playing cards with stoat-toothed tools and squirrel-hair brushes. He painted by turning a blind eye to blemish and transforming his sitters into ruffled gods and goddesses, all of which made Hilliard quite sought after at court.

Considered one of his masterpieces, the unknown man standing before a raging fire was described by Auerbach as "a symbol of burning love" with an "ecstatic face" and "fanatical eyes." But the professor, much to my astonishment, also claimed it didn't matter who this sitter had been, a statement that caused me to return my tequila bottle to the bed table with a thud. How the hell could it not matter who he'd been? Of course it mattered.

All that week I kept pondering Hilliard's unknown man. His identity couldn't be that difficult to deduce, could it? With this in mind I ordered Dr. George C. Williamson's 1904 primer *How to Identify Portrait Miniatures* and gradually took up this antiquated hobby, little suspecting the degree to which modern curators despised anyone meddling in their realm. I also started buying expensive coffee-table books of Elizabethan portraits and using them to attach faces to familiar names from history while staring extra hard at every unidentified courtier. That's what I did every night once I was done bartending. (During the divorce I had refused to hire a lawyer and had given my ex-wife the imported-clothing store

we'd opened together on Church Street.) These courtiers I kept studying didn't feel dead to me. Sometimes I could sense them staring back.

After a few months obsessing over this heartbroken cad, I hit upon a possible identification that appealed to my romantic nature, and soon began pestering London's Victoria and Albert Museum to change his status from Unknown Man to Possible Sir Charles Blount. I supported my feeble argument with a disturbing number of Photoshop animations and side-by-side comparisons while babbling on in emails about the scorched-earth tactics Blount had employed as a general and also his legendary love for his mistress, Penelope Devereux, the "Stella" of Sir Philip Sidney's famous sonnet cycle. In my mind's eye I could see Blount holding that miniature portrait of Stella to his heart while burning down some village in Ireland.

It was a beautiful theory, you'll admit.

The Victoria and Albert could hardly contain its laughter. My career as a curator's nightmare had begun. Although these V&A experts were correct in doubting me—it wasn't Sir Charles Blount— I still remember being shaken when a curatorial assistant confided to me that the museum had no desire to identify the sitter because the miniature's anonymity lent it mystery.

Once again the bottle hit the bed table. Until then I had imagined the V&A to contain a subterranean lab crowded with technicians bickering over miniatures, but, as I would learn, the reidentification of portraits is approached as a thankless and even hazardous task. Why risk converting your employer's Elizabeth I into some unknown redhead? Private owners are even more guarded. Nobody wants to be caught holding some dapper lacky purchased at the price of a Sir Walter Raleigh.

Undeterred, I soon turned my attention to another unknown courtier painted by Hilliard, a scant-bearded fellow wearing a sugarloaf hat and clasping hands with somebody hidden inside a cloud. And I became more fascinated by this portrait after learning

that Harvard's Leslie Hotson had written a book arguing that this miniature depicted William Shakespeare. Bear in mind, this was the same professor who had famously unearthed documents proving the playwright Christopher Marlowe to have been stabbed in the eye not by a stiffed barkeep or "lewd love" but by royal intelligencers.

In *Shakespeare by Hilliard*, Hotson argued, via a tedious deciphering of the miniature's symbolism or *impresa*, that its auburn-headed sitter was no less than Shakespeare ad vivum, the poet painted from life. Was Hotson correct? Well, the sitter didn't look like any Shakespeare I'd been raised on, but maybe that was because the miniature had been abused by history. Brown paint appeared to blot the sitter's right eye, and his left cheek looked scoured by sandpaper. Not content with this marred genius, Professor Hotson, an old man writing his final book, set off to find a fabled copy of the miniature that had been painted by Hilliard's apprentice Isaac Oliver. Hotson believed that this copy, if found, would reveal the unmolested poet in all his glory.

And there you have it, white rabbit syndrome: an aging scholar sets off Lear-like to confront his god. Forsaking reputation and a lifelong devotion to logic, down the rabbit hole they go. In Hotson's case, he at least trapped his hare, which is to say he found the Oliver copy in a private collection in Canada. And when the professor set eyes upon his bard, it was all fireworks and violins:

> Its startling effect on me is something I cannot hope to describe . . . For here I felt a power of expression, an intensity of thought beyond that presented by the familiar one in the Museum. A pregnant message seemed to spring not only from the eyes but from the whole face and the very poise of the head: stirring in me an unreasoning conviction of opportunity at the flood, an urgent presentiment of unseen treasure . . .

Well, yes. That urgent presentiment, and the flood. Described less erotically, the Oliver copy turned out to be a purple-hatted,

blue-eyed, and red-haired version of the same walleyed man minus the charred cheek. Smitten, Hotson purchased the miniature, which he could "ill afford," and shortly thereafter went to his reward convinced he had saved Kit Marlowe from slander and proven Will Shakespeare to be a ginger dandy with cornflower-blue eyes slightly akilter.

Hotson's *Shakespeare by Hilliard* was no fun to read, but, for all its bombast and tangents, the book did make some strong points, and if I didn't quite trust the professor's objectivity, I was intrigued enough to begin dabbling in his world of snake-doctored poets. So it began, my obsession with Shakespeare's disfigured face. The marred cheek and blighted eye became my points of interest. And it all happened so gradually I hardly noticed as my fishing camp on the lake transformed itself into a medieval Mermaid Tavern teeming with shifty-eyed bards, their faces pitted and mangled, all drinking on my dime.

2

O Monstrous Shakespeare

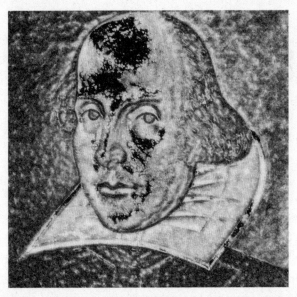

The Droeshout engraving, perverted by Photoshop filters to highlight its anomalies. The scholar Samuel Schoenbaum described the engraving: "A huge head . . . surmounts an absurdly small tunic with oversized shoulder-wings . . . The mouth is too far to the right, the left eye lower and larger than the right, the hair on the two sides fails to balance. Light comes from several directions simultaneously: it falls on the bulbous protuberance of fore-head . . . an odd crescent under the right eye . . ." (Folger Shakespeare Library).

Shortly after moving to Malletts Bay I also became obsessed with Champ, the serpentine monster said to lurk beneath the placid waters of Lake Champlain. Initially I assumed Champ to be a tourist-trap creation—"Vermont's Nessie"—but after a dozen or

so local boaters had told me stories about their interactions with Champ, I began scouring the whitecaps during my evening strolls along the beach in front of my camp. Upon reaching the end of that quarter-mile strand, and startling a blue heron into its laborious flight toward Coates Island, I would stand there rooted ankle-deep in brownish sand staring toward the breakwater in search of sea monsters. Soon I started looking for Champ from my back porch, and occasionally out my bedroom window, or while eating breakfast, lunch, or dinner. Before long every time I glanced at water I was secretly searching for Champ.

Therefore it was with monsters on my mind that I began interrogating a portrait of Shakespeare so disfigured that the tourist industry at Stratford-upon-Avon would love to erase it from history. Unfortunately for them, this portrait, a four-hundred-year-old engraving, had much better credentials than any handsome likeness of the poet. It was the ur-Shakespeare to which all other bards must bow.

The Droeshout engraving appeared seven years after Shakespeare's death inside the 1623 First Folio, a collection of his plays without which some of those masterpieces would have perished. In the folio's opening page the playwright Ben Jonson, a friend and rival of Shakespeare's, approved this engraving of the author inside a poem in which Jonson lamented that the engraver, a twenty-two-year-old artist named Martin Droeshout, had been unable to capture Shakespeare's wit as well as he had his face. To my knowledge that face has not been complimented since.

It is difficult to fathom why Shakespeare's friends would have selected this cartoonish mug for such an important tribute unless the engraving was modeled on an ad vivum portrait now lost to history. Many experts assumed this to be the case, and the search for this painted portrait had been ongoing for centuries, a search I was destined to join. It was the Droeshout engraving that would inspire my strategy of ferreting out the butt-ugly portraits of Shakespeare. To that purpose, the Droeshout was my Rome. All roads led there.

Someday I would find that lost template portrait, I vowed, and when I did, it would be gloriously heinous.

Then one morning while reading J. P. Norris's 1885 book *The Portraits of Shakespeare*, I came upon a passage that gave me pause. Norris stated that a collector named James Halliwell-Phillipps possessed a unique print of the Droeshout engraving that revealed "a difference so great as to present an absolute variation of expression." Norris described this proof's delicate rendering of shadows and how the light fell upon facial muscles "with a softness not found in the ordinary impressions."

The owner of this proof believed his engraving had by necessity been downgraded in order to mass produce the disappointing folio image we know today of the bug-eyed bloke with the pecan head. But where was this "unique first proof" now? I wondered.

After some digging, I found it shackled to the wall of the Folger Shakespeare Library in Washington, D.C. This surprised me because I had already by then upended the Folger's collection of would-be Shakespeare portraits via its excellent online gallery, and no such "unique first proof" had surfaced during any of my ten thousand million searches. Yet when I queried the Folger, I learned that the Folger did indeed own the Halliwell-Phillipps First Unique Proof but had "never gotten around to photographing it."

Huh? I thought, surprised. You would think that the likely most authentic portrait of Shakespeare in existence might merit some interest from its keepers in a library named after him, but that was not the case. Entire Elizabethan books had proven worthy of its lens and shutter, but not this singular portrait. How to explain that neglect? Don't try, I would soon learn. The Folger played by its own rules, and in the end I had to pay a research library to photograph its namesake.

"This might take some time," the Folger warned me.

It did. At first I was fine with the long wait because I was only marginally excited about this so-called unique first proof. Judging from its descriptions, the portrait sounded awfully refined, whereas

I preferred those images where Shakespeare's face had been murdered with whiskers, acne, nodules, rashes, and scars. I liked how his lower lip at times appeared tumored—or at least blistered. I enjoyed the pinched left earlobe (which might be the right earlobe since engravings are often reversed images of portraits), and I fancied that diamond patch of missing mustache in the philtrum above the lip and the way one of his eyes sometimes appeared to be blighted or blind. Most of these imperfections surfaced in the Droeshout print used in the First Folio, and I was grateful for these flaws because when you are trying to identify a sitter you must acquire the eye of a caricaturist and home in on deformities.

Regarding Shakespeare's possible deformities, I had compiled the above list plus my pet anomaly: a swirling birthmarkish stain across the forehead that perhaps extended down the left side of his face. In his autobiographical sonnets Shakespeare had complained about "the vulgar scandal stamp'd upon my brow." Could that vulgar stamp have been a reference to the scars of syphilis? If not, then what exactly was the nature of this scandal stamped onto his forehead?

But the longer I waited for that photograph to arrive, the more I began to fixate on the unique first proof. There were moments I even found myself getting paranoid that the Folger wasn't sending me their image because they knew it would reveal some dark secret of history. I imagined the library holding secret underground staff meetings with everyone wearing ocher robes in which they whispered plots to circumvent my query and occasionally broke into Gregorian chant.

The act of waiting, and waiting, also served to redouble my interest in the famous engraving that appears in the folio, and I began to delve into the many conspiracies orbiting that pop-eyed poet. The most popular theory, by a mile, was that the Droeshout's face had been fashioned to resemble a mask thereby signaling the existence of a hidden author, or authors, writing under the pen name "Will Shake-speare." In pushing this theory, the authorship heretics

were making the case that the Droeshout was a conceit, that is, one of the visual riddles popular throughout London. (Recall, for instance, the Hilliard miniature of a young man holding the hand of somebody lost inside a cloud.) Elizabethans adored these visual riddles—entire books of them were being published. Was the authorship tribe correct? Was the Droeshout engraving, with all its peculiarities, an intentional riddle designed to nudge us toward a hidden truth?

It seemed possible. The culture was, after all, steeped in these conceits. Even Shakespeare sonnets were penned riddles, purposely obscured yet littered with clues and side winks. With all this in mind, it's little wonder that the Droeshout engraving had evolved over the centuries into a Rorschach test in which people saw what they wanted to see, a phenomenon known as confirmation bias that haunted all aspects of Shakespeare studies.

Day after day I asked myself if young Martin Droeshout had intentionally made Shakespeare's face resemble a mask. The right side of my brain argued that anyone who dismissed this possibility knew nothing about the Elizabethan thirst for visual conceits. The left side of my brain countered that the masklike effect was a coincidence brought about by a young engraver learning his licks. I waffled back and forth, and waited, and waited.

Another strange theory orbiting the Droeshout concerned the different sources of light illuminating the poet's face. Marion Spielmann once described the effect as "the contradictory lights and shadows in the head." E. K. Chambers's 1930 study elaborated: "The head is too large for the body. The line of the jaw is hard. There is a bad drawing in the hair, eyes, nose, ear, and mouth . . . The lighting comes from more than one direction."

But was the light really coming from different directions? Or was that, as I'd begun to suspect, an illusion created by a wine stain or some skin disease visible on the forehead (and possibly snaking down the left cheek)? J. H. Friswell's 1864 *Life Portraits of William Shakespeare* described the Droeshout's eyes as "hardly fellows," and

21

conceded the "whiskerless cheeks" as "giving the figure a spotted appearance." Had a young engraver simply done his best to re-create a spotted rash or scar from a painted portrait?

One of the most fascinating theories I came across held that the Droeshout engraving might have been copied, not from an ad vivum portrait, but from a plaster death mask or a painted portrait modeled on a death mask. This suggestion was put forth by the German professor Hildegard Hammerschmidt-Hummel. No other theory I'd encountered better explained why the Droeshout bloke appeared neither healthy, happy, nor sane. Unlike a lot of Elizabethan portraiture filled with flattery, death-mask portraits had to present the sitter exactly as God had left the cadaver. These portraits were designed to be inhabited, or possessed, by a fragment of the dead sitter's soul. The portraits worked like spiritual birdhouses but could only be inhabited by the dearly departed if the painter had adhered to the rules governing such portraits as set down by Catholic bishops. Hammerschmidt-Hummel's theory, if correct, would therefore out Shakespeare as a secret Catholic during a time when that could get you fined, imprisoned, or worse.

Another anomaly riddling the Droeshout involved the sitter's torso and how it appeared puny compared to the galactic head. Everyone agreed this disparity was unfortunate, but scholars tended to blame this stunted body on the young engraver. Nobody wanted to accept the obvious implication that our great genius had been a runt with a watermelon head, even though Shakespeare's grave in Stratford measured in at only three and a half feet long. (His wife's grave, by contrast, tops out at five feet.) Shakespeare, if his own grave be trusted, was half a foot shorter than people diagnosed with dwarfism today, a detail I'd never come across in a single Shakespeare biography.

There was also one extremely morbid theory about the Droeshout that I initially rejected out of hand. This theory argued that the sitter's head only appeared oversized because it had been decapitated by an ax and was being presented to us on a traditional

shield—or rather on a collar mimicking a shield. (That would certainly explain the bug eyes.) The theory claimed that a line showing the severance along the neck was distinctly visible in the engraving. Here again the Droeshout was being presented as a conceit, a sphinxlike riddle holding forbidden knowledge of Shakespeare's execution.

As much as I disliked that theory—I did not want Shakespeare to have died horribly while bending over a chopping block—I would keep returning to it as the winters ticked by.

In fact, all these conspiracy theories were playing havoc in my mind as I awaited the Halliwell-Phillipps First Unique Proof, and when it finally arrived one afternoon with a bright ding in my inbox, I sat there for half an hour too nervous to double-click on the email. Instead I went for a walk and stared through the snowflakes at the ice patches forming on the water and imagined Champ as having two giant bug eyes inside a humongous head scarred with fishing lures. I returned home, made a large drink, set it next to my computer, then finally held my breath and opened the damn thing.

At first I could make no sense of what I was seeing. The photograph the Folger had sold me was so large I was staring up into a single Shakespearian nostril. I adjusted the image until it was of comprehensible proportion, and there he was, Shakespeare, better shaded, a tad less caddish, but lacking any telltale clues as to how he had lived or died. I sighed and finished my drink.

At that moment all my imaginings seemed silly. Had I actually expected the photograph to reveal Shakespeare as a Catholic martyr with a halo over his severed head? How absurd. I made another drink and cursed myself. *You idiot*, I thought. *You fool.* Yet I continued to study the photograph all that winter. Here, I told myself, is our perhaps most accurate portrait of Will Shakespeare. Losing myself in its spell, I wondered at times if the skeptics might be correct in anatomizing the engraving into an amalgamation of poet parts, a Frankenstein monster of collaborative swans: eye of Marlowe, ear of Bacon, forehead of de Vere, cheek of Elizabeth I, nose of Mary

Sidney. But I doubted that. My sense was I was staring at a portrait of a singular human being—a portrait, not a conceit, but I couldn't be sure, and there were moments I wavered.

Soon my obsession with the first proof bled over into real life and I started to encounter people on the street who stopped me cold with their resemblance to the Droeshout. One day while watching Chelsea F.C. play football, I noticed that their center back bore a resemblance to the Droeshout bloke. Could John Terry have written Shakespeare? A few days later while shaving I realized my own reflection bore a resemblance to the cadaverous Droeshout sitter—or at least I had the same high forehead and heavily lidded eyes.

In the end I printed a copy of the first proof and taped it to my office wall with my other mug-shot bards. Despite my disappointment that the proof had not revealed any sphinxlike riddles, I still hoped that the image might give me a leg up in tracking down the long-lost template portrait to the Droeshout. That template, and not the Droeshout itself, soon became my real fixation, the star to my wandering bark, and there were nights I could almost see it hanging hideously above the frozen lake inside the flickering northern lights.

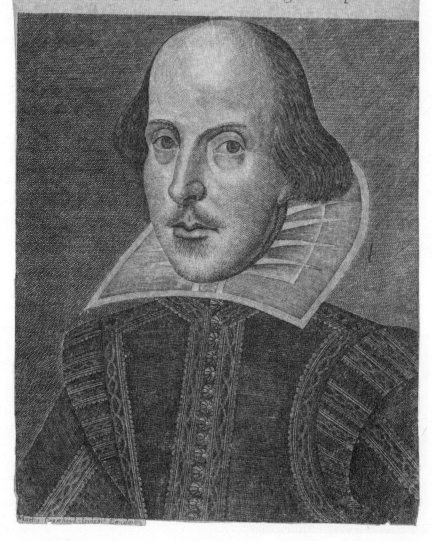

Halliwell-Phillipps first unique proof of the Droeshout engraving (Folger Shakespeare Library).

3

Swarthy Shakespeare

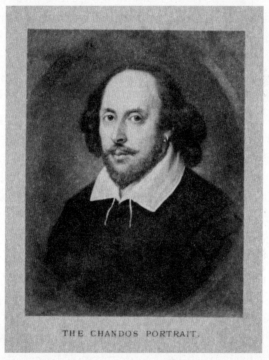

THE CHANDOS PORTRAIT.

The NPG Chandos portrait (photograph from J. H. Friswell's 1864 *Life Portraits of William Shakespeare*). Jorge Luis Borges once remarked in *The Paris Review*, "I always feel something Italian, something Jewish about Shakespeare."

My son was raised among hideous Elizabethans. Every weekend when he arrived at my lake camp, we'd fire up the GameCube to play the latest edition of an EA Sports soccer game that

allowed us to design our own virtual squads. I always fielded a pitch of grotesque English courtiers my son came to recognize via their caricatures and dribbling skills. He knew Lord Burghley and Francis Walsingham to be no-nonsense defenders, whereas the more exalted lit-clique gulls such as Phil Sidney, Tommy Nashe, John Lyly, and Kit Marlowe wreaked havoc on the attacking half. Among holding midfielders I fancied John Dee and Chuck Blount with the gnomish Robbie Cecil sweeping. Shakespeare in all his monstrous incarnations guarded the goalmouth. But since these avatars could only be created masculine, my most noxious player was always my number nine striker Queen Elizabeth I, who roamed the pitch like a ghoulish flame-haired Leo Messi.

During those eighteen pitiless winters I endured in Vermont—at times it felt like one long tunnel of winter—Hayden was the only person who shared my fascination with Shakespeare's portraits. Upon arriving each Friday he'd ask about the latest photograph purchased or swan unearthed. We'd examine jpegs while listening to whatever rapper had captivated him that week. We traded obsessions. We traded poets. And although my office was plastered with the most gangsta MCs imaginable, one OG ruled them all, my starting goalkeep, the Chandos.

In the grifter world of painted bards, the Chandos portrait was the boss of bosses. It was also the first painting ever acquired by London's National Portrait Gallery. But in spite of its powerful backers and bohemian earring, the British public was slow to embrace the Chandos, which was not surprising in that its sitter didn't look particularly British but more resembled some swarthy Italian or, God forbid, Spaniard.

In 1864 the author J. Hain Friswell had noted with obvious disgust:

One cannot readily imagine our essentially English Shakespeare to have been a dark, heavy man, with a foreign expression, of decidedly Jewish physiognomy, thin curly hair, a somewhat

lubricious mouth, red-edged eyes, wanton lips, with a coarse expression and his ears tricked out with earrings.

This wanton, lubricious, tricked-out Swan of Avon was hardly unique in his Jewish physiognomy. Blizzard by blizzard I started compiling a whole side bet of rabbinical Shakespeares. Why, I wondered, on a consistently anti-Semitic island, were there so many Jewish-appearing contenders?

This is one of the advantages to being a dilettante: the freedom to ask questions experts consider laughable. The dilettante works alone, a solitary figure, no colleagues to shock, no tenure at risk. Not only are we free to ask naive questions, there's nobody around to tell us how things are supposed to be done. We make up new rules, rig together new methods, and in doing so sidestep familiar pitfalls. We might still lurch into a ditch, but it will be a ditch of our own making and not one already filled with dinted scholars.

"Could Shakespeare have been Jewish?" I therefore asked myself over a beaker of tequila one evening while watching the horrible snow falling hideously onto the decrepit lake. Well, no, he could not have been. At least not officially, because officially there were no Jews allowed in England during Shakespeare's prime; however, a few loopholes existed in Elizabeth's brutal anti-Semitic laws, the most noteworthy being her personal physician, Roderigo Lopez.

It's hard to imagine a more perilous job than being the Spanish and illegally Jewish physician to a so-called Virgin Queen in a day of race-baiting theater, but in this hate-filled arena Dr. Lopez lasted an astounding thirteen years before being found guilty, on scant evidence, of having attempted to poison his royal patient. Dominic Green described the endgame in *The Double Life of Doctor Lopez*: "To the rapture of the mob, the executioner castrated him, slashed his torso open, eviscerated his internal organs and cut out his heart, raising it with a bloodied forearm like an Aztec priest."

Despite such atrocities, London's Jewish underground often thrived under Elizabeth. These marranos, as they were derisively

called, even formed their own intelligence network. They were ed-
ucated, many of them doctors, and were therefore both despised
and revered. As Green noted, "It was an open secret at the Court
of Queen Elizabeth that London was host to this illicit gaggle of
medico-merchant-spies, but their potential in diplomacy, finance
and medicine overrode the illegality of their position."

Confronted with an anointed Shakespeare who appeared part
of that illicit gaggle, British scholars proved inventive in dodging
any hypothesis involving Jewish blood. Regarding the Chandos
portrait, the nineteenth-century collector John Rabone hit upon a
nifty solution:

> It has been assumed from the darkness of the countenance, the
> expression of the face, and the contour of the features, together
> with the earrings, the full lip and curled hair, that the poet had
> sat to the artist when he had assumed the dress and character of
> his own wonderful creation—Shylock.

Now, at first glance, the theory that Shakespeare had wanted to
be immortalized as a heretical usurious madman might seem, well,
insane, but it's important to remember that we weren't there and
anything's possible, so, yes, perhaps Shakespeare did hover over the
painter's shoulder urging him to make those lips more lubricious,
the eyes more red-edged and wanton.

We don't know who painted the Chandos portrait, but we can be
certain the artist was no genius. (The eighteenth-century antiquar-
ian George Vertue suspected the picture had been painted by an
actor friend of Shakespeare's named John Taylor.) Eventually the
portrait wound its way into the collection of the Duke of Chan-
dos via a man named Sir William Davenant, a renowned actor and
playwright who enjoyed hinting he was Shakespeare's bastard son.
Davenant's father had owned the Crown Tavern, and the whisper-
ings went that Shakespeare had paid Davenant's mum a nocturnal
visit there. This particular rumor about Shakespeare, unlike ninety-

nine percent of them, might actually be true. Late in life Davenant was awarded sole right to certain Shakespeare plays by the crown, and even the great scholar Schoenbaum seemed to believe that "Sir William was more than Shakespeare's mere poetical offspring . . ."

Though never embraced, the Chandos did eventually win over the public. Its challengers came and went, but the Chandos, with the backing of the powerful NPG, always reemerged, rightly and perhaps at times wrongly, as the most-legitimate painted portrait of Will Shakespeare. It, too, became an icon of sorts, not beloved but ingrained, a portrait touted as possibly depicting Shakespeare from life. And perhaps that's true, though it's worth recalling that Dr. Tarnya Cooper, the onetime chief curator of the NPG, admitted there was "no conclusive proof" the portrait even depicted Shakespeare. In her *Searching for Shakespeare,* Cooper also described the portrait's early history as a hodgepodge of "hearsay, half-remembered facts and assumptions."

Other scholars have issued even harsher decrees. Back in 1824 James Boaden suggested the Chandos was perhaps the most touched-up portrait in history. In 1883 the scholar C. M. Ingleby noted that the Chandos "even if its history be as stated, is of very little real value: for it has been so often repaired or 'restored,' and is at present in such a dilapidated condition, that it cannot be relied upon . . . the existing picture no longer represents the man— whosoever he may have been—from whom it was painted."

Perhaps the biggest objection to the Chandos has been its lack of resemblance to the iconic Droeshout bloke from the First Folio. Both sitters owned similarly lubricious lips beneath a large thick-bridged nose, both had a receding hairline above mismatched eyes, but it's fair to say that, on first glance, nobody would assume the two portraits revealed the same man.

Due to the dubious condition of the Chandos, with all its retouchings, it's possible, even likely, that the earliest copies of the portrait, one of which was used as a tavern sign, might be more authentic likenesses of the sitter. Many of these copies now reside

at the Folger Shakespeare Library in D.C., but in all of these copies the Chandos Shakespeare remains stubbornly swarthy.

As I began plastering my office wall with these Chandos copies, my court favorite soon became the suicide-watch Lumley portrait, a sluggish Poe-like creature as imagined by Tim Burton on laudanum. The scholar Marion Spielmann once dismissed the Lumley as "a striking, not very competent, portrait of a clumsy, heavy-jawed man bearing some resemblance to the Chandos." But back in 1922, Frank H. G. Keeble of the American Art Association sang a different tune: "There is no doubt in my mind whatever," Keeble wrote, "that this [the Lumley] was painted by Shakespeare's erstwhile manager and confrere, Burbage."

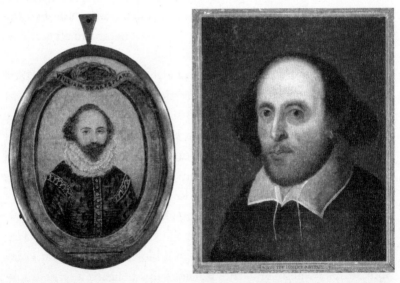

Left: Portrait of Shakespeare, unknown artist, circa 1721 (Folger Shakespeare Library).
Right: The Lumley portrait of Shakespeare, unknown artist (Folger Shakespeare Library).

Was Keeble correct? Could the glum Lumley have been the original to the large Chandos group of portraits? Well, Keeble's theory hinged on the Lumley family inventory of 1725 having mistakenly mislabeled the sitter as Chaucer. If that were the case—and the

odds seem against it—then the Lumley dated back to Shakespeare's lifetime and might therefore be the original of the Chandos group. That said, we will likely never know the truth about the Lumley's origins because the portrait resides in the Folger Shakespeare Library, the place where candidate Shakespeare portraits go to die.

A quick word about the Folger Library. Located in Washington, D.C., the library was the child of Henry Clay Folger, the chairman of Standard Oil, and his wife, Emily Clara Jordan, who together made plans to share their private collection with the public. Later Amherst College took over the administration of the library, which continued to acquire as many would-be bard portraits as obscene wealth could buy. Unfortunately, for me at least, a trustee statement forbade this hoard of pictures from being X-rayed unless there was a public outcry to do so, and you can probably guess how many public outcries to X-ray Shakespeare portraits have rattled the corridors of power in Washington.

To date only two portraits in the Folger's bard collection have ever been plumbed with X-rays. For my purposes, the Folger was a curatorial Tower of London crowded with morose swans, many of them quite Jewish in appearance, that might never receive a fair trial in the court of science. The mutt-ugly Lumley, a long-shot contender for the ad vivum crown, seemed doomed to pine away its hours gazing out a foreign window toward London, where the Chandos held court over the fawning British art world.

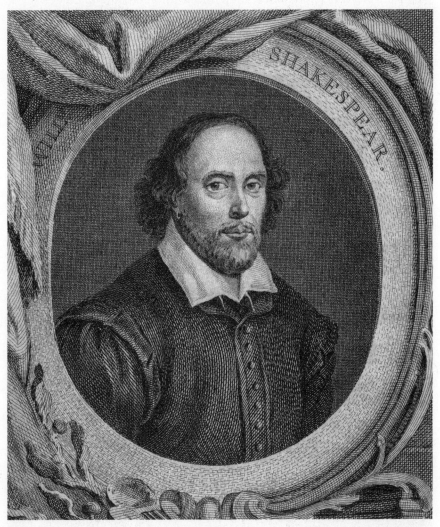

Detail from engraving based on the Chandos portrait by Hubert François, 1744 (Folger Shakespeare Library).

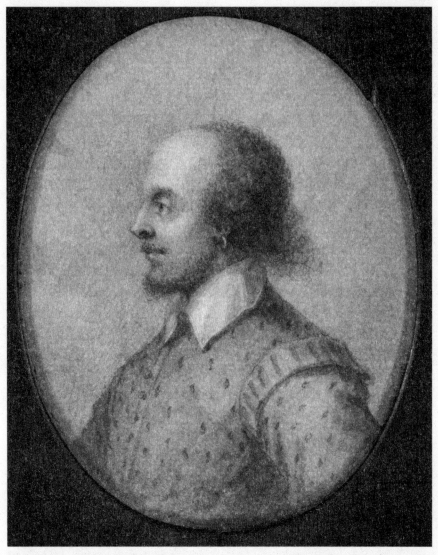

The antiquarian George Vertue's pen-and-ink profile of the Stratford memorial bust in Trinity Church, circa 1734 (Folger Shakespeare Library). Some critics believe that Vertue imposed the Chandos likeness onto his drawing of the bust.

4

Saint Shakespeare

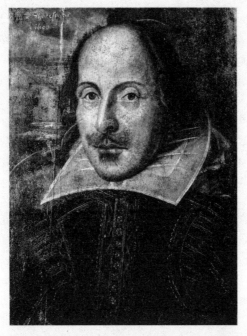

The Flower portrait after its 1979 restoration (Royal Shakespeare Company). For decades many experts believed the Flower to be the template portrait used to create the famous Droeshout engraving for the 1623 First Folio.

I became interested in attention deficit disorder after my son got semi-diagnosed by some teachers in elementary school. As Hayden grew older, he wanted to start taking Adderall—half his friends were already on it. His mom also thought Adderall might be a good idea. As I began studying ADHD, I realized Hayden's diag-

nosis was equally applicable to my own brain—if anything, I had it worse than he did—so I decided to try Adderall myself, as a guinea pig, before letting my son use it.

That decision might sound noble, but it wasn't. Like many writers, I enjoyed drugs, always had, love at first sight, Romeo meets Juliet, and I suppose I had hopes these amphetamine salts, a type of legal cocaine, might transform me into a Russian novelist while curing me of seasonal depression, the magic pill we've all dreamed about.

My doctor at a local clinic was famous among my friend set for the quick prescription. When I broached the subject of ADHD with him—little suspecting he would soon be stripped of his medical license—he brightened and told me his own son had been diagnosed with ADHD, which in turn had caused him to diagnose himself. The medication transformed his life, he claimed. Eager to help—almost evangelically eager to help—he set me up with an ADHD test, then, after I scored off the charts, started me on the Adderall dosage that had best suited him. He weighed eighty pounds more than me. His dosage was far too high, and soon so was I.

At first Adderall hit me like coffee when I was a kid, that mosquito-buzz burst of enthusiasm for damn near anything, but especially for my Night Gallery of bards. I became consumed, immersed, and immediately started a blog called *Curious Portraits of Dead Elizabethans* that became the vortex of my obsession. Adderall also inspired me to start any number of dubious writing projects, one of which, a hip-hop version of *Hamlet*, with vampires, I set to Nas's classic comeback album *Stillmatic*. None of these new projects deterred me from blitzing bagloads of emails into the in-boxes of beleaguered curators.

What happened to me was not that uncommon, I suspect. People take Adderall to temper their ADHD symptoms, but in certain cases the amphetamines can fuel the overlapping OCD symptoms. From the first pill onward, my life became a blur of portraits. I'd awaken from having dreamed about some portrait and would con-

tinue to investigate it until I hit a dead end, then I'd move on to another portrait. Later, if an X-ray or jpeg arrived, or if I found some new article on provenance—provenance was fun now!—I would backtrack to the earlier portrait and spend a month or two submerged in it. I pinballed from portrait to portrait while subsisting on the occasional crust-trimmed cherry Pop-Tart or grilled-cheese sandwich.

Such was my mindset, diet, and physique when I turned my attention to a clown-faced bard layered with accusations of chicanery, switchery, malpractice, and tomfoolery. The Flower portrait had been celebrated for decades, a true rock-star picture that had graced the pages of *Life* magazine before things went horribly wrong for this jack-in-the-box bard. You've seen the Flower. Ten million mugs, sixty thousand T-shirts and tote bags, the Flower could be found under the glass of your watch or painted onto the bottom of your tumbler. Or at least that used to be the case prior to its undoing in the 1990s, at which point the picture vanished from sight. To this day it's anyone's guess where the Flower resides. Maybe it's in rehab. Or perhaps it's joined the witness-protection program. Or swims with the fishes—or the swans.

Yet things had started out so promising for the Flower. Shortly after its discovery around 1840, when the collector H. C. Clements acquired the picture from some unknown dealer, the portrait was proclaimed to be the long-lost template portrait used to create the Droeshout engraving for the 1623 First Folio. By 1892 the portrait had been purchased by Mrs. Charles Flower, wife of a wealthy brewer, and was soon presented as a gift to the Memory Gallery of the Royal Shakespeare Company in Stratford. In 1898 the greatly esteemed scholar Sidney Lee weighed in on the Flower with this proclamation:

Connoisseurs, including Sir Edward Poynter, Mr. Sidney Colvin, and Mr. Lionel Cust, have almost unreservedly pronounced the picture to be anterior in date to the [Droeshout] engraving, and

they have reached the conclusion that in all probability Martin Droeshout directly based his work upon the engraving.

The Droeshout template had finally been discovered! Lee's *A Life of William Shakespeare* displayed the Flower on its cover while describing the picture as the only painted portrait with a serious claim to be contemporary to the poet. For over eighty years the Flower basked in glory while overshadowing the NPG's sluggish Chandos portrait. The battle between these two heavyweights continued for decades. London's NPG placed a caption beneath their Chandos portrait that touted their champion as "The only picture that has any claim to be a portrait of Shakespeare painted from life." Meanwhile, back in Stratford, the Flower was being displayed above a sign proclaiming it to be "the Droeshout original."

This was more than a battle over portraits, it was a battle over Shakespeare's face, because these two sitters did not appear to depict the same poet. As Paul Bertram and Frank Cossa stated in their 1986 paper in *Shakespeare Quarterly*: "Defenders of the Chandos as a portrait of Shakespeare have said they find that 'the main features tally,' while skeptics reject it 'because in every important physiognomical particular, and in face-measurement, it [the Chandos] is contradicted by the Stratford bust and the Droeshout print.'"

The fight raged on with the clown-car Flower now pummeling the tricked-out Chandos, but, every time the Flower had seemingly delivered a roundhouse winner, it turned around—in the astonished style of Apollo Creed—to see the Chandos struggling back up the ropes. Then in 1979 a flurry of low blows began to unfold when the Flower was restored by the Ashmolean Museum in Oxford. The Ashmolean owns no notes regarding their conservation work on the Flower—nor do the portrait's current owners at the Royal Shakespeare Company. All we know for sure is that this restoration changed the Flower in ways unimaginable.

The Chandos's only beloved feature was of course its dope earring, but, uh-oh, once the restoration of the Flower had been

completed, its sitter was suddenly tricked-out with an even cooler gold-leaf earring. Better yet, a cross of the type popular with Dan Brown's Priory of Scion had emerged above Shakespeare. Instead of some nondescript brown background, Shakespeare was posing outdoors among rocks that gave way to a desert sunset. And, oh, yes, this new and improved bard now had an actual halo hovering behind his head.

Saint Shakespeare had finally arrived.

None of these new details, including the halo, were native to the Flower portrait. As it turned out, there was another portrait buried beneath the Flower, an Italian-looking painting likely from the sixteenth century that portrayed the Virgin Mary, baby Jesus, and toddler John the Baptist. Prior to the Flower's restoration, the Ashmolean and the Royal Shakespeare Company already knew from the portrait's 1966 X-ray that this portrait existed beneath the paint. Yet today nobody can explain why they chose to dissolve the existing backdrop on what was arguably the most authentic painted portrait of Shakespeare in the world.

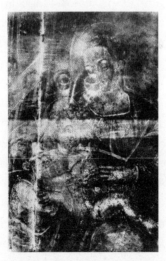

The 1966 London Courtauld Institute of Art X-ray reflectogram of the Flower portrait revealed the likely Italian underportrait featuring Madonna, baby Jesus, and John the Baptist (Hildegard Hammerschmidt-Hummel).

The Ashmolean claimed to have no idea why—or even if—its restoration destroyed the Flower's original background. The Royal Shakespeare Company likewise had no clue. That said, a likely benefit behind the beatification of the Flower, when looked at in terms of tourism, seemed crystal clear.

Two portraits alike in homeliness were competing for the love of a nation, and suddenly one of them reappeared decked out like Jesus complete with halo. It seemed a bit suspicious to my mind. We can be grateful that the restoration at least spared the Flower portrait's inscription, which gave us the poet's identity and the year the picture was supposedly painted, 1609 (seven years before Shakespeare's death and the same year his sonnets were published). Some skeptics argued that this inscription, in which two letters were painted in cursive, served to debunk the 1609 date, but the Flower's advocates insisted the inscription was painted with the same yellow pigment as parts of the sitter's doublet thereby proving the inscription native to the portrait.

The Flower's greatest champion, when all was said and done, would prove to be the German professor Hildegard Hammerschmidt-Hummel, the same scholar who put forth the theory the Droeshout might have been copied from a death mask. In 2002 Hammerschmidt-Hummel had just completed a six-year research project with the German FBI and a Justice League team of scientists that attempted to employ crime-solving facial-recognition technology to establish the consistencies of facial features within a select number of accepted images of William Shakespeare. Her study would eventually lead her to make some interesting accusations, one of which involved portrait switchery.

When she began this project in 1996, Professor Hammerschmidt-Hummel had obtained a high-resolution Ektachrome of the Flower portrait from Brian Glover, the collection director of the Royal Shakespeare Company. Seven years later, with Hammerschmidt-Hummel's book about to go to press, her publisher requested a transparency of the Flower to use for the book cover. This transparency was provided

by the new director of the RSC, and, lo and behold, this transparency revealed a portrait Hammerschmidt-Hummel described as "distinctly different from the one Brian Glover had supplied to me in 1996."

So vexed was the professor that she boarded a flight to examine the current Flower portrait and later informed David Howells, the new curator of the Royal Shakespeare Company, that the painting currently on display was not the same portrait depicted in her earlier photograph. Her claim was backed by Reinhardt Altmann of the German Federal Bureau of Criminal Investigation, who supplied a written report stating the current picture had to be a copy. Professor Wolfgang Speyer, an expert on Old Masters at the Dorotheum in Salzburg, added: "The picture must have been restored, or, to put it more precisely 'repainted' . . . During this process everything was smoothed out on the surface but the character had been utterly lost."

The blemishes in both pigment and varnish had been corrected in such a way that Speyer concluded, "More damage had been inflicted than had been repaired."

Hammerschmidt-Hummel also pointed out that the portrait's wooden panel had been repaired, and it goes without saying that four-hundred-year-old panels, even ones depicting saints, seldom healed themselves. Yet Howells insisted neither the portrait nor its panel (almost all the portraits discussed in this book were painted onto wooden panels) had undergone any conservation during those six years. The Flower had been healed without conservation. It was a miracle!

Instead of calling the pope, Professor Hammerschmidt-Hummel, no romantic and as traditional a Stratfordian scholar as one could hope to meet, concluded that the Flower portrait must have been switched. To support her argument she reproduced photographs of both portraits side by side in her book *The True Face of William Shakespeare*. Then in 2010 she published another book championing the (now apparently missing) Flower as an authentic ad vivum portrait of Shakespeare while repeating her claim that the original had been replaced. This new book also supplied a CD-ROM filled with

visual evidence to support her argument. As far as I could tell, her book went ignored yet the evidence it provided seemed damning.

Something stank in Stratford.

Then things got weird.

Shortly after Hammerschmidt-Hummel finished her study, the NPG, owners of the rival Chandos portrait, decided to perform a series of tests on various candidate portraits including the Flower. Hearing about this development, Hammerschmidt-Hummel wrote the NPG warning them that the portrait they were about to test was not the original Flower, but this warning was also ignored. The ensuing 2005 test results on the Flower revealed the presence of a pigment, chrome yellow, that had not been available to English painters until 1814.

And that quick—*POW!*—the Flower became a fraud, a laughing-stock, a disgrace. Following their haymaker, the NPG chimed the boxing bell and raised the glove of their haggard champion, the punch-drunk Chandos, who had once again labored back to victory.

Hammerschmidt-Hummel cried foul play, and it's interesting to observe how the scholarly world reacted to a respected professor's accusations against London's vaulted curatorial world. Her evidence that the portrait had been switched continued to be ignored; instead, certain scholars went schoolyard on the professor. Professor Stanley Wells, as quoted in *The Times*, even described Hammerschmidt-Hummel's claim as "disgraceful" and added that many books written on Shakespeare contained similar "lunatic theories."

Meanwhile Hammerschmidt-Hummel remained as baffled as anybody by this supposed switchery, and what she kept pointing out was that her visual evidence argued that within a six-year period the portrait's panel had been somehow healed in places as had some of its pigments. If anyone was defending science, it seemed to be the German team. Nobody could dispute that the panel of the original Flower had been decayed by wormwood. As Hammerschmidt-Hummel pointed out, "It had already been described in these terms by British experts at the end of the 19th and the beginning of the

20th centuries, among them the director of the National Portrait Gallery." Yet now the panel appeared improved, "showing no signs of wormwood damage . . . [and] the peripheral areas, which in the original painting are brittle and have been broken or chipped away in places, exhibit no such damage in the portrait inspected in the RSC depository."

Then, once the Chandos had regained its heavyweight belt, the Flower portrait, or perhaps the portrait being touted as the Flower, discreetly vanished from public display.

While watching the snow and studiously nibbling a Pop-Tart, I had no idea what to think about this curious battle between two portraits and once again found myself imagining subterranean meetings punctuated by Gregorian chant. My confusion would linger for years. Eventually I would board a plane in search for the Flower, but that wouldn't happen until long after I'd fled Vermont in fear of my life.

5

Brawler Shakespeare

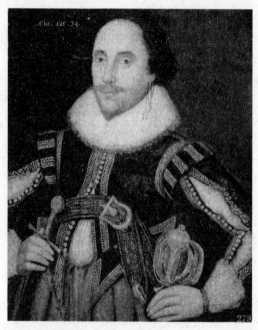

Portrait of a Man (artist unknown, seventeenth century). This picture is also known as the Hampton Court Shakespeare. Note the peascod-style stuffing, called bombast, exposed by the unbuttoned doublet. The peascod style, seen here overhanging the belt as it did in the early 1590s, went out of fashion in England circa 1598 (Royal Collection Trust / © Her Majesty Queen Elizabeth II 2021).

The April 2007 *Harper's Magazine* chose for its cover a painting created in 1766 by Giovanni Battista Cipriani in which a tanned and chiseled Shakespeare, with pen poised, strides into the

eye of a storm while wearing the red and blue robes cribbed from da Vinci's *Last Supper*. The breeze lifts the locks of his abundant hair, the cutwork of his collar, the blue of his cape, and the pages of his manuscript (almost certainly *Lear*). And this is one ripped bard. If we were to strip him of Jesus's clothes and strap on a toy holster, Cipriani's Shakespeare could moonlight as a Chippendale dancer. So here he comes, ladies and gentlemen, riding the storm, the posterchild Bard of Avon who moves product: mugs, movies, mags, totes, beer, bios, and even porn—Shakespeare as we would want him.

It's a lie, every brushstroke, but nobody wants to paint this picture the way it actually existed, with our bald boy Will straddling a canal of horse piss en route to some witch hunt or whore flogging. Unlike much of Europe, Shakespeare's England remained starkly medieval, not because of those festering heads piked along London Bridge but because such a beheading was considered an act of unfathomable mercy. Every night prisoners went to bed in the Tower of London praying to be hacked to death by an ax. Other options available to the Virgin Queen (who was quite demanding of her pet torturer and rumored lover Richard Topcliffe) included having traitors dissected alive before cheering crowds. First you were bellied open and gutted with your decamped penis set alight before your dimming eyes and eventually stuffed into your mouth to stopper the screams, but this sequence could vary depending upon how the executioner decided to play the crowd that day.

Regardless, after you'd been scissored, hollowed, disassembled, and set alight, your head was spiked on the bridge and your limbs and trunk set in tar to be displayed throughout the city as cautionary works of art. Every morning these grotesque statues clung to the shadows to watch England's Golden Age awaken, the chambermaids emptying pots of noble excrement into the canals while legions of blinged-out men-at-arms stepped over sewers in search of entertainment: a bait, a brothel, a witch burning—hell, even a play—anything to distract from the constant paranoia over armadas

and arrests, towers and tortures, agents and double agents, duels, fleas, rats, spies, lawyers, plagues, public defamations, and private poisonings.

Under Elizabeth a whole smorgasbord of dementia awaited the idle gull. No prostitutes to be whipped naked through the streets today? Ah, no worry, lads, there's always the cathartic art of bear-baiting, a ballet in which the lowly mastiff rips to death the regal and tragical bear. Lions, bulls, monkeys, apes, roosters, they were all baited. Then, following the epiphany of a good bait, and assuming there was no Jesuit to be torched alive, the art-loving gull had only to saunter downriver past the line of brothels into a neighboring playhouse.

Imagine that transition, though: a five-minute jaunt from some blood-splattered bait pit into the ethereal world of Elizabethan drama. Well, yes, it's pretty to think so, but on a good day the Southwark playhouses could make a pit bull blush. Those theaters, banished outside city limits as vaguely satanic, were essentially larger-scaled bait pits that offered a competing menagerie of mutilations, executions, murders, rapes, etc. The scripts were of course infused with Tudor propaganda to be lapped up by the illiterate masses. As one drunk groundling spat at an actor, another clamored onstage to protect Mercutio in a swordfight. (Eventually the Globe had to ban all steel at the door.) Meanwhile, the more affluent patrons hardly noticed the play at all, there being too many other distractions, such as dice and cards, with pickpockets, blackmailers, and prostitutes working the crowd.

Like it or not, the Globe was a G thang, a drunken vice-ridden delivery system of Tudor duplicity, its grand finale each evening not the play but the bawdy jig that followed. To any out-of-favor courtier these plays were poison. Shakespeare's pen was dipped in courtly scandals and his audience titteringly aware of who it was being pulled apart onstage. Nobody was safe from his satirical barbs, not Elizabeth's hunchbacked secretary of state Robert Cecil, whose deformities were likely parodied in *Richard III*; not the powerful

Lord Burghley, ruthlessly mocked in *Hamlet* as the Alzheimered Polonius; and not even the queen herself, who once snappishly complained of having been roasted in *Richard II*.

Everywhere you looked London was beef and bling, especially in the bait and brothel theater districts. The North Side (aka Shoreditch) had the Curtain and the Theater, whereas the Dirty South(wark) claimed the Swan, Rose, and Globe. The inner city belonged to the Blackfriars troupe with its ill crew of child actors. Meanwhile powerful noblemen controlled traveling companies of actors to distribute their own brand of propaganda. Inside this battle royale, freelance writers, vying for the sparse onetime payments given new plays, turned on each other like game cocks. The most famous of these feuds started when Ben Jonson (who had been jailed, racked, and had once killed a man in a duel) dissed a crosstown rival named Thomas Dekker, the two playwrights squaring off in what became known as *poetomachia*, "the Battle of the Poets." It was vicious and hilarious stuff, dark as night, and boy did it pull in the bear-bait crowd. As word of each new beef spread, the coffers filled, the insults peaked, and a month later Jonson and Dekker could be glimpsed drinking together, pockets padded.

This same scam worked for the pamphleteers. A profitable rhyme battle between the wordsmiths Gabriel Harvey and Tom Nashe proved so one-sided it was like watching Suge Knight dangle Vanilla Ice off some hotel balcony of doom. Nashe, the city's most feared and fearless satirist, once compared the closing stanza of Harvey's latest poem to a fart after a bowel movement. Nashe also transformed Shakespeare's exalted *Venus and Adonis* into a porn parody about one man's epic attempt to bring a London prostitute to orgasm using a dildo. Constantly offending authorities, forever on the run, Nashe jumped pen name to pen name: Cutbert Curryknave to Pierce Penniless to Adam Evesdropper to Jocundary Merry-brains. A pamphlet got him tossed into Newgate Prison, a satiric play forced him to flee London. A friend and collaborator of Shakespeare's, Nashe died likely of the plague around 1601, two

years after the queen thought it prudent to set his life's work ablaze in a great bonfire of lost lewd literature.

"Truth is ever drawne and painted naked," Nashe once confessed, "and I have lent her but a leathren patcht cloake at most, to keepe her from the cold . . ."

So this, more or less, was the honest backdrop to any Elizabethan portrait, and splashing toward us through this lurid backwater comes its gangster king, the playwright billed as "Will. Shake-speare," who ascended his throne, following the brutal assassination of Kit Marlowe, via the tragedy *Titus Andronicus*, a play that took the art of sex-crazed violence further than anyone ever dared, even Kit, and in doing so captivated the city. *Titus* became the most profitable play in the history of London and remained so throughout Shakespeare's life. What's better than a public execution? Hey, *Titus* promises you four executions, seven murders, buckets of gore, degradations galore, blatant racism, rampant dismemberments, incestuous cannibalism, and a rape scene unrivaled in theatric brutality in which a young woman's husband is stabbed to death before her eyes after which she is repeatedly raped on top of his corpse after which her hands and tongue are lopped off with knives.

Just how demented is *Titus*? The stage directions alone are worth the penny paid for horror. "Enter meffenger, with two heads and a hand"; "Enter Empresse Sonnes, with Lavinia, her hands cut off, and her tongue cut out"; "She takes the Staffe in her mouth, and guides it with her Stumps." And who can forget that poignant moment late in the play when Lavinia staggers offstage with her father's dismembered hand shoved inside her butchered mouth? And all for a penny! Yes, for the true lover of S-and-M debauchery, the play was the thing.

It was this Southwark Shakespeare I wanted to find portraited, an armed-and-dangerous rhyme animal, his face pickled with venereal disease, his eyes rheumy with dissolution, and one hand resting half cocked on his sword pommel. Much to my surprise I soon

picked up the trail of just such a ribald poet, one who had been hidden from sight for centuries.

Back in 1864 the Hampton Court portrait, as it's sometimes known, was described by J. Hain Friswell as having the "peculiar strut and stare" of a "bilious military ruffler," and again some thirty-four years later by the Shakespearian scholar Ernest Law as "rather a truculent version of the 'gentle bard of Avon.'" This truculent bard of Hampton Court had been banished, Friswell noted, to the top of "a room with a deep ceiling, and quite out of sight." J. P. Norris described this portrait in 1885 as hung "so high it was difficult to say what it was."

Though all but forgotten, the Hampton Court had once been championed as Shakespeare by royalty. In 1834 William IV, England's "sailor king," had obtained the portrait, understood to be Shakespeare, from the descendants of the Sidney clan at Penshurst Place. Could there be a better provenance for Shakespeare than Penshurst? The Sidney family was, after all, the only family ever rumored to have had "the man Shakespeare" pay them a social visit. Mary Sidney even stood accused of having written, or coauthored, the plays of Shakespeare due in part to the elite literary salon she fostered known as the Wilton Circle. Mary's husband had founded Pembroke's Men, the first acting troupe to perform Shakespeare's plays. The hallowed 1623 First Folio was dedicated to their two sons. With apologies to Stratford, Wilton was about as close to Shakespeare as you can get.

I soon learned, with some excitement, that *Scientific American* had recorded the spectral testing of the Hampton Court portrait—with both X-ray and infrared light—back in 1937. These tests had been administered by a photographic expert named Charles Wisner Barrell, an early authorship-debate gadfly; yet when I contacted the Royal Collection I was informed that the picture's conservation file was empty.

Huh, I thought.

The Royal Collection did have a nice photograph of the Hampton

Court portrait displayed as an unknown gentleman in their online gallery. I spent a lot of time gazing at that jpeg through my magnifying glass. Initially I became fascinated with the sitter's eyes. In the local library I'd found two different nineteenth-century sources that emphasized the striking blueness of the Hampton Court's eyes; yet the eyes currently displayed were a blatant green, whereas a photograph I'd found of a copy of the portrait revealed eyes decidedly chocolate in color. None of this should have surprised me. What I didn't yet know was that as varnish ages it yellows, and this yellowing can affect pigment color. Pigment color can also be altered by restorers, who tend to err on the side of blue-eyed beauty, each touch-up a facelift. Eye color, perhaps the first detail novices seize on, is often the most meaningless.

Having yet to learn this, I began to suspect that somebody was up to no good in regards to the Hampton Court. There was some strange behavior here that needed explaining, and I was just the chap to get to the bottom of it. Even the royal curators admitted that the Hampton Court had been massively overpainted. Just how much? Well, even its overpaint had overpaint. I kid you not—its inventory number, which somebody *had painted directly onto the picture*, had later been manipulated into a different number.

Another baffling detail was the circa 1623 dating of the portrait. That date, the same year as the posthumous First Folio, eliminated any hope the portrait might depict Shakespeare painted from life. The Royal Collection claimed the sitter's costume had dictated the dating of the portrait. That seemed odd since the sitter was wearing a peascod doublet, its lower belly stuffed with bombast to make it overhang the waistline and point downward to where the codpiece had ruled in earlier years. This Dutch peascod fashion had become popular in England around 1575 but had vanished by 1600. Nobody was rocking peascod in 1623 England, and yet that was the date assigned the portrait.

Stranger yet, the sitter's peascod belly had been left slovenly unbuttoned with its bombast stuffing exposed, a pose specifically as-

sociated with literary courtiers of the 1590s. Jane Ashelford's *Dress in the Age of Elizabeth I* described this fashion as one of "melancholy disarray . . . perhaps influenced by the sonnet." Henry Percy, "the Wizard Earl" who was Marlowe's patron, had sported just such an open-bellied peascod in his circa 1593 painting by Hilliard. Tom Nashe was likewise immortalized with bombast exposed in his only known portrait, a 1597 engraving that showed him under arrest, his ankles shackled by bilboes. Nashe once described this style as "gelt," or undone, "in the belly as though, like a pig ready to be spitted, all my guts had been plucked out . . ."

Confused as always, I wrote yet more emails to the Royal Collection. Confronted with this inventory of discrepancies, the curators there did something that shocked me: they agreed to X-ray their picture. Assistant curator Vanessa Remington helpfully replied, "In the light of the very heavy over-painting this portrait has undergone, an X-ray examination of it will take place in September and I will let you know the outcome. However, I should stress again that all the indications are that it is very unlikely to represent William Shakespeare."

Well, I couldn't believe my luck. I was clearly on top of my game. My seasonal depression lifted, and I suddenly noticed that falling snow, seen from certain angles, contained a type of beauty. Soon, I told myself, I would own the only existing photograph of the Halliwell-Phillipps First Unique Proof plus the sole existing X-ray of the banished Hampton Court brawler.

Yeah, Adderall and me, we had this Shakespeare thing licked.

The only known portrait of the brave and bombastic writer Thomas Nashe (seen here shackled in bilboes). Detail from the frontispiece engraving of the 1597 book *The Trimming of Thomas Nashe, Gentleman*, artist unknown (Folger Shakespeare Library).

6

Gigolo Shakespeare

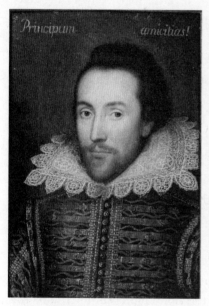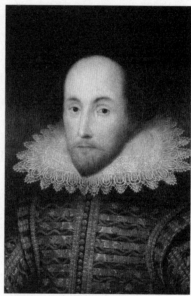

Left: The Cobbe portrait of Shakespeare (private collection of Alec Cobbe). *Right*: The Janssen portrait when still overpainted bald (Folger Shakespeare Library). Stanley Wells argued that the Janssen was likely copied from the Cobbe and that both portraits depict William Shakespeare.

Lowering your dosage is a dull chore. You know something's wrong, but given the option of upping or downing your meds, the latter is the drive home from the beach whereas the former, hiking that dosage, sustains the hope of endless summer. To lower your meds is to admit defeat, but by upping them you remain in line

to meet the guru who will cast out your demons forever. Many of my demons were by now pasted onto the walls of my office. Somewhere along the line I'd become possessed by the glum Lumley portrait and had transformed into a pathetic Poe-like figure obsessed with ugliness who lived off jarred olives and crust-trimmed cherry Pop-Tarts.

After upping my dosage I took up a new hobby. Actually I took up a number of hobbies, but this was the rare wholesome one. What I did, I began creating, and coloring in, large paper birds using aerodynamic origami patterns from inside a book I'd once given to my son called *Paper Birds That Fly*. Completing my first bird, a Canadian honker, took over a month. My next venture, a red-tailed hawk, consumed a bit less time, as did my third, a turkey buzzard. Finally, after finishing my masterpiece, a sooty owl, I hung all four by strings from the blades of the ceiling fan in my living room. When I turned on the fan, the birds rose up and went soaring in widening circles while I lay on the floor beneath them, their orbits filling my eyes eyes eyes as they went round round round.

Prone on the carpet beneath their whirl, I was essentially a *Looney Tunes* character knocked unconscious. And that's how life found me on the afternoon the radio announced that Professor Stanley Wells, chairman of the Shakespeare Birthplace Trust, had just anointed a new portrait, one owned by Mr. Alec Cobbe, to be Will Shakespeare. Following a hush, the houselights dimmed and this debutante swan emerged from the wings to strut down the Stratford runway, stopping only briefly to assess the crowd with the expression of a bereaved hairdresser.

It was, I'll admit, hate at first sight. Gazing upon my homespun collection of leprous poets, I sensed them imploring me to debunk this imposter, this soap-opera doctor calling himself the Cobbe.

As things turned out, I didn't have to. Within days of Wells's proclamation, the dogs were loosed upon his dandy. First to attack this new gigolo bard was London's National Portrait Gallery. It's difficult not to sympathize with the NPG here. Their heavyweight

Chandos, the Jewish Joe Frazier, had ruled for over a century, taking on one contender after another. They'd all had the champ beat, seemingly, but the Chandos always lummoxed back to silence the crowd, and now here he was once again slumped on his corner stool bleeding heavily after the first round and staring sullenly across the ring at the lemon-suck cheekbones of bobbing Kid Cobbe: coifed, buff, doubleted in gold leaf, and soft-focused as any playmate.

Sure, I hated him, but not as much as the NPG did.

Following some initial criticism from the NPG's Dr. Tarnya Cooper, their former director Sir Roy Strong lambasted the Cobbe's legitimacy as fantasy. "Codswallop!" was how he phrased it. Then the formidable Katherine Duncan-Jones, whose writings on the sonnets are considered sacrosanct, weighed in by describing the Cobbe theory as "irrational."

But it didn't matter what the experts said. This time the fix was in. Scholars no longer scored the fight, Google did. And because of this, the Cobbe's debut, launched on Shakespeare's birthday as part of a Stratford publicity stunt, proved a choreographed success that would redefine the playwright. A star is born: the prettiest Shakespeare of them all.

To comprehend the Cobbe claim to fame you have to understand that Shakespeare's portraits often come in groups, the two most authentic being (in theory) the Chandos and Janssen groups. If you think of the original portrait as a planet, and its subsequent copies as moons, Professor Wells was making the argument that the Cobbe portrait was the newly discovered planet of the many-mooned Janssen group (now the Cobbe group). But there was a problem with his theory: The Janssen portrait had already been debunked as Shakespeare by its owners at the Folger Shakespeare Library. Back in 1988 the Folger had X-rayed their Janssen portrait before recasting their star bard into the less enviable role of Sir Thomas Overbury, Disagreeable Jacobean Courtier Poisoned with Tarts and Jellies by the Wife of his Homosexual Lover.

In questioning the authenticity of the Cobbe gallant, the skeptics

were asking an obvious question: How could this Cobbe "original" depict Shakespeare if its Janssen "copy" depicted Tom Overbury? Even Stanley Wells agreed the two portraits portrayed the same man, but it was his contention that the Folger had erred in debunking and thereby devaluing their prized Janssen Shakespeare. Wells believed both portraits depicted Shakespeare and was quick to point out the Cobbe had been found in a collection descended from the 3rd Earl of Southampton (the consensus Fair Youth of the sonnets) thereby attaching the Cobbe's provenance to Shakespeare in a six-degrees-of-Kevin-Bacon way. Both portraits depicted the bard, Wells argued, but since the Cobbe was the older of the two—recent tree-ring tests had dated its panel to as early as 1610, some six years prior to Shakespeare's death—the Cobbe was therefore a likely ad vivum portrait of Shakespeare even though it bore zero resemblance—none, zip, nada—to the Droeshout bloke.

How certain was Wells? He claimed to be—*ahem*—ninety percent sure this new portrait was Shakespeare painted from life. With that number in mind, let's have a look at the ten percent of doubt.

First, we have to ask if Wells was correct in assuming the two portraits revealed the same courtier. The Janssen sitter had a much thinner upper lip, but both sitters did appear to be wearing similar costumes, that is, until you raised a magnifying glass. As it turned out, there was one big difference. The cutwork of the Janssen's whisk collar had been designed using the Tudor-rose pattern associated with Elizabeth I. But the Cobbe collar had been fashioned after the thistle pattern of James I, who became king after Elizabeth's death.

In criticizing the Folger's decision to debunk their Janssen portrait, Wells failed to mention a decision made by the Folger during their restoration of the Janssen that had caused the *Independent* to run the 2009 headline: "How Restorers Ruined the Last Portrait of Shakespeare." In the course of that restoration, it seems the Folger team had destroyed a layer of surface paint that might have been added to the portrait while Shakespeare was still alive.

We'll return to that destroyed layer of paint in a moment, but

for now let's fast-forward. A few years after the Janssen portrait was debunked by the Folger, the owner of the Cobbe picture scheduled his own restoration—*which he decided to do himself*—and dissolved a layer of surface paint on his portrait that had possibly been applied, according to Wells, while Shakespeare was still alive. Yet nobody criticized Alec Cobbe for destroying that layer of ancient paint—or for refusing to release some of his portrait's test results to the public. All that mattered, it seemed, was that our new Soul of the Ages looked like a Calvin Klein underwear model.

Both the Cobbe and Janssen portraits had a layer of ancient overpaint destroyed from their surface, but what's perplexing here is that, in both cases, that destroyed layer of paint had been applied in order to render the sitter bald. Now why, a rational mind might wonder, would anyone overpaint a fetching portrait of Will Shakespeare bald while he was still alive (or freshly dead)? Shakespeare died in 1616. The iconically bald Droeshout first appeared in 1623. Were the Cobbe and Janssen Shakespeares overpainted bald prior to the Droeshout's First Folio debut? If so, why?

Stanley Wells had an answer to this riddle; however, it was not a good one. His scenario played out like this. Shakespeare was dying (or recently dead). His friends, not wanting to remember their genius in the spring of his life sporting his trademark bouffant, decided to overpaint their beautiful ad vivum portrait of the playwright bald to better reflect how he looked as he staggered toward the grave. But, before doing this, they commissioned a magnificent copy of their ad vivum portrait, similarly coiffed and known today as the Janssen portrait. Once this copy had been completed, they then overpainted the original Cobbe portrait bald—because, again, that's how they wanted to remember their once beautiful friend. Then they overpainted the Janssen copy bald, too.

Questions?

Yes, you in the back holding the Pop-Tart with the dark circles under your eyes.

"Hi, Dr. Wells. I'm just wondering if anyone in the history of

our planet has ever overpainted a valuable portrait bald in order to make its sitter appear less attractive? Can you give one example of this ever having happened? Yet we're to believe this happened, um, twice?"

Professor Wells supported his ad vivum argument with the results of the tree-ring test performed on the Cobbe's panel. Those results established that the tree used to create the panel might have been cut down six years before Shakespeare died; however, the tree might also have been felled six years after his death. Yet somehow Wells remained ninety percent convinced the Cobbe was painted from life.

There was another detail ignored by the press in addressing this ad vivum claim. As Andrea Kirsh and Rustin Levenson pointed out in *Seeing Through Paintings: Physical Examination in Art Historical Studies*, "When using dendrochronological data, art historians factor in the drying time [of the wood panel] by adding a minimum of two to five years to the felling date." Since this drying process might take even longer in perpetually damp England, it didn't really matter when the tree was cut down—no artist chops down a tree to paint a portrait—what mattered was when the portrait was actually painted. Yet Wells remained ninety percent certain the tree in question had been felled years before Shakespeare's death.

Begging the question, was this an argument based in science or confirmation bias?

So here let me take a moment to suggest a one-word counterargument to explain why both these portraits had been overpainted bald.

Shysters.

Yes, the jittery fellow in the back again?

"Um, sir, with all due respect, isn't it far more likely both these portraits were overpainted bald in attempts to foist off relatively worthless portraits of the disgraced poet-courtier Sir Thomas Overbury as invaluable Shakespeares?"

There was a knock on my office door.

"Dad, who are you talking to?"

I glanced around the office, my eyes settling on the Lumley sitter sulking above my Samsung monitor.

"Uh, no one," I replied in a rather high-pitched voice.

Pause.

"The Olympics are on," he said.

"What?"

"You said to tell you when they started."

A few minutes later I walked into the living room to watch the Olympics with my son. While slumped on the couch, we had to endure those annoying up-close-and-personal segments instead of actual sporting events. This caused me to notice how impossible it was to recognize the speed skaters after they'd donned their skullcaps. If you wanted to disguise a portrait, I realized, the easiest way to do this might be to inflict baldness on its sitter. The rest of the portrait, including the invaluable face, would be left undamaged. Later, as the Elizabethans knew, a salve of lemon juice and water could be used to re-expose the hair.

Baldness as a disguise? The implications were interesting, especially if Wells was correct in his belief that both portraits were legit Shakespeares. Could Shakespeare, I began to wonder, have fallen from grace to such a degree his portraits became political liabilities that needed to be disguised or destroyed shortly after his death (or even while he was still alive)? And if you did overpaint Shakespeare's hair bald, wouldn't that create the illusion of a poet with a freakishly tall pecan-shaped head? Was it possible the 1623 Droeshout engraving had been copied from such an overpainted portrait?

"When Shakespeare died in Stratford it was not an event," Mark Twain once noted. "Nobody came down from London. There were no lamenting poems . . . no national tears—there was merely silence, and nothing more."

Sparrows have fallen to greater fanfare. Not one obit, lament, poem, ditty, or dirge. This organ-blast of silence following his death has been interpreted in two ways: Some scholars argued, rather sur-

really, that Shakespeare achieved no great celebrity in life. Others claimed his star had faded before he died—perhaps due to some courtly scandal.

Seven years before Shakespeare's death, the 1609 publication of his sonnet cycle, filled with hints at same-sex lust, had been met with an equal death knell of silence. Years earlier, his monumentally inferior poem *Venus and Adonis* was embraced with reprints, praises, and at least one pornographic parody. Not so with the sonnet cycle, of which there was no contemporary mention. A hundred years would pass before the sonnet cycle was accurately republished. Could its initial publication have led to Shakespeare's disgrace and banishment from London?

Well, maybe, but there was one other scenario that might explain such a scandal. Few crimes were considered more scurrilous than suicide, as in Sonnet 66 ("Tired with all these, for restful death I cry"), as in: Cassius, Brutus, Portia, Romeo, Juliet, Othello, Ophelia, Lady Macbeth, Mark Antony, Cleopatra, Charmian, Goneril, and Eros. During Shakespeare's life, suicide was considered an act of murder against God, Nature, and King, a trinity of stigmas so severe that even a nobleman who offed himself would have his assets seized. Only one man in England had a samurai approach to the art of self-destruction, and that was Shakespeare himself, who seemed to admire it under certain circumstances.

Admittedly, the idea of Shakespeare's portraits having been overpainted bald due to any scandal, be it suicide or homosexuality, seemed farfetched—though not nearly as farfetched as Professor Wells's theory—and this in turn brings me to a much-overlooked detail about the Cobbe portrait that reeks of scandal: its inscription, a mere two words of Latin: *"Principum amicitias!"* Translated literally, the phrase means "the friendship of princes!" (We should understand the word *prince* to stand for king or queen in this context.) Stanley Wells believed those two words were an allusion to a passage in Horace in which a writer named Gaius Asinius Pollio was warned to stop using political references inside his plays. According to that

theory, the Cobbe's inscription should be understood as a warning to satirical writers that meant "beware the friendship of princes!"

If Wells was correct about this, then the inscription on the Cobbe was presenting its sitter as a cautionary tale. Here we had a playwright who thought he could get away with political satire because he was pals with the king. But the writer was dead wrong about this, and the king subsequently betrayed and punished him. Therefore: Beware the Friendship of Princes!

With that in mind, one might think that Professor Wells, and the whole Shakespearian world, would be interested in the implication that something dreadful happened to Shakespeare due to the political content of his plays. Yet all Wells seemed to care about was that the two-word inscription linked the portrait, via the patented Kevin Bacon method, to the poet Horace, who was one of Shakespeare's favorite writers. And while I remain impressed that Wells can extract so much meaning from a mere two words, nevertheless I would like to point out that this Latin inscription, as interpreted by Wells, would seem to offer strong support to the Folger's conclusion that the sitter of their Janssen portrait was the murdered Tom Overbury.

King James I, who had once been Overbury's friend and likely lover, was believed by everyone to be at least ninety percent complicit in the poisoning of Overbury, who had made the mistake of putting his trust in princes. The inscribed warning therefore fit Overbury like fine Italian armor. And if both these sitters did depict the same courtier, as Wells believed, it seems far more likely to me that the courtier in question was Sir Thomas Overbury and not Will Shakespeare.

It's worth wondering, of course, if this dire inscription also fit Shakespeare. Let's hope not, since the warning would seem to imply dire consequences not excluding murder. Yet Wells appeared to have little interest in such implications. Nor did the press. Nor did the modern choir known as Google. So it was that most fascinating detail about this newly ordained Cobbe Shakespeare went ignored by everyone. Shakespeare was a babe. Nothing else mattered.

At the end of the day, I think it's fair to wonder how Wells could be ninety percent certain of anything, but perhaps the professor knew more than he was letting on. After all, he'd studied the portrait's underbelly test results. Why weren't the rest of us allowed to see those test results? After a four-hundred-year parade of frauds, were we really being asked to take the word of Alec Cobbe that his family owned a priceless Shakespeare?

Truth be told, I didn't quite trust the Cobbe restoration and had never been particularly impressed by the Cobbe family's insights into their portrait collection. In 2002 a visitor to their gallery had to inform them that they owned a portrait of the 3rd Earl of Southampton. So why had the Cobbe family failed for centuries to recognize a portrait of their most celebrated ancestor? Well, they had a good excuse. They thought the sitter was a girl.

Apparently the Cobbe clan wasn't familiar with a sonnet penned about their famously effete ancestor, the one that began "A woman's face with Nature's own hand painted."

God save art from the rich.

In the end, none of the arguments against the Cobbe mattered. All that mattered was that Shakespeare was finally fuckable. It had taken some four hundred years, but now it was undeniably true. Stick a staple in his belly. Kid Cobbe had won the day and was blowing kisses to the crowd above the fallen Chandos.

7

Ill Odour Shakespeare

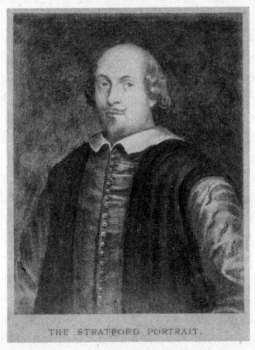

THE STRATFORD PORTRAIT.

The Hunt or Stratford portrait of Shakespeare owned by the Stratford Birthplace Trust (photograph from J. H. Friswell's 1864 *Life Portraits of William Shakespeare*).

It felt as if Kid Cobbe had clobbered me with a right hook I never saw coming. I woke up on the canvas with birds circling overhead, and it wasn't until the nine count of that winter had sounded that I struggled to my feet and stared spider-eyed across the ring at a new contender, a portrait that would infest my brain unlike any other.

Also known as the Stratford portrait, the Hunt had a lot of layers, a lot of wounds, aliases, and disguises. It was, as Joe Pesci once described a simpler subject, a mystery wrapped in a riddle inside an enigma. The portrait had been discovered in 1860 when Mr. William Oakes Hunt, the town clerk of Stratford, employed a visiting art expert named Simon Collins to examine a group of portraits long lodged inside the Hunt attic. These paintings were believed to have descended from the aristocratic Clopton family. Mr. Hunt recalled as a child using the portraits for archery practice, but by 1860 he'd become curious as to their value.

When hired to appraise these attic portraits, Simon Collins had just finished the prestigious job of restoring Stratford's world-famous funerary bust of Shakespeare that hovered like a putty-nosed wraith over the poet's tomb in the chancel of Holy Trinity Church. Posed with pen and paper while sporting the pickdevant-styled pointy beard and up-brushed mustache popular from 1570 to 1600, the bust has long been championed as one of the most authentic likenesses of the poet; nevertheless, back in 1793 a curator named Edmond Malone had decided to whitewash the entire bust, which until then had been unique in portraying Shakespeare wearing a blood-red jerkin beneath a black sleeveless jacket. Why would Malone do this? Again, let's not go there. Suffice to say for the next sixty-seven years the bust remained whitewashed until the expert Collins was called in to restore it to living color.

So it was, a few days after completing this high-profile job, Mr. Collins found himself rummaging among the ghosts in the Hunt attic when a strange portrait caught his eye. "Whofe there?" he must have thought. According to J. P. Norris's 1885 *Portraits of Shakespeare*, Collins came upon a dilapidated, nearly life-size portrait depicting a man with a wild black beard that "nearly covered the face, and was so arranged as to utterly disfigure the picture."

Note that Norris, writing only twenty-four years after the discovery of this portrait, described the overpainted beard as a disguise, something "arranged" to "disfigure." Likewise, the collector John

Rabone in an 1883 lecture would describe the Hunt's giant beard as "more like a caricature than anything else."

Intrigued, Collins began his excavation of the portrait in the presence of at least four men, including the town vicar. After he'd applied his magic solvents, an odd thing happened, a miracle almost. The portrait transmogrified in front of them like some creature snatched from Ovid—its werewolf face giving way to a more shaven and soulful one, the dun clothes to a brighter costume—until what stood before the townspeople appeared to be the near twin of the famous town bust. Bear in mind, this was the same bust *Collins had just finished restoring*. It must have been a staggering event, and I wonder if any of the witnesses stopped to consider the incredible coincidence of it all.

Regardless, a debate was born that day: Which came first, the portrait or the bust? As J. H. Friswell noted in his 1864 *Life Portraits of William Shakespeare*: "At a glance one sees that the picture is inextricably connected with the bust. There are the same folds of the dress, the same buttons on the front of the jerkin, the same attempts to show certain slashes, or worked pattern, on the garments . . ."

The memorial bust of William Shakespeare at Holy Trinity Church in Stratford-upon-Avon.

There was no doubt in anyone's mind that these two works were related. But the vital which-came-first debate would, in the end, be decided not by technology or logic but by neglect, which is to say that the eventual owner of the Hunt portrait, the Shakespeare Birthplace Trust, had not, for over a century, had their portrait tested in an attempt to date it scientifically. Due to this lack of curiosity, or perhaps lack of funding, scholars had come to assume the Hunt portrait to be a mere copy of the celebrity bust; however, back when the portrait was discovered in the nineteenth century, experts quarreled with that chronology, many of them siding with the portrait as having served as the bust's template.

The Shakesperian Charles Wright, reacting to what he believed to be a smear campaign against the portrait, published a pamphlet arguing the Hunt to be Shakespeare ad vivum. Then on May 18, 1861, the London journal the *Examiner* concluded the bust had likely been based on the portrait. And finally, the *Birmingham Gazette* chimed in with: "We are strongly inclined to the opinion, not only that the bust was modeled from the picture, but also that the picture was painted during the poet's lifetime."

Yet this portrait had been forgotten? How could that be?

It was a spider egg of enigmas, the Hunt. In a town brimming with forged relics, why would anyone take a seemingly legitimate portrait of Shakespeare, one with a provenance that placed it inside the wealthy Clopton clan, and then purposely obscure the face behind Clouseauean whiskers? That might seem an obvious question, yet nobody has asked it in the 136 years since J. P. Norris wrote his *Portraits of Shakespeare*:

> But how can the strange condition in which it [the Hunt] was found by Mr. Collins be accounted for? Who painted over the face with a full beard, and disguised the red and black costume of the figure? The high respectability of Mr. William Oakes Hunt and his father, in whose possession the portrait has been for many years, forbids the idea of any deception from that quarter.

Since I was no intimate of the Hunt family, my first instinct was to suspect them of foisting another con-man bard on the world. Wasn't it quite the coincidence, my thinking went, that this portrait had been found by the same expert who had just restored the town bust? But if this were some elaborate scheme, then why would Mr. Hunt have subsequently turned down a generous offer of three thousand pounds in order to donate the portrait to the town of Stratford?

I nibbled around a Pop-Tart while considering this quandary. Was it possible, I began to wonder, that somebody had overpainted the portrait to protect it? We've already delved into the notion that Shakespeare might have fallen out of favor while alive or recently dead, but we know for a fact that he fell into disgrace when the Puritans gained power in 1653 under Lord Protector Cromwell and declared Shakespeare and his ilk spawn of Satan. After nailing shut the Globe and other such lairs, the Puritans started torching art. Did some Clopton hero disguise the family portrait to protect the poet from these buzzkill iconoclasts?

In an 1883 lecture, the collector John Rabone stated as much: "It was suggested that the [Hunt] painting had been obscured in Puritanical times, as many portraits had been, to conceal it, as players then were in ill odour."

I liked Rabone's "ill-odour" theory. It reeked of logic. It also dated the portrait to within forty years of Shakespeare's death. But it still vexed me that the picture had been discovered by the same expert who'd just restored the bust, and my suspicions were rekindled when I came across an even more startling passage from Norris's book, one that hinted at conspiracy:

> When Mr. Collins had finished cleaning the picture, but before it was taken to London to be "restored," some photographs of it were taken by a Stratford photographer. Using one of these photographs, Mr. John Rabone, of Birmingham, had a large painting executed, of the same size as the original portrait. This copy is of great value, as it represents the original as it was *immediately after*

Mr. Collins cleaned it, and before it had been retouched in the process of restoration. Mr. Rabone states that the latter process has caused much alteration in the original portrait . . . In his [Rabone's] copy the lines follow this first photograph exactly, and the expression of the face, as it originally was, is faithfully reproduced. *The pose of the figure is now somewhat different, and the face has been altered.* (Italics added.)

According to expert testimonies, the Hunt portrait, after being cleaned by Simon Collins, was photographed before being taken to London, where it was mysteriously altered by some unknown restorer. Due to this London alteration, which transformed the poet's face, figure, and pose, a picture known as the Rabone copy, which had been produced from a photograph of the freshly denuded Hunt (prior to its alteration in London), now represented Shakespeare as he had first appeared to the town vicar that day stripped of his fake beard and shoddy jerkin.

Huh, I thought.

Concerning the altered Hunt portrait, the nineteenth-century scholar C. M. Ingleby declared, "This [the Hunt] is not in its original state, and cannot be judged of apart from a copy of it in the possession of John Rabone, Esq., of Birmingham."

C. M. Ingleby, the author of seven books on Shakespeare and a textbook on theoretical logic, became a legend in 1859 after helping to expose one of the vilest Shakespearian con men of all time, a librarian named John Payne Collier, who claimed to have unearthed the proofreading copy to Shakespeare's 1632 Second Folio. Collier then set about emending Shakespeare's works in a six-volume set, and we might still believe Collier's lies had not Ingleby wrested that folio from Collier, raised his trusty magnifying glass, and detected traces of pencil marks lurking beneath the Elizabethan script.

Before his death, the con-man Collier would confess in his diary: "I am bitterly sad and most sincerely grieved that in every way I am such a despicable offender. I am ashamed of almost every act of my life."

One would assume that C. M. Ingleby would have fared better in his own final self-evaluation, but that was not the case. Before his death, Ingleby noted, "I am morally weak in many respects. In some matters I have been systematically deceptive, and occasionally cowardly and treacherous. I am passionately fond of personal beauty; but on the whole, I dislike my kind, and my natural affections are weak."

In the end Ingleby had even debunked himself.

In spite of his damning confession, I liked Ingleby. How could I not feel kinship with a man fond of magnifying glasses who had published the ominously titled tract *Shakespeare's Bones: The Proposal to Disinter Them, Considered in Relation to Their Possible Bearing on His Portraiture: Illustrated by Instances of Visits of the Living to the Dead*? The two of us had a lot in common. We both wanted to dig downward after Shakespeare albeit with different-type shovels. I admired Ingleby's wit, eye, and prose, but he worried me, too, for his years spent exploring the candidate portraits had led him toward the ghoulish art of skulduggery. Was that where I was headed? Debunking, after all, is not so much an occupation as a blood disease, something you are either born with or contract dubiously.

Winter was starting again (winter had just ended) and giant snowflakes were already wafting down. My garage-sale UV lamp burned like a fire on my desk as I gazed out the window at the hypnotic snow. I thought about the pickax hanging in my carport and about Shakespeare's three-and-a-half-foot grave. Would I end up skulking into Stratford with a pike under my cloak? Throughout that late winter the Hunt portrait ranged my brain like a hungry wolf. Why was this portrait, after having been cleaned by Collins, suddenly realtered in London? And who were these London curators who had overruled the poet's face and body? What had happened to the Rabone copy, which now stood in for the original? And where were these photographs that had been taken of the denuded Hunt before it was re-disguised in London? Every day it snowed, record accumulations, and every day I hit new dead ends.

The Hunt portrait, I reasoned, was in its current state a mirror

image of the Stratford bust. Yet we know, via the written reports of experts, that the original Hunt portrait, when first cleaned, had owned a somewhat different face and pose. Therefore it must follow, as snow does the snow, and winter the winter, that the original Hunt picture must have been altered, while in London, in such a way as to make it more resemble the town bust.

Yes, logic screamed this had to be the case. And although this conclusion seemed sound, what did it accomplish? You can't solve a mystery with an enigma. So I tried again. Okay, the Hunt must have, in its virgin state, differed in some ways from the town bust, therefore it seemed reasonable to assume that somebody, for unknown reasons, had not wanted that original version of Shakespeare to surface. Or maybe not. Maybe the portrait had been altered in London to create an aesthetically superior work of art?

Uh, no.

"As a suggestion of the face of Shakespeare," Friswell observed back in 1864 of the realtered Hunt, "it would be very good, save for the weakness, want of power, and, indeed, vacuity which is to be seen in it."

In fact, nobody had anything nice to say about the Hunt portrait as it appeared following its London alteration. By contrast, the *Birmingham Gazette* had gone out of its way to praise the beauty of the now missing Rabone copy:

[A] finely-executed painting in oil, the same size as the Stratford portrait, which he [Rabone] had had painted many years ago in the lines of the photograph of it after it had been "cleaned," and before its "restoration." In the course of the latter process, he said, the Stratford picture had been sadly altered. He pointed out that the pose of the figure in his picture, while it perfectly agreed with the first photograph, *was very different to that in the Stratford picture as it now is* . . . the painter, had successfully *caught and reproduced the nobleness of expression seen in the first photograph, which was entirely wanting in the "restored" picture.* (Italics added.)

Because of its mysterious dumbing down in London, the Hunt portrait was now assumed to be a mere copy of the bust. But these two Shakespeares were not born identical twins. The portrait, as originally painted, must have differed from the bust, and it seemed possible that vestiges of this original Hunt sitter, such as carbon-based underdrawings, still existed below the surface paint. Yet no attempts had ever been made to uncover what might well be an ad vivum portrait of William Shakespeare.

Why this lack of interest? Did the town of Stratford desire an altogether prettier corporate spokesperson? Did they perhaps worry the Hunt sitter might not move product?

But all that was about to change. Shortly after I began pestering the Stratford Birthplace Trust about the degraded portrait they owned, I learned that the SBT had already scheduled a long overdue restoration of the Hunt. It would be X-rayed! It would be IR-ed! I was thrilled. Maybe Stanley Wells wasn't such a bad guy after all. Maybe there was no conspiracy.

Then something else exciting happened, by accident.

When I first began querying the SBT about the Hunt, they seemed to know very little about their own portrait. I'd even had trouble getting them to reply to my emails until I offered to purchase a photograph of the Hunt. That quick, a reply came from a Ms. Ann Donnelly, the Shakespeare Birthplace Trust curator. Yes, they would happily sell me a photograph. To this purpose, Ms. Donnelly had attached a thumbnail photograph of the portrait and a purchase form.

Except, oops, it wasn't the Hunt portrait in the thumbnail; instead, it was a photograph of some smallish copy of the Hunt that was also in the possession of the SBT, and this copy displayed a more soulful Shakespeare, one with hazel eyes and a wine-stain birthmark engulfing the top of his forehead.

Mother, I thought, grinning ear to ear.

The obvious question was: Could this wine-stained portrait be the lost Rabone copy? But the obvious answer was a clear-cut no; it was too small to be the Rabone. Then I recalled having read that at

least one of the photographs taken of the denuded Hunt had later been painted over by Simon Collins into a miniature copy of the newly cleaned portrait (before it was altered in London). Had Ms. Donnelly accidently emailed me a photograph of that overpainted photograph? If so, might this copy reveal to us the original Hunt as it appeared after being cleaned before the town vicar by Mr. Collins?

It didn't take long to learn, via Ms. Donnelly, that this soulful Hunt copy, which I now suspected to be an overpainted photograph, had been created the same year the original Hunt portrait was discovered by Mr. Collins. *Presto*, I thought. I also learned that the copy hailed from Birmingham, the home of John Rabone, who had commissioned the photographs. This news inspired me to ask Ms. Donnelly to inspect the small portrait to find out if it had been painted on top of anything. Perhaps I'd won her over because this time she promptly replied:

> The picture came into the museum some time pre-1927, housed in an elaborate little case. It came with very little documentation other than it had been presented by one George Mackay of 70 New Street, Birmingham. I have investigated this little image further, taking the back off the case and image backing, to reveal an overpainted print. Written by hand on the bottom of [the] picture it reads "Shakespeare, from the Stratford [aka Hunt] Portrait."

So there it was, "an overpainted print." Could that print be a photograph? And could that overpainted photograph reveal something very close to Shakespeare ad vivum? It seemed to me there was reason to be hopeful.

For the next nine days I stared at the small copy of the overpainted "print" Ms. Donnelly had sent me by mistake. In it, Shakespeare had a forehead clearly marked with a grayish wine stain shaped like a horseshoe set on its legs that spanned eyebrow to eyebrow and also snaked down the left cheek. Hadn't I conjectured the existence of exactly such a wine stain? And anyone trying to

reproduce that wine stain on an engraving, as perhaps young Martin Droeshout had done, might well create the illusion of light hitting the forehead there.

Excited by these developments, I sat in my office tapping my foot and gazing out the window to where the previous night's subzero plummet had cracked the windshield of my Honda. After watching that crack lengthen itself for half an hour, I walked onto my back porch to view the snow falling onto the desolate lake. Ice fishermen skirted the snow like shades. At that moment the Hunt seemed to me a ghost trapped behind paint. I wanted to summon that spirit and desperately hoped it could be conjured via the dark art of spectral technologies.

As the date of the portrait's conservation drew nearer, I started planning a trip to Stratford. A submerged Shakespeare, arguably painted from life, was about to float to the surface like a murdered body. I wanted to examine the test results, or maybe even view the process (if that were possible). I would write about my trip, I decided, a newspaper piece, or maybe something longer.

But, no, that trip never happened. Instead I got the bad news from the Stratford Birthplace Trust that they'd canceled their planned conservation on the Hunt. There was a funding problem, it seemed. The same foundation that had purchased an early copy of the Cobbe, and had tested that portrait, had no money left for their own picture, a possible ad vivum Shakespeare that might have been used to create the world-famous bust.

I didn't take this news of the cancelation well. It felt like I'd been punched in the gut. Night after night I walked around my camp, muttering, bottle in hand. One morning, understandably hungover, I once again began pricing airline tickets to London and imagined myself staggering into Stratford, jet-lagged, half drunk, with a pickax stashed beneath my cloak.

8

Spooky Shakespeare

Robert Peake's equestrian portrait of Henry, Prince of Wales, at the tiltyard, circa 1610, after its remarkable 1985 restoration (© Parham House & Gardens, West Sussex).

I s there any place more treacherous to the Adderall-fueled OCD mind than a New Age bookstore? Being from the Deep South I'd grown up ignorant of their charms, but while in Vermont I ambled into Spirit Catcher Books one day to pursue an interest in Hindu mythology but found myself distracted by dozens of interdimensional bubbles: UFOs, tarot decks, astral traveling, channeled entities, angels, spirit guides, kundalini, astrology, dowsing, the travails of Bigfoot. They were all religions of a sort, and it was sobering to realize that, viewed objectively, few of them were as utterly insane as the born-again Christian cult I'd been raised inside in Mississippi.

That bookstore contained everything I needed to go mad. I would park myself on the floor of Spirit Catcher and start reading about quantum entanglement and hours later somebody would roust me outdoors, like forcing a drunk to leave a bar, and like that drunk I would wander the snowy landscape of this infinitely magical world that we, almost in an act of self-defense, summon all our powers to see as mundane.

One book I found there, *The Occult Philosophy in the Elizabethan Age*, argued that the Elizabethan court had been infiltrated by magicians, a "school of night" that collaborated with demons in an attempt to create great works of art. Far from some quack theory, the book had been written by Dame Frances Yates, a legend in Renaissance studies who had been awarded the UK's female equivalent of knighthood. England's forgotten occult movement that Yates spent the latter part of her career excavating was known as Neoplatonism.

This "religion of the Renaissance," as she called it, combined the esoteric teachings of the Christian Kabbalah with that of occult Hermeticism. Neoplatonism began in Egypt around the third century, but it wasn't until the dispersal of the Jews from Spain in 1492 that these rediscovered teachings began migrating toward medieval England. During Elizabeth's reign, these Neoplatonist writings, attached to the thrice-great sage Hermes Trismegistus, were incorrectly believed to predate Plato; hence they were revered as godlike within the Renaissance zeal to worship antiquity. In Yates's opinion the reemergence of this philosophy, the once-dominant ideology of the ancient world, *was* the Renaissance, and its daemonic practices inspired the works of art and philosophy we still look back upon with astonishment.

Other scholars have since argued that Yates overemphasized the movement's singular importance to the Renaissance, but nobody was disputing the existence of this cult inside Elizabeth's court. Yates strongly suspected that both Shakespeare and Queen Elizabeth were active practitioners of this movement, the calling-card

axiom of which was "As above, so below," a message certain Eliza-
bethans expressed in their portraits via the hand signal of an index
finger pointed downward. In his Tower portrait by de Critz, the 3rd
Earl of Southampton, posing beside his cross-eyed cat, Trixie, was
immortalized making just such a gesture.

When this magical ideology from the Greco-Roman world fi-
nally washed ashore in England, it was embraced, and curated, by
the powerful courtier Dr. John Dee. But this was no pure form of
the ancient teachings. In England Neoplatonism became a muttish
cult of magical rites, more Christian Kabbalistic than Hermetic, in-
side a tenaciously medieval landscape where sorcerers roamed the
earth, writers were held to be magicians, and the whole concept of
good magic was considered dubious. The teachings and practices
championed by John Dee would eventually fall out of favor to the
extent Dee himself had to disown his own movement. Ultimately
the cult was erased from English history by, among others, James I,
a king terrified of hobgoblins and fond of witch burnings, but
Neoplatonism's effect on England remained profound. Yates even
argued that Shakespeare's great magician Prospero had been mod-
eled on John Dee.

I took Yates's book home with me that evening just as a bipolar
cold wave was descending on the Burlington area. The tempera-
ture rose, plunged, and rose again. One morning, after an insomniac
night spent peering through magnifying glasses, I teetered outside
just as the sun was rising over the fishing shacks spread upon the ice.
Nothing better for the lifelong asthmatic than a good blast of lung
freeze. While standing there puffing my inhaler and listening to the
lake crack in gunshot blasts, I gazed along the shoreline and could
not for the life of me make sense of what I was seeing, which was, it
turned out, my first ice storm.

Staggeringly beautiful, yet ruthlessly destructive, the ice storm
encased the gleaming treetops. Every limb and twig seemed to re-
flect the pinkish colors of sunrise. Then, as I blinked stupidly at this
crystalline world, the trees, the lake, and even the clouds began to

divide themselves into a jigsaw of cartoonish animal faces, grinning, grinning, always grinning.

Odd, I thought.

Apparently the act of staring through magnifying glasses for hours on end had turned me into a Druid. By this point I'd been working fifteen-hour days on my portraits before driving the twenty minutes to Richmond to bartend at night. On Photoshop alone I spent five hours every day creating what I called "morphs." I'd size up two portrait jpegs and then layer one atop the other, adjusting the opacity of the top photo so that the lower one slowly emerged into its lines like a body floating to the surface of a lake. Aside from being great fun, it was the best method I'd discovered for comparing facial anomalies.

Perplexed, I stood on my porch grinning back at the animal faces quilting the snow and haunting the ice. These beastly faces—later I would start calling them "sendaks"—would not go away. Every time I ventured outside, the world divided itself into this animist puzzle of creatures escaped from *Where the Wild Things Are*. I needed a vacation, I realized, but when I went online to find a hostel in Mexico, I got distracted by another morph and forgot how desperately I needed to escape.

Soon these sendaks began infiltrating the portrait I was obsessing over, a picture of Henry, Prince of Wales, the eldest son of James I and heir to the throne of England. In this portrait, the young prince, who held the hopes of the nation, was portrayed on horseback en route to the tiltyard. The portrait wouldn't have interested me had I seen it prior to 1985, the year spectral tests detected a naked angel censored beneath an intricate landscape of overpaint. This angel, who owned an extremely unangelic face, was trailing on foot behind the royal tilt horse and was tethered to the young prince by a forelock, a hairstyle associated with the Egyptian gods Horus and Khonsu and favored by warlocks.

It was a shame, I felt, that Frances Yates had not lived long enough to see the restored painting as its composition would seem

to confirm her theories about England's censored occult movement, especially regarding the practice of *angel magic*, wherein God's angels were kidnapped and made slaves to human whims. Lots of questions came to mind as I examined the magnificently restored portrait, but the main thing I wondered was whether the naked angel had been modeled on anyone in particular. This was a tough question to answer because every time I studied the portrait, sendaks began blossoming inside it like crocuses in snow.

I was still reading Yates's book on the day the electricity snapped off in my camp. The ice storm had downed all the power lines, and it would be weeks before our electricity returned. Vermont had been plunged backward into the Elizabethan era of firelight and starlight. I hauled in firewood, filled my oil lamps, and pushed a half-dozen candles into wine bottles I had fortuitously emptied.

Perhaps the most beautiful catastrophe known to man, the ice storm continued with a magic all its own. One night, with the wind howling through my chimney, I lay beneath four blankets in front of the roaring fireplace puzzling over that naked angel. His coarse face contained too many anomalies, I felt, for it to be just some cookie-cutter angel or generic Father Time figure. The portrait was the work of Prince Henry's official court painter, Robert Peake, an artist known for inserting real-life courtiers into his pictures. Sir Roy Strong once identified no less than twelve real-life courtiers in Peake's procession portrait *Eliza Triumphans*. With that in mind, it seemed logical to approach Peake's angel as depicting some unidentified courtier, one who might have embodied the young prince's ideals yet, in the end, had proven controversial enough to warrant censoring.

I had just fallen asleep beneath those blankets when a dark voice from some primordial lobe of the brain bellowed the name John Dee into my cranium so forcefully it bolted me upright and left me blinking into the fire.

Holy shit, I thought, after my heart had settled somewhat.

I knew from my recent readings that Dee's name during his heyday

had become synonymous with angels. He claimed to communicate with them inside crystal balls and had even written books he touted as translated from angelic tongues. More controversially, he had advocated the practice of tethering God's angels to serve human needs.

Initially Dee had prospered wildly while employing such practices and had even left England in 1583 to spread his gospel to the continent. But during his absence, plays like Marlowe's *Doctor Faustus* helped turn public opinion against angel magic—the Puritans were gaining power—and when Dee returned home in 1589, he discovered angel magic had been condemned. Cold-shouldered by Elizabeth I, and later banished from court by James I, Dee eventually made a show of contrition by burying his book of magic in a field. Yet even in disgrace, Dee was esteemed so highly by many intellectuals that, according to the dubious source of Aubrey's *Brief Lives*, "Sir Robert Cotton bought the entire field to digge after it [Dee's book of magic]."

The mention of Sir Robert Cotton brings us to the dreary subject of provenance. Around 1614 "a picture at large of Prince Henry on horseback in armes" had entered the collection of Sir Robert Cotton. (The British Museum has now acquired the remnants of Cotton's collection of John Dee's occult paraphernalia.) Unlike his father the king, the young prince was a great admirer of John Dee during the two years Henry held court in Richmond before suddenly dying from typhoid fever. Prince Henry's court embraced the symbols and ideals from the golden age of Gloriana as well as that Elizabethan itchiness for imperialism. The son of a famously unpopular pacifist, Henry even adopted a conqueror's motto on his shield, *Fas est aliorum quaerere regna* ("It is right to seek for kingdoms of others"), and adorned his court with the trappings of Elizabeth by reviving Shakespeare's plays and Henry Lee's tiltyard.

Around 1610, the same year the equestrian portrait was said to be painted, the prince fell out with his father and started visiting the imperialist Sir Walter Raleigh in the Tower of London. Raleigh, one of the last courtiers associated with the wizardry Shakespeare

dubbed "the school of night," would eventually be beheaded by James I, but for the time being this unlikely pair, a disgraced wizard and a discontented heir, met in the Tower to plot England's expansion into the New World via a revival of Elizabethan ideals.

But what ideals were being revived exactly? Yates argued the answer was in no small part the occult. "The occult philosophy in the Elizabethan age was no minor concern of a few adepts," she wrote. "It was the main philosophy of the age, stemming from John Dee and his movement." Although it's unclear when exactly the equestrian portrait was censored, the motive for doing so seems obvious: to help erase the occult influence attached to Prince Henry—especially the disgraced practice of angel magic.

Dee died in circa 1609, about one year before the equestrian portrait is believed to have been painted. His death would not have passed unmarked in Henry's court. We now know, via spectral testing, that the naked angel was not part of the painting's original composition and are left to wonder what might have prompted Peake to impose this angel upon a work in progress. Could Dee's death have inspired his likeness to be added to a half-finished portrait as a form of commemoration?

Freshly awakened, I kept staring into the roaring fire that night with my heart racing. The angel had to be Dr. John Dee, I felt. But I had no firm memory of what Dee had even looked like aside from his trademark skullcap. I lit a lantern and carried it into my frigid office in search of John Dee. Sure enough, the angel and Dee turned out to be twins. Here, flickering beneath my oil lamp, was (or so it seemed to me) an example of the occult practice of angel magic censored from English history exactly as Yates had claimed. The northern lights flashed outside as I stood by the window. I cupped my hands against the glass to watch them.

"Show me the magic," I whispered, just like John Cassavetes had done in his weird adaptation of *The Tempest* starring Molly Ringwald as Miranda. Cassavetes had cast himself as a Mafia-attached modern-day Prospero, and whenever he recited the above incanta-

tion, lightning would flash in response. But each time I said it nothing happened aside from the window fogging over. There was no reply from the cosmos.

Angels aside, Peake's portrait contained another enigma, a visual riddle that appeared along the skirt of Prince Henry's armor and on his saddle blanket. NPG director Lionel Cust had once noted:

> This strange device represents a number of hands, each holding an anchor, issuing from the holes in a ground, with a sun setting behind mountains in the background. It almost passes the wit of man to explain the elaborate symbolism in these *impresas*, which were so much in fashion at this date.

Despite Cust's awe at the task, if we looked at this device through the lens of Yates's theories, its message made perfect sense. The anchors issuing from the graves became a simple allegory referring to the Elizabethan revival of the navy-based imperialism embraced by the young prince and associated with John Dee, whereas the hands holding up the anchors from the boneyard belonged to the dead legends of Elizabeth's court.

"Show me the magic," I tried again.

Nothing.

Yates had argued that Shakespeare's *The Tempest* was a defense of Dee, angel magic, and Neoplatonism. When we see Prospero sinking his book of magic in the ocean, we are also watching John Dee burying his book of occult practices in the earth. In her own final book, Yates even attempted to redefine how Shakespeare wrote his plays. Many masterpieces of the English Renaissance, she argued, were created via *inspired melancholia*, an occult technique in which the artist allowed himself to be possessed in order to collaborate with a demon on a work of genius. The Melancholy Dane, Yates insisted, had been created through the occult technique of inspired melancholia.

"Show me the magic," I whispered.

Queen Elizabeth I holding a bouquet of roses, artist unknown, 1580s to 1590s (National Portrait Gallery, London).

rtist impression of how the verpainted serpent, detected in n infrared reflectogram, might ave appeared before it was hidden eneath a bouquet of pretty roses Gillian Barlow/National Portrait allery, London).

1594, Elizabeth I's Privy Council assed a law ordering "unseemly ortraits" of the queen to be found nd destroyed. Did this law cause e snake, a symbol of occult nowledge, to be overpainted?

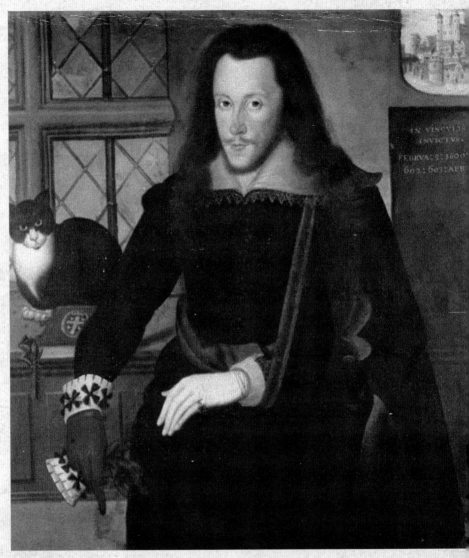

Henry Wriothesley, the 3rd Earl of Southampton, with his cat Trixie, as painted by John de Critz the Younger, circa 1603 (Broughton House, Northamptonshire/private collection Duke of Buccleuch and Queensberry).The portrait depicts the emaciated earl in the Tower of London shortly after his release from imprisonment there for his role in the 1601 Essex Rebellion. A picture of the Tower hangs above the earl's shoulder with a Latin phrase meaning "In chains unconquered."

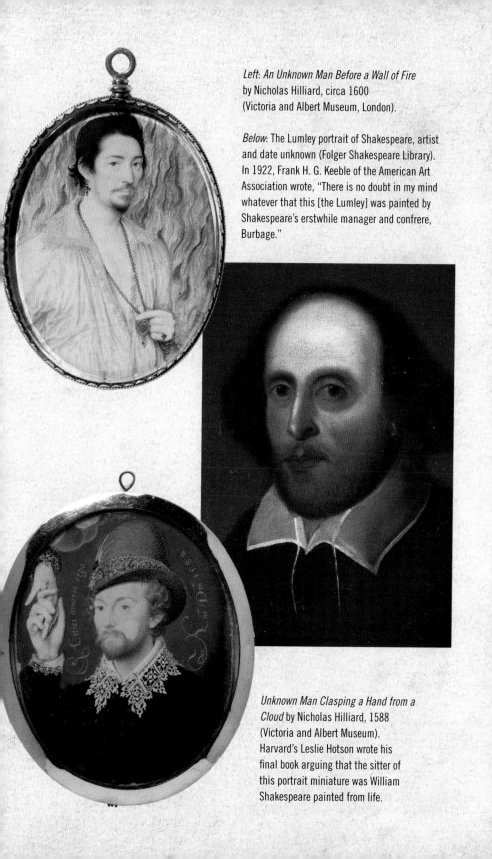

Left: *An Unknown Man Before a Wall of Fire* by Nicholas Hilliard, circa 1600 (Victoria and Albert Museum, London).

Below: The Lumley portrait of Shakespeare, artist and date unknown (Folger Shakespeare Library). In 1922, Frank H. G. Keeble of the American Art Association wrote, "There is no doubt in my mind whatever that this [the Lumley] was painted by Shakespeare's erstwhile manager and confrere, Burbage."

Unknown Man Clasping a Hand from a Cloud by Nicholas Hilliard, 1588 (Victoria and Albert Museum). Harvard's Leslie Hotson wrote his final book arguing that the sitter of this portrait miniature was William Shakespeare painted from life.

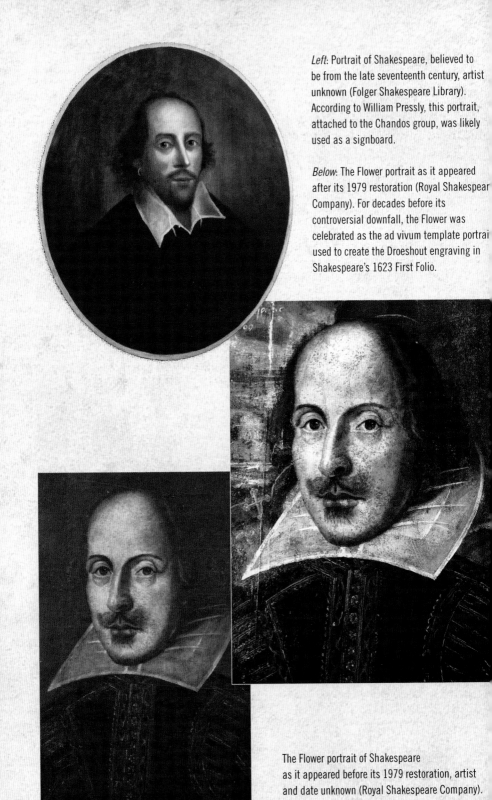

Left: Portrait of Shakespeare, believed to be from the late seventeenth century, artist unknown (Folger Shakespeare Library). According to William Pressly, this portrait, attached to the Chandos group, was likely used as a signboard.

Below: The Flower portrait as it appeared after its 1979 restoration (Royal Shakespear Company). For decades before its controversial downfall, the Flower was celebrated as the ad vivum template portrai used to create the Droeshout engraving in Shakespeare's 1623 First Folio.

The Flower portrait of Shakespeare as it appeared before its 1979 restoration, artist and date unknown (Royal Shakespeare Company).

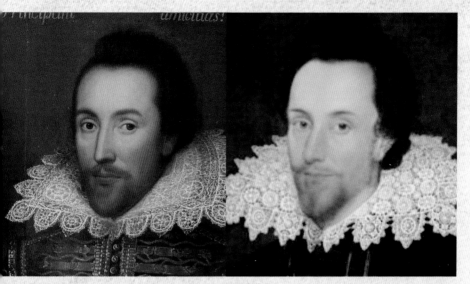

eft: The controversial Cobbe portrait of Shakespeare, artist and date unknown (Private Collection of Alec Cobbe).

ight: Portrait of Sir Thomas Overbury by Marcus Gheeraerts the Younger (Bodleian Libraries, University of Oxford).

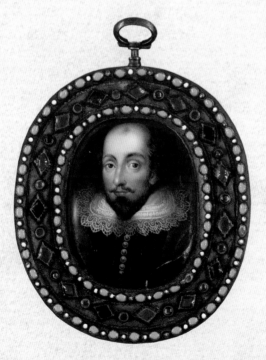

...rtrait miniature of Shakespeare, artist unknown (Folger Shakespeare Museum). William Pressly described this ...rtrait, likely painted in the nineteenth century, as based on the Janssen portrait of Shakespeare and noted its ...26 date is "obviously false."

Early copy of the Hunt or Stratford portrait and arguably one of our most authentic images of Shakespeare, unknown artist (Stratford Birthplace Trust). This small copy was painted in 1860, the same year the original Hunt portrait was discovered inside a Stratford attic. Note the horseshoe-shaped stain along the forehead.

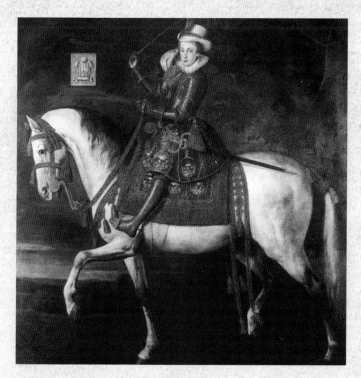

Robert Peake's equestrian portrait of Henry, Prince of Wales, circa 1610, before (*top image*) and after its 1985 restoration in which a strange naked angel was discovered beneath the paint (Parham House and Gardens, West Sussex).

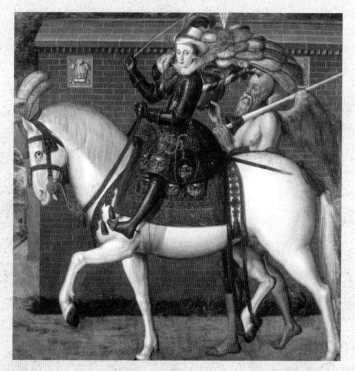

ÆTAT SVÆ 43

Portrait of Phineas Pett, circa 1612, unknown artist
(National Portrait Gallery, London). This portrait was
originally attributed to Marcus Gheeraerts the Younger.
The antiquarian George Vertue once recorded a portrait of
Shakespeare painted by Gheeraerts. That picture has since
been lost to history.

Right: Detail from portrait of Phineas Pett
(National Portrait Gallery, London). Note the worker on top
of his scaffold while sailors appear to be staggering ashore
beneath a black cloud hovering over the beached ship.

ÆTAT SVE 43

Infrared reflectogram of portrait of Phineas Pett, circa 1612, artist unknown (National Portrait Gallery, London).

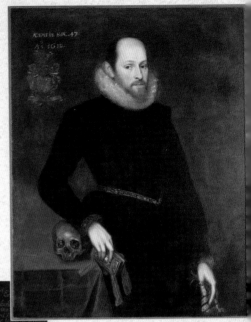

The controversial Ashbourne portrait of Shakespeare (Folger Shakespeare Library).

The Welbeck portrait of Edward de Vere, a seventeenth-century copy of a picture, now lost to history, originally painted in Paris, circa 1575 (Welbeck Abbey, on loan to National Portrait Gallery, London).

Portrait of Sir John Parker by Hieronimus Custodis, 1589 (Royal Collection, London).

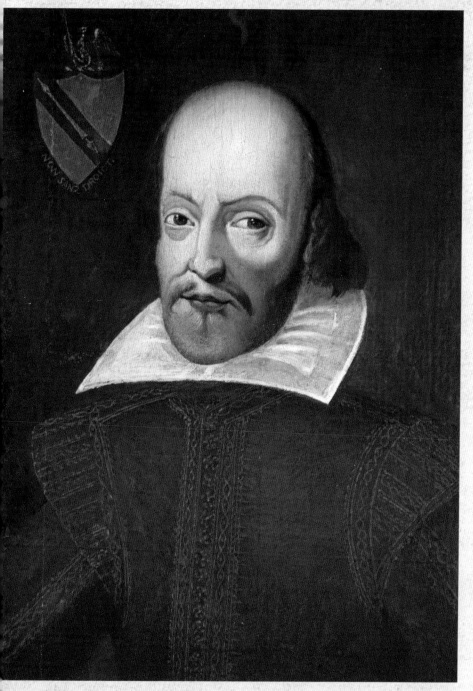

The Buttery portrait of Shakespeare (Folger Shakespeare Library). After describing the portrait as a nineteenth-century painting, Pressly noted a 1902 Sotheby catalogue entry that argued, "from its resemblance to the engraving by Droeshout it is conjectured that the painter of this picture and the engraver must both have worked from a common original."

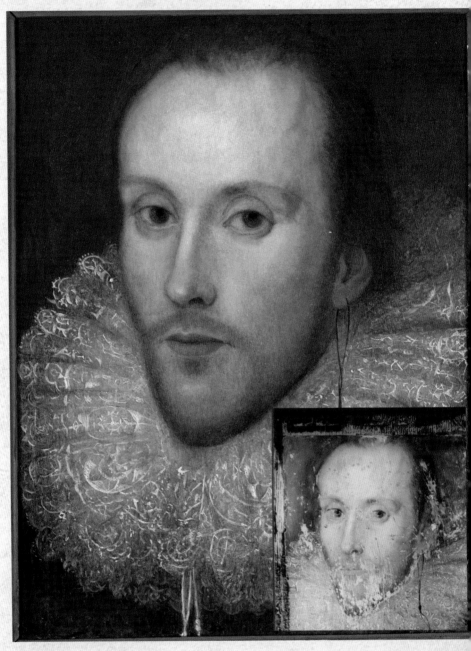

The Archer or Bath portrait of Shakespeare, the most beautiful yet most greatly abused bard portrait in the Folger Library. The portrait was once attributed to Federico Zuccaro, who visited England in 1575; Pressly estimates its date of creation to be from 1615 to 1620.

Lower right: 1988 midconservation photograph of the Archer portrait (Folger Shakespeare Library).

Does the Hampton Court portrait of Shakespeare actually depict Sweden's Gustav the Great?

Upper left: Portrait of Gustav II, date and artist unknown (Nationalmuseum of Sweden).

Upper right: Portrait of a Man also known as the Hampton Court Shakespeare (Royal Collection, London).

Bottom left: Portrait of Gustav II by JH Elbfas, circa 1620 (Skokloster Castle).

Bottom right: Doublet belonging to Gustav II in the 1620s (Royal Armory, Sweden).

The only surviving ad vivum painted portrait of Sir Fulke Greville, First Lord Brooke, English School, 1586 (private collection, Lord Willoughby de Broke; on loan to Warwick Castle).

Left: Early copy of Fulke Greville's painted portrait as photographed in 1903 (photo from *Warwick Castles and Its Earls* by F. E. Greville).

Right: The Flower portrait of Shakespeare (Royal Shakespeare Company).

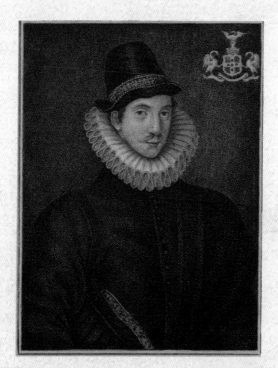

Engraving of Sir Fulke Greville, First Lord Brooke, created from his original portrait kept at Warwick Castle, date and artist unclear (Folger Shakespeare Library). Note the trinity of swans in upper right corner.

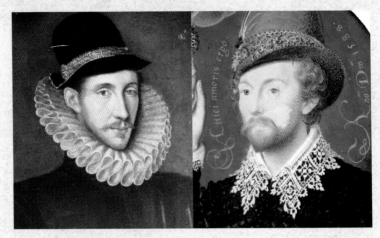

Left: Detail from original painted portrait of Sir Fulke Greville, English School, 1586 (private collection, Lord Willoughby de Broke; on loan to Warwick Castle).

Right: Detail from *Unknown Man Clasping a Hand from a Cloud* by Nicholas Hilliard, 1588 (Victoria and Albert Museum, London).

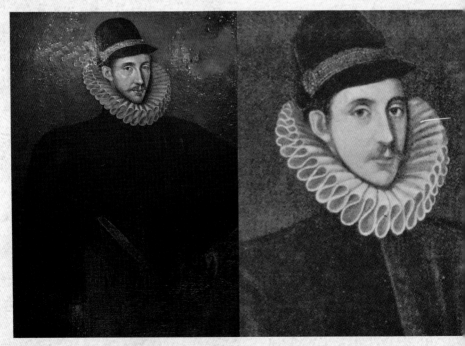

Left: Early copy of Sir Fulke Greville's original painted portrait. Note extirpation and scrubbing around inscription area and hat badge. Likely painted in the seventeenth century, artist unknown, though sometimes attributed to Patoun (Warwick Castle).

Right: The early copy of Sir Fulke Greville's painted portrait as it appeared in 1903 (photograph from *Warwick Castles and Its Earls* by F. E. Greville).

Finally I gave up on the cosmos and started rereading passages from Yates's book I had previously underlined, such as this quote from Agrippa's *De occulta philosophia*:

The *humor melancholicus* . . . has such power that they say it attracts certain demons into our bodies, through whose presence and activity men fall into ecstasies and pronounce many wonderful things . . .

Shakespeare as Robert Johnson. Shakespeare at the crossroads shaking hands with Legba. Shakespeare's head ratcheting in circles and gushing soliloquies of green slime.

Also underlined was another passage from Agrippa:

When set free by the *humor melancholicus*, the soul is fully concentrated in the imagination, and it immediately becomes a habitation for the lower demons, from whom it often receives wonderful instruction in the manual arts; thus we see a quite unskilled man suddenly become a painter or an architect, or a quite outstanding master in another art of some kind . . .

Another underlined passage came from George Chapman's poem on inspired melancholia:

No pen can any thing eternal write,
That is not steept in humour of the night.

When I awoke the next morning, the book on my chest, I glanced into the trees outside my window to discover my sendaks huddled there spying on me. Like loyal pets returned from some incredible journey, they poured inside my camp: gaggles and murders and herds and pigpens of sendaks.

"Show me the magic," I whispered to them, which, in light of things to come, turned out to be a big mistake.

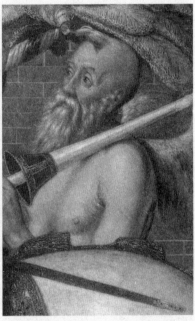

Left: Portrait of the Astrologer Johannes Dee, Londinensis, artist unknown, circa 1700–1750 (British Museum, London). *Right*: Robert Peake's naked angel from his equestrian portrait of Henry, Prince of Wales (© Parham House & Gardens, West Sussex).

Chris Caple identified Albrecht Dürer's 1513 engraving *Knight, Death, and the Devil* as having inspired the design of Robert Peake's equestrian portrait of Henry, Prince of Wales. Dürer was the artist most closely associated with the occult Neoplatonist movement in Germany. In Peake's painting the naked angel occupies the space of Dürer's devil (National Gallery of Art, Washington, D.C.).

9

Shipwrecked Shakespeare

Phineas Pett by unknown artist, circa 1612 (National Portrait Gallery, London).

The wall you hit with Elizabethan portraits is lack of ground. There is nothing to affix your faith to. After a while you stop trusting inscriptions, crests, identifications, provenances, curators, museums, and entire layers of history. Five years into my search, I had already acquired the eye of some basement forger who can't help but scour

every portrait he meets for the telltale signs of his trade. Stretched out on the carpet beneath my whirling birds, with the sendaks rustling in the bedroom, I was filled with melancholy yet far from inspired, until a distinct ping of optimism sounded in my in-box.

I stumbled to my laptop to discover an email sent by the Japan–United States Friendship Commission that informed me I had been awarded a fellowship to live in Japan for six months as a visiting artist. The fellowship would provide a comically generous stipend covering all expenses as well as an apartment in Tokyo. All I had to do for that six-month period was "absorb Japan's culture."

Was this some kind of joke? Had I made an enemy this inventive? Or maybe, just maybe, the fellowship was legit? For a moment I imagined myself bartending that night and mentioning to every waitress on staff that I'd been selected as a cultural ambassador to Japan. Then I imagined telling my son and wondered if I'd be allowed to bring him along. Maybe the two of us could hang out with our scratch-master hero DJ Honda in Tokyo. And, of course, I imagined Hayden repeating the news to my ex-wife, who would tear at her hair and curse the day she divorced me.

Why is good news so difficult to believe? We certainly don't doubt the validity of bad news when it pings into our lives. But my good fortune seemed especially unlikely as I had no memory of even applying for this fellowship—in fact, it's safe to say my whole life had been constructed around the act of not filling out applications. But eventually I recalled a morning, shortly after I'd started taking Adderall, spent manically jumping through hoops for this fellowship. Then I found the short story I'd submitted to the Japanese judges as part of the application. That story concerned the misadventures of a thirteen-year-old boy in south Mississippi who liked to climb pine trees and jerk off to photographs of Yukio Mishima.

Huh, I thought, impressed, obviously, with Japan's taste in American literature.

With a year to go before my visiting-artist stint began, I signed up for some language lessons and was dismayed to learn Japanese

has three alphabets, two of which proved conventional, but the third, kanji, topped out at some fifty thousand characters. Upping my dosage again seemed the mature response to such a herculean task. But when I went online to order some kanji flashcards—flashcards are the Mecca of the ADHD mind—I got distracted by another project, a riddle-thick portrait I'd recently happed upon and was starting to think might be the legendary lost Shakespeare I'd been searching for all these years.

You might recall the Rabone theory that argued Shakespeare had once posed as Shylock. Although I held no truck with that theory, it did seem possible Shakespeare might have posed as one of his characters. Still under the occult sway of Frances Yates, I assumed Prospero would be that character. And so one day I went in search of the magician. And to my surprise he proved easy to find. In fact, I'd had him all along, trapped inside an old computer file labeled "Rabato Collars." Not only had I found my Prospero but I'd found his floundered ship and its motley crew of lovable castaways. Hell, I'd even found the black-magic storm cloud he'd conjured. To my delight, this Prospero turned out to be a Droeshout doppelgänger—down to the strangely shaped earlobe and trademark shield-shaped (or rabato) linen collar with underpropper.

Then I noticed the rash on his forehead, and my eyes began to tear. Was I dreaming this portrait? After pinching myself a few times, I trimmed the crust of a grilled cheese, popped another Adderall, and forgot Japan even existed.

NPG 2035, artist unknown, depicted a piratical sitter posing with pen and paper before a floundered ship, its masts absent, its haggard survivors seemingly wading through wind-whipped waves beneath a storm cloud. Or at least that's what I saw through my various magnifying glasses. But what the National Portrait Gallery saw was something quite different. When the NPG first acquired this portrait back in 1924, it was then believed to depict the shipwright Peter Pett as painted by the talented Marcus Gheeraerts the Younger, but after acquiring the portrait, the NPG quickly reidenti-

Top and bottom left: Detail from *Phineas Pett* (National Potrait Gallery, London). *Top right*: Reverse-image Halliwell-Phillipps unique proof (Folger Shakespeare Library). Note: Seventeenth-century engravings were often reversed images of painted portraits. *Bottom right*: The Marshall engraving from the 1640 edition of Shakespeare's Poems (Folger Shakespeare Library).

fied the painter as unknown and the sitter as not Peter Pett but his father Phineas, a Jacobean shipwright proudly posing in front of his *Prince Royal*, the *Titanic* of its day, while the ship was being repaired in dock in 1612.

Docked? Repaired? Under my magnifying glass the ship appeared to be wrecked against trees on a storm-ridden beach with windblown sailors pitched in the waves. (Was it my imagination or was one of those sailors lying fetal in the shallows?) Yet in spite of this tempest-tossed mayhem, Phineas Pett, the sitter, stared out at us vaingloriously, as if to say, "Behold my fabulously floundered ship beneath its black storm cloud." Meanwhile all other shipbuilders of this era were being portraited in front of *floating* ships, masts displayed, sails blustered, grandeur captured, whereas this portrait revealed only a portion of mired hull with no attempt to celebrate the largest ship ever built in England.

I lost a week of kanji study while attempting to find a similar portrait of a shipwright posing before a beached ship, but no such portrait existed—after all, why would a shipwright choose to pose that way? This portrait had to be a conceit, I felt.

Left: Detail from *Phineas Pett* (National Portrait Gallery, London). *Right*: Detail from the Flower portrait (Royal Shakespeare Company). Note the rashed forehead on the NPG portrait.

Now let us suppose for a moment—humor me here—that the portrait presented to us not a shipwright but a magician. The sitter's swagger became understandable. I am proud, this magus would seem to say, because I have rained terror down on my enemies with my awesome tempest. I am a magician, wearing my dope John Dee skullcap, and that is what magicians do. Who wants beef now?

Another red flag I noticed right away was that the sitter's arms had been painted by different artists, one talented, one not. The cuffs didn't even match, and because of this I began to suspect a portion of the panel backing had been replaced. The inscribed age of forty-three appeared blatantly patched on as well. Intrigued, I popped another pill, mixed a large drink, took a deep breath, then plunged into the portrait and snorkeled around inside it for days, weeks, months, as my flight to Japan ticked closer.

Detail from the portrait of Phineas Pett that appears to show men struggling ashore through waves while a repairman works on the boat, artist unknown (National Portrait Gallery, London).

At some point I surfaced long enough to email the NPG, where Paul Cox, an extremely helpful curator, informed me that no part of the panel had been replaced, but the portrait's conservation report did confirm that "the sitter's right arm appears to be almost completely overpainted down to the cuff and hand; it is suggested that this overpainting may have taken place in the 18th century."

The coat of arms belonging to the Pett family had also been added by a different painter, Cox added.

Well, well, I thought, rubbing my hands together like Iago.

The portrait had originally been attributed to Marcus Gheeraerts the Younger, which made perfect sense as it greatly resembled many paintings from the popular Gheeraerts school. Could this, I wondered, be the infamous missing Gheeraerts portrait of William Shakespeare, dated circa 1595, that the antiquarian George Vertue had recorded in 1719 as residing in the Keck collection? And hadn't Tarnya Cooper mentioned in her book that this missing Gheeraerts picture might have been the missing template portrait to the Droeshout engraving? And didn't the sitter wearing a shield-shaped collar resemble the Droeshout bloke to an unusual degree?

As to provenance, the NPG stated the painting had first surfaced in the Earl of Hardwicke's collection around 1924, but not much else was known about its history. That meant any clues to be found would have to come from the portrait itself. I sighed and picked up my magnifying glasses. They worked especially well, I'd discovered, when I stack one on top of the other. But employing this method also served to create more sendaks in my world.

In this manner I discovered a few details that gave me pause.

Inscription. The inscribed age of the sitter was planted inside a block of what appeared to be freshly cleaned paint—or perhaps the pigment used in that block was just a different color. As no records of select cleaning existed in the NPG file to explain this patched-on effect, it seemed possible, considering the amount of confirmed overpaint, that the sitter's age had also been added at a later date—

perhaps at the same time the coat of arms was painted in, or when the right arm was added.

Costume. Dr. Tarnya Cooper once noted that Shakespeare's trademark rabato collar first appeared in England around 1604, but was she correct? To my eye the sitter's costume appeared to have been cut earlier than that date. For instance, the tabbed or pickadiled lower skirt of the sitter's jerkin (the jacket worn over the doublet) had gone out of fashion long before 1600. As to the sitter's breeches, known as Venetians, that style had migrated to England during the 1590s. Cuffs had come into style during the late 1580s. Was this portrait really painted in 1612 as the NPG claimed?

Boat. Was this ship the massive *Prince Royal* being repaired in 1612? Two details demanded attention. First, in surreal contrast to the sailors straggling ashore, a tiny workman, dressed identically to our main sitter, was standing atop a scaffold holding a paintbrush. The scaffold beneath him was structurally nonsensical and appeared to be perched above crates that had been washed ashore. Was this repairman part of the original design? Because if he wasn't, then there was nothing in the portrait to indicate the ship was being repaired and instead we had an obvious depiction of a shipwreck.

Red balconies decorate the ship's stern, yet the stern of the *Prince Royal* had been gilded and lined with ornate statues. Scale-wise, it seemed to me the portraited ship bore little resemblance in size to the *Prince Royal.* Just look at the size of the repairman compared to the height of the stern. Either the repairman was a giant or this was not the fabled *Prince Royal.*

I started to look for other portraits identified as Phineas Pett, of which I found two, almost identical to each other, one located in London, the other in Australia. Both appeared to be heavily overpainted pictures depicting the same NPG sitter wearing a similar skullcap. There was no ocean however, and instead the two sitters were standing before a thickly inpainted background of wood and rock with nary a boat in sight. A shipwright without a ship? That seemed odd. And when I began communicating with the owner

of the Australian portrait, he readily agreed his portrait appeared overpainted and confessed to having wondered what lurked beneath the paint. Both these portraits had been identified as Phineas Pett because of their resemblance to the NPG portrait. If the NPG portrait had been misidentified, then so had these. It even crossed my mind that these two pictures might be overpainted copies of the NPG portrait.

There was also one other Pett portrait, a watercolor the NPG believed had been copied from the Australian picture. Presented to the NPG in 1949 by Mrs. C. S. Warwick of Bath, this watercolor depicted the same skullcapped courtier, but this time the sitter was wearing a sword with a distinctive two-faced pommel (both faces appeared to be male). The copy was assumed to have been painted in the nineteenth century. There was no additional information about its donor, though the city of Bath was connected to Shakespeare as the poet mentioned his trips there in his autobiographical sonnets.

Instead of practicing my Japanese, I began hounding the NPG to include their pirate portrait in their upcoming *Making Art in Tudor Britain* project, which would include a barrage of tests on select pictures. Eventually Dr. Cooper informed me that she had placed the Pett portrait on the reserve list, but she made it clear that, as a reserve, the portrait was unlikely to receive any spectral testing. Undeterred, I kept pestering the NPG until they issued a collective sigh and agreed to test the portrait with infrared light. Dr. Cooper cautioned that the results might be slow in arriving. Furthermore, if I wanted to study the results, I would have to travel to London.

But how could I travel to London when I was bound for Japan?

Three days before my flight to Tokyo, I sat slumped at my desk late at night practicing my Japanese and shuffling my deck of kanji flashcards. The porch light outside cast shadows of falling snow onto my office wall plastered with bastard bards. For the last few weeks I had been bowing to these mangled swans while practicing various Japanese greetings. But on this evening, while doing this, I felt something suddenly stab into my heart, as if some enemy sorcerer,

or perhaps NPG curator, had jabbed a needle into a voodoo doll of me. The pain passed quickly and I thought nothing of it.

My plane ticket, my passport, everything I needed was on my desk, ready to go. Then, two days before my flight, I felt a second voodoo needle jab into my heart, this one more pronounced, altogether more poignant. My knees almost caved. A few hours later I was screaming wildly while attempting to drive myself to the emergency room.

10

Bokashi Shakespeare

Photoshop mock-up by the author combining Toshiro Mifune's movie poster from *Throne of Blood* with a doublet and linen fall collar cribbed from a 1594 portrait miniature of the 3rd Earl of Southampton kept at the Victoria & Albert Museum in London.

The censorship of Japanese pornography evolved over time into a mosaic art form known as *bokashi*, in which a taboo image was divided into a thousand moving squares, a rotating rubric that served the same purpose as a Renaissance art fig leaf. The forbidden fruit remained blurred by motion, yet every so often the image appeared to lock into its original alignment. The rate by which it did this, and how long it held that alignment, became controversial.

Laws were passed making certain methods of bokashi illegal, but at the same time new types of loophole pixelation were constantly being created. Some forms were deemed too small, others too transparent, but it could take years before each new method was dissected and declared illegal. In the meantime, connoisseurs sought out the more daring technologies, which had names like street drugs: Moodyz, Degiemons, and Hypers.

In a state of stupor toggling between agony and ecstasy, I sat studying the history of bokashi censorship on Japanese genitalia inside a Roppongi business hotel while heavily sedated yet ironically still in great pain. During the moments when the gods grew bored with torturing me, I also delved into the history of Shakespeare's popularity in Japan, a love affair that began in 1884 when the great Shōyo translated *Julius Caesar* into the metric system of Bunraku (puppet theater) and climaxed many decades later with Akira Kurosawa's adaptations of *Hamlet*, *Macbeth*, and *Lear*.

I was exploring these topics using something new to me called broadband internet, though occasionally I flipped on the hotel TV to watch the English-language news loop of my home state Mississippi being ravaged by a hurricane. No bokashi protected me from those images, and for hours I watched that loop of horror with the drowsy ambivalence of a god.

The stabbing pain I had experienced before my flight had been caused by shingles, a virus that makes you feel as if you are losing a knife fight to a ghost. The disease attacks nerve endings, causing them to signal extremes of distress, yet only the slightest rash appears on the afflicted areas, in my case a pink circle the size of a quarter located directly above my heart. This virus, triggered by stress, proved catastrophic for the woman sitting beside me on the flight. I couldn't stop whimpering or throwing my arms about or cursing various gods, even though I was clutching to my bosom the world's largest bottle of Percocet. My herky-jerky trips to the bathroom in the rear of the plane seemed to bemuse everybody.

While convalescing in the Tokyo hotel and waiting for my

apartment in the north of the city to become available, I made the mistake, late one night, of turning my television to a channel that played pornographic movies. I was bored, I suppose, and lonely men are known to do such things. The movie I watched that night proved a terrible introduction to a country I would grow to love. The plot was, I later learned, a Japanese archetype. A man implants an electrode into a woman's bokashi. Then, using what appears to be a mobile phone from the 1980s, he follows her around Tokyo turning a black dial that activates the electrode at inopportune moments (to say the least) and causes the woman to experience waves of debilitating arousal. The man then turns a red dial on the same contraption at which point his victim crosses the miasmic threshold between ecstasy and torture.

For many reasons, including the lack of subtitles, the film confused me. The relationship between the man and woman remained unclear, although I suspected he was a shrink or teacher or guru, and therefore the woman had submitted to this torture for therapy or class credit or . . . enlightenment? It was hard to say, what with my sake-bottle Japanese. Pondering this, I blinked myself to sleep and when I awoke the TV had gone mercifully black.

But that sadistic plot set me to thinking, and I began to wonder about the relationship between censorship, via bokashi pixelation, and the brutality of so much Japanese porn. Had the censorship of genitals somehow spurred the popularity of torture as a genre mainstay? Was it the pixelation that inspired such extremes? I was unqualified to say, but, as William Blake liked to point out, repression always has toxic consequences.

Trying to clear my head, I thought about Hokusai's *The Dream of the Fisherman's Wife*, a woodprint *shunga* from the Edo period cult of man-swallowing vaginas and world-splintering penises that revealed a woman engaged in a sex act on the ocean floor with two octopuses. Back in Hokusai's day, all the great artists drew shunga. Owning a shunga was considered a good-luck charm. You gifted shunga to brides. Samurai carried shunga for protection. There was

103

no stigma attached to these lurid woodprints, and it never occurred to anyone to censor them.

Another question I pondered while watching that movie was: Why, God, are you treating me like the starlet of a Japanese porno? Hadn't I suffered through three flights and a dramatic entrance into my hotel lobby in which I behaved exactly like that poor actress when her bokashi was activated? While convulsing through customs I'd felt as if some evil Bunraku puppet master were jangling my strings. What I experienced was both comic yet excruciating, and even while screaming inside the airplane bathroom I'd been aware of the stench of slapstick.

Bokashi. Censorship. Repression. The technology of concealment. Yes, bokashi seemed to me the enemy I'd been fighting all these years, the bokashi of history, portraits, poets, players, plays, and paint.

Especially paint. Before I'd left Vermont, the Royal Collection had emailed me the X-ray results of their Hampton Court portrait, the brawling bard originally owned by Penshurst Place. Although the quality of the X-ray was stunning, nevertheless there were vital areas that suffered from what my paranoid brain suspected to be censorship. For instance, a long swatch of Tom Sawyer whitewash obscured much of the portrait, including a sword I had hoped would prove an identifying feature. Part of the sitter's face was hidden behind that same white swatch which the Royal Collection later informed me was caused by repair done to the back of the painting.

As much as I longed to get beneath that whitewash, I had no time to harass the Royal Collection for an IR that might reveal any carbon underdrawings. My six months in Japan would be divided between the guilty pleasure of studying portraits late at night alongside the more enviable daytime task of absorbing Japan's culture, specifically the history of Japanese theater.

A week later, situated in my new digs in the northern suburbs of Tokyo, I began to range outside my apartment while still heavily sedated. The pain had eased somewhat, but my addictive personality

had already begun cocktailing booze with the Percocet and the Adderall in combinations that sometimes resulted in waves of euphoria. During my first jaunt outside I strolled along the Kanda River and by chance came upon the poet Bashō's old home. I entered the walled compound through an open-air bookstore and wandered among the gardens. It wasn't the original hut, I learned from a pamphlet, just a facsimile; however, the goldfish pond was original, so I sat on a bench there to commune with the mottled descendants of Bashō's carp.

My grasp of kanji had progressed to the point I could perform crude translations of haiku, a hobby I resumed while under the scrutiny of a large scholarly looking carp. I kept the English translation bokashied until I had completed a degenerate translation of a haiku by the Buddhist monk Issa. This poem, I was pretty sure, concerned a man leaving his girlfriend after catching her having sex with another man.

Not very Buddhist, Mr. Issa, I was thinking until I peeked at the real translation:

I'm leaving now, flies,
So relax,
Make love.

"Damnit," I whispered to the carp lipping the pond's surface with such soulful eyes I suspected he might be Bashō reincarnated.

Later that week, with Bashō still on my mind, I caught the subway to Hamamatsucho. I'd been converted to Buddhism by a girlfriend while in graduate school and was eager to explore Tokyo's Zōjō-ji temple of Pure Land Buddhism. Every evening at dusk the monks there lug out a collection of eccentrically shaped *taiko* drums and start berating them, the percussion flooding the temple and lifting you upward toward a giant statue of golden Amida, the Buddha of Infinite Light.

One of the Buddha's earliest teachings warned us that we view

our world incorrectly because of the human tendency to wrap everything we perceive inside cultural concepts. We see these concepts instead of what's inside them. Shakespeare, or so it seemed to me that evening while riding the subway toward the temple, was wound thick as Tut's mummy in our concepts about him and was almost impossible for anyone to unravel, but imagine the difficulties of being a British historian and having the soul of your country embodied by this one icon buried inside layers of myth and veneration and even patriotism, and then trying to view that icon, even for one moment, with any objectivity. Was objectivity possible, I had to wonder, when describing Shakespeare honestly would inspire cries of treason among your academic colleagues and cast you into the role of pariah, someone to be greeted with ridicule on a daily basis?

I entered the Zojo-ji temple warily, as I do all religious edifices, and sat in a folding chair in the back row as the monks were hauling out their drums. Centuries earlier this temple had been part of the secretive Shingon school of Buddhism, a Tantric sect that migrated to Japan indirectly from China. Tantric Buddhism, most associated with the adepts of Tibet, had a lot in common with the teachings that influenced John Dee's cult. Hermeticism, like Tantra, defines the ultimate, the godhead, as a mental resonance that creates and permeates our world. Humans become microcosms who contain their own divinity—both the created and the creator.

Interestingly, science was catching up with the teachings of Tantra and Hermes Trismegistus. In 2005 Richard Conn Henry, a professor of physics and astronomy at Johns Hopkins University, published an article in the journal *Nature* that stated, "A fundamental conclusion of the new physics also acknowledges that the observer creates the reality. As observers, we are personally involved with the creation of our own reality. Physicists are being forced to admit that the universe is a 'mental' construction."

Another aspect of Dee's Neoplatonism I'd become fond of was called *hermaion*, the idea of the (seemingly) lucky find that changes everything and allows the infinite to be glimpsed in something as

small as a fingernail clipping. That moment of hermaion seemed to me the great god of the obsessive-compulsive pilgrim.

Just a few rows behind where I sat viewing and co-creating the golden statue of the Buddha was a donation well that worshippers pelted coins into thereby adding another layer of cacophony to the taiko symphony. At some point the drums find your heart and there's a moment of realignment in which you fear you are having a stroke. This fear passes, however, as the outer and inner cacophonies coalesce, and soon the drumbeats feel as if they are coming from inside you.

Before leaving the temple I pelted a handful of coins into the well. It's considered good luck to throw the coins really hard and make lots of noise. Then I descended the dozens of steps to street level and strolled through Tokyo twilight toward the Toei line until I noticed an orange sign glowing in the dusky distance. My kanji flashcards obsession paid off here when I determined it was a sake bar, but upon entering the squat building I discover it was actually a small grocery store stocked with sake bottles displayed inside refrigerated bins. Many of these bottles were decorated with kanji, but other labels pictured the odd landscape, portrait, or even shunga. After a brief discussion with the owners of the store, called the Meishu Center, I learned that they scoured the islands exclusively for *jisake*, high-quality small-batch brews, the best of which hailed from the holy waters around Niigata. I held a green bottle at arm's length, an *arabashiri*, the vaulted first run, the bottle glowing behind the moist calligraphy.

Following the instructions I'd been given, I selected three bottles and set them on a nearby standing bar where some businessmen were conversing at machine-gun speed about baseball—or at least I suspected it was baseball. A waitress brought me a rack of glasses, but I asked to sample the sake *kikijogo* style inside the ceramic *choko* cups with the blue circles on the bottom to test clarity. By then the businessmen had noticed the lurid labels I'd selected.

"*Sanmi ga tsuyoi*," I whispered, and my tentative comment that the sake had been a bit sour was met with a round of appreciative *ahhs*.

I was speaking Japanese, y'all!

The drumming of the monks returned with the taste of the sake, a conjugation forged forever in my mind. I finished my samples and fetched three more bottles.

"*Otsukaresama deshita*," I toasted the businessmen this time. "Because we have worked hard," I was attempting to say. And we drank to the consolations that followed a hard day's work. Or maybe we drank to something else entirely.

"You are *kikizakeshi*," one businessman remarked, meaning a sake expert, and I blushed with pride because I actually knew the word.

I kept drinking. It was great to be outside my apartment and stumbling over my language skills. The Adderall kept puppeting me upright while the Percocet and booze behaved like twin albatross pulling my neck in opposite directions—or at least that described how I was walking by the time I exited the store.

Needing fuel for what I sensed would be a long night with horrific consequences, I wound down the street toward a *kaiten* sushi joint. Kaiten is a beautiful thing. No fumbling with the native language, no jab-stammering at menus, instead you simply park yourself before the revolving metal smorgasbord of eccentric sea creatures—sucker-cupped, mucous-bodied, or bouquet-eyed— peeking out at you above their emerald lairs (and you in turn seeing your own human hideousness from their point of view). Unfortunately, in this my initial installment of kaiten, I walked directly into the glass door of the restaurant, rebounded without quite collapsing, then walked into the door again. On my third attempt to enter I jostled inside and alit at the nearest barstool. After being helped up off the floor, I gamely signaled the waitress with the international pint-swilling motion and began to pluck and scarf down whatever sea creatures most offended the eye. Midway through my second pint, my Hampton Court wingman bard suddenly materialized beside me on a barstool and started egging me on, daring me to try this or that repugnant creature. A half hour later, with my stomach resembling a Pixar crime scene, I deftly hopped backward from the

bar stool to pay my tab. After being helped up again, I stood there swaying while my wobbling phallus of plates was tallied by an awed waitress, who then tore off my bill, handed it to me, and bowed.

The next morning I pried open one eye (the other remained crudded shut) and scanned my apartment for incriminating evidence. Nothing too bad, really, just a few empty sake bottles scattered among tussled sheets. I conceded to a glass of water and used a sip to swallow two Percocet and left the rest in the glass where it belonged.

All that day I remained exhausted from having absorbed so much culture. And as I continued to coax along my new addictions, it occurred to me that in traveling abroad I had assumed the role of the fool, which was very Japanese, or at least it had been Kurosawa who had perfected the archetype of the fool he'd inherited from Shakespeare. Kurosawa's fourth movie, a low-budget studio number called *The Men Who Tread on the Tiger's Tail*, had featured Ken'ichi Enomoto as a bumbling porter who helped guide, and beguile, six samurai and their feudal master across mountains of danger to safety. Filmed in 1945, and based on a kabuki play, this beautiful film was perhaps Kurosawa's most Buddhist effort in that the samurai were disguised as monks, and the plot stressed the importance of using intelligence over violence. Enomoto's role as Kurosawa's first fool deeply influenced his fools to come, especially the greatest fool of them all, Toshiro Mifune's Kikuchiyo in *Seven Samurai*.

Still wretchedly hungover, I was attempting to count Kurosawa's fools on my fingers when an earthquake struck. It wasn't a big earthquake, or even a noteworthy one, unless it was your first earthquake. That quick the red dial of terror bounced off the glass. The quake didn't last long, less than three seconds probably, but it could start back up at any moment, right? Like . . . it could start back up right now.

Had I known it would be the first of many, and that my half year in Japan would be plagued by an unusually active spate of daily earthquakes, I might have cursed Yukio Mishima out loud. But at

least one thing was going my way. Broadband internet had revolu-
tionized my ability to pilfer art from virtual galleries that had been
designed to thwart thieves like myself. Certain museums I won't
name had arranged their viewing platform so that you couldn't zoom
in on an entire portrait, only on whatever small detail you selected,
but if you photographed each one of these details at maximum
zoom, and then meticulously stitched all the details together into an
Elizabethan quilt, eventually you created a high-quality jpeg worth
studying. And that's what I did late at night after returning from
the theater or from my favorite soccer bar in nearby Takadanobaba.

What I've been leaving out of this account, it occurs to me now,
is all the dead-end Shakespeares—the weeks, months, and years
wasted in pursuit of portraits that offered no promises of X-rays
or IRs. I had about forty folders in a larger folder called "Suspect
Portraits," and each of these folders contained additional folders. It
wasn't that I had the largest private collection of digital Elizabethan
pictures in existence—although I did—what was remarkable, and
utterly psychotic, was that all the files divided into costume or art-
ist or museum or sitters holding cats or monkeys or dogs or skulls
or sporting specific-type hats or collars times infinity. I had a file
devoted to pregnant-women portraits. I had a file of men posing as
writers with pen and paper. Often I would own no memory of hav-
ing collected these portraits—a file labeled "Cross-dressed Shake-
speares" for instance—and yet there it was, and it must have taken
weeks to collect. I had a file of sendaks. I had files devoted to armory,
heraldry, and inscriptions. And all these files contained subfiles that
contained other subfiles. It occurred to me that I could murder any
curator I wanted to and then plead not guilty by reason of insanity,
and exhibit A in my defense would be my computer files.

During those first months in Tokyo, before my son came to
stay with me, I became consumed with a subsection of portraits
I'd found in London's Royal Collection that had museum numbers
painted directly on the portraits. There were dozens of these, and

many were from the English School contemporary to Shakespeare. While exploring this phenomenon I discovered an unknown man that bore a strong resemblance to a death mask purportedly belonging to Shakespeare. Intrigued, I tried to zoom in on his features, but when I did this a series of gray blocks appeared and thwarted my view. *Odd*, I thought. Was this another form of bokashi? Suspecting as much I dove headfirst into the Royal Collection determined to find every portrait that contained these obscuring *Tetris* pieces.

Then one night, while pursuing this bread-crumb trail, I aimed my virtual flashlight onto a portrait marred by gray-block bokashi and beheld a Droeshout look-alike with blue maniacal eyes and a sword raised above his domed head as if he were about to cleave the painter in two.

I'd found my Macbeth.

11

Samurai Shakespeare

Sir John Parker by Hieronimus Custodis, 1589 (Royal Collection Trust / © Her Majesty Queen Elizabeth II 2021 London).

Many critics consider *Throne of Blood*, Kurosawa's *Macbeth*, to be the greatest adaptation of Shakespeare ever filmed. The

movie stars Toshiro Mifune as Washizu, a feudal general, who, after consulting a loom-spinning witch inside the Cobweb Forest, follows the superstitious path of many a previous Macbeth to his doom. Kurosawa, always improvising, opted to have Washizu killed by a flurry of arrows fired by his own turncoat troops, and the director contrived to make these hundreds maybe thousands of whizzing arrows stick into Mifune's armor without actually killing the actor inside. The result is a miracle of sorts, an astounding five minutes of footage that's arguably the best death scene in film history as Washizu, porcupined yet undeterred even by the arrow suddenly piercing his jugular, reaches for his sword to punish his treasonous army before the weight of that motion topples him to the ground.

On the night I discovered my Washizu Shakespeare, his blue eyes made more sinister by the sword poised above his swollen head, I smiled grimly into this snake pit of pigment. The picture appeared to have been finger painted in certain areas yet exquisitely rendered in others, scrubbed here, scamped there, and I giggled into my hand when, while zooming in to examine it closer, gray bokashi blocks kept appearing to thwart my inspection.

The sitter had been identified, based on the picture's coat of arms and motto, as the only known portrait of Sir John Parker. Painted in 1589 by Hieronimus Custodis (a name that translated into "Defender of the Sacred Word"), the portrait's 1898 royal catalog entry, written by Ernest Law, noted about Custodis: "Nothing is known of this bad painter." But in truth Custodis was a gifted Flemish artist who lived in London between 1589 and 1593 and painted many members of the nobility. His pictures were relatively easy to identify, as Sir Roy Strong once pointed out, via their telltale inscription style. Francis Mere's 1598 almanac *Palladis Tamia* cited Custodis as one of the finest painters in London.

Sake bottle in hand, I immediately went psychobabble overboard in trying to convince the royal curators to test their Custodis. How obsessed? One email reply I received from the Royal Collection began this way: "Thank you for your emails of 14, 16, 18, 20 August

and of 3 September which I have received upon my return from leave this week."

Within days of discovering this egg-headed Samurai Shakespeare, I had compiled a dementia of pinballing theories that the Royal Collection endured with great patience. In response, one assistant curator stated that, in her opinion, the portrait contained no signs of tampering. This stunned me. *No signs?* thought I, my right eye twitching as it roamed across the portrait's tide lines and scour marks.

My reply email did at least score a palpable hit:

Not to dwell on our disagreement on the overpainting (or not) of the Sir John Parker portrait (RCIN 403915) but I will point out in my own defense that Ernest Law in his 1898 *Royal Gallery at Hampton Court Illustrated* (see attachment below) did describe Custodis' signature on that portrait as being located in *the upper-left-hand corner*. The signature is currently located in *the lower-right-hand corner*. It remains the strangest portrait I have ever seen.

Thanks again, Lee

The painter's eccentric signature—one of the few portraits Custodis ever signed—had wafted down like an autumn leaf to settle onto the bottom, but I was the only person who found this unusual.

While delving into this mystery, I discovered that the portrait had been photographed in 1871 and immediately wrote the Royal Collection to request a jpeg of that photo. They agreed to send me one but their email reply also reported some discombobulating news: In 1871 the royal curator Richard Redgrave's inventory had noted the artist's signature to be located in the portrait's *lower-left-hand corner*. Not in the *upper-left-hand corner*, as Mr. Law would record it almost three decades later. And not in the *lower-right-hand corner*, where it currently resided.

"I'm afraid," that email added, "this does not help with the con-

fusion around the inscription since Redgrave provides a third different location . . ."

Upon receiving the 1871 photograph of the portrait, I zoomed into all corners hoping to find that elusive signature only to be left befuddled by a wide margin of what appeared to be crude white overpaint lining the portrait bottom. The corner where Redgrave had indicated the signature resided in 1871 seemed especially obscured, and the museum inventory number, 288, had also been painted onto that corner.

No more answers to my questions were forthcoming, but the Royal Collection did offer some hope in solving the Custodis mystery. The portrait was being considered for an exhibit, I was informed. If selected, it would undergo a series of spectral tests for conservation purposes. I wrote back and stated, perhaps too adamantly, my belief that the portrait should be tested regardless of any exhibition. Within a few days I received what I considered to be an archetypical British response:

> Thank you for your email. It is fascinating to hear your thoughts on this painting. We will certainly examine this portrait further the next time that it comes into the conservation studio, but as you can imagine we have a schedule of work and allocated budget responsibilities so we will not be able to do this immediately.

Did I detect a trace of English sarcasm in that description of my theories as "fascinating"? Well, I in turn found it fascinating that royal curators thought it a good idea to paint catalog numbers directly onto portraits and that some of their most respected nineteenth-century experts had a tradition of getting dizzyingly drunk before recording inventories. It was additionally fascinating to me that Mr. Law had recorded the use of periods separating the words of the migrating signature, as in "Jeronimo. Custodis. Antverpien. Fecit. 10 August." Yet no such periods existed in Redgrave's earlier tran-

scription, in which the spelling of Antwerp was different and the word *August* was missing entirely.

Instead of dwelling on these curiosities, I wrote back to thank the Royal Collection for the photograph they'd sent me and in closing added, "Please do let me know any future developments regarding the portrait (and especially if the Custodis signature moves yet again)."

While waiting to hear if the portrait would be selected for testing, I reread *Macbeth* and began to wonder if that play was itself the victim of some bokashi. The tragedy we know today came to us patched together with lines lifted from the works of another playwright, Thomas Middleton. Since *Macbeth* was not considered one of Shakespeare's last plays, it's difficult to explain why the tragedy had to be cobbled together in that manner. Was it possible that *Macbeth*, due to its bloodthirsty portrayal of Scottish royalty, had been censored by James I? Was *Macbeth* always the shortest play in the canon, or was its brevity the result of censorship? Could its author have suffered dire consequences as a result of a king's displeasure, and was that the reason "the Scottish play" had always been associated with bad luck?

At least one contemporary reference hinted at just such a scandal attached to Shakespeare. A poem written in 1610 by John Davies of Hereford had lamented Shakespeare's downfall or disgrace for having displeased his king:

> *To our English Terence, Mr. Will. Shake-speare.*
> *Some say (good Will) which I, in sport, do sing,*
> *Had'st thou not plaid some Kingly parts in sport,*
> *Thou hadst bin a companion for a King;*

Beware the friendship of princes!, I thought.

Eventually I forced myself to put aside my portraits and took a cab to the airport to pick up my son. Hayden stayed with me in Japan for a month and together we toured the temples of Kyoto and gasped

at Mount Fuji and cheered through some sumo *bashos* and gawked at the absurdly high prices in DJ Honda's gift shop and perhaps most memorably sat contemplating the Peace Park of Hiroshima, especially that one stone building, formally a domed observatory, now a haunted ruin, that the American pilots had used as a target when they exploded the atom bomb above a city teeming with innocent men, women, and children.

While at the Peace Park we visited its museum and were stopped dead in our tracks by a diorama of life-size mannequins, three of which—a mother, her child, and a student—had been immortalized fleeing a burning building with their skin melting off their bodies like hot wax. Here was a work of art that served as the hellish inverse to "Ode on a Grecian Urn," its pastoral celebration of timeless lovers forever young replaced by a ghoulish tableau of agony that seemed to mock that famous last line, "Beauty is truth, truth beauty,—that is all Ye know on earth, and all ye need to know."

While staring into that almost unbearable work of art, I couldn't help but recall how Larry Flynt, the founder of *Hustler* magazine, had described war as the real pornography. And, sure enough, that Hiroshima diorama was later censored and is no longer part of the museum's exhibit, yet another example of historical bokashi.

After Hayden left Japan, I traveled north and visited a mountain called Osore-zan, an old pyre ground filled with jagged rocks and volcanic updrafts rising from cairn-flanked chasms. Statues of dead children with real ravens nestled atop their heads stared out at me through the mist like shy aborigines. Then, upon returning from Hokkaido, I received an email from the Royal Collection and made myself a drink before reading it. The message informed me that the Custodis portrait of my so-called Macbeth had been rejected for the exhibition and therefore would not be tested in any way. I bellowed like a wounded Washizu, my scream so fierce it triggered another earthquake, at which point I donned the metal helmet that had come with my apartment and dove under the bed.

Goddamn you, Yukio Mishima.

On my last day in Japan I returned to the Zōjō-ji temple to bid goodbye to the Buddha of Infinite Light. I'd kicked the Percocet habit during my son's visit yet those drums still found my heart. With their percussion echoing inside me, I exited the temple intent on saying farewell to a few bottles of sake when a flock of teen-age girls in blue pleated skirts began ascending the steps toward the *honzo* entrance. The schoolgirls were between the ages thirteen to sixteen, I'd guess. I was descending as they were ascending, and when we collided they swarmed me like a cloud of blue butterflies. The girls were from the countryside, where Westerners were seldom seen, and they all wanted to be photographed standing beside the tall emaciated American with the dark circles under his eyes. For ten minutes I posed with one girl after another, which moved me more than I can perhaps describe. Fearing I might never return to Japan, I began weeping as I descended the remaining steps alone.

12

Strange Fantastic Shakespeare

Portrait of An Unknown Woman by Marcus Gheeraerts the Younger, circa 1590–1600 (Royal Collection Trust / © Her Majesty Queen Elizabeth II 2021).

While I was away in Tokyo, my ex-wife moved to Montpelier, Vermont, the smallest state capital in America—it didn't even have a McDonald's—leaving me with little choice but to up-

root and follow. Montpelier was comically picturesque—even the local gun store looked quaint. With a nighttime population of about five thousand, the town seemed especially depleted if you'd just left Tokyo. There were no young people there. High school kids fled after graduation and didn't return until they'd retired. All the local bands were white-haired men in tie-dye murdering the sixties.

My son, a teenager now, had better things to do than hang out with his dad on weekends. I'd never been so bored, so lonely, so reluctantly wholesome. My life felt like a *Twilight Zone* episode in which a man awakens trapped inside a Norman Rockwell painting. Montpelier, I couldn't help but think, would have made the perfect setting for a horror movie.

A type of horror did unfold soon after I'd moved there when my ex-wife opened a candy store downtown, presumably to be operated by our son to teach him responsibility. This was admirable on her part, the only flaw in her plan being that Hayden was a punk kid exactly like I'd been at fifteen and therefore used the store as a party den. What better place to smoke up with your running buddies than a closed candy store? But it was the impact of the store on the town that hinted at horror. Everywhere I looked kids were main lining plastic wands of sugar. Candy wrappers wafted down the sidewalks while obese children waited in line to buy cartoon-decorated bags of poison. Bright kid that he was, Hayden felt wretched about all this and vowed to quit eating candy forever.

By then, I had made a down payment on a low-end condo, moved in, and soon got hired at Rivendell Books, where it was part of my job to rummage through the boxes of used tomes people lugged in every day. One morning a middle-aged couple carried in two boxes of books about spiritual healing. It was usually fun to psychoanalyze customers based on their reading habits, but in this case my boss informed me that a few years earlier the couple's teenage son had gone *In Cold Blood* on a local homeowner. No motive per se, just knock on a door and kill whoever answers, a murder seemingly performed out of boredom.

It was during my first month at the bookstore that the final *Harry Potter* dropped and I was sent to transport these books to a tent party we'd organized to celebrate the re-infiltration of witches into America. I dollied up the boxes, which were decorated with pseudo-occult symbols, and started pushing them down Main Street, and as I did this a kite tail of children appeared and began trailing after me. Every so often a kid would spur her broom forward to touch one of the boxes. They took turns doing this. It was kind of weird but kind of cool, too, and it made me recall the amazing power of books and how so much of my present misery had begun inside used bookstores.

I enjoyed my new job, but the condo I'd just bought proved a disaster. Within days of unpacking, I realized that the owners of the other four units all hated one another. Then my basement flooded. Then my hot-water heater broke. Then the real-estate market suffered a historic crash. No, things were not going well. I missed my lake, my sea monster, and when one of my son's schoolmates broke into a crypt at the local cemetery, stole an old man's skull, and used it to fashion a bong, I rather sympathized.

With not much else to do, I burrowed into my portraits and soon hit upon the perfectly psychotic way to compare their facial features. What I did, I sized up my jpegs, inserted them into slideshows, then staggered these presentations so that my three monitors juxtaposed random portraits. That done, I sat in front of this cockpit like Neo downloading kung fu. After a while all I had to do was close my eyes to watch the barrage of deformed faces. In this manner the winters began blending together—I have little memory of any other season there.

One particularly frigid night I found myself sitting alone in my devalued condo sipping a glass of Merlot under the séance glow of three candles set along the coffee table on which my feet rested. There was a lamp next to my couch I kept flicking on and off, like a psycho killer might, while staring up at a full-length portrait print I'd had framed years earlier known historically as *Qu. Elizabeth in a*

Strange Phantastick Habit (Vertue), a painting attributed to Marcus Gheeraerts the Younger and dated circa 1600.

This portrait's conceit came from Ovid and cast the Virgin Queen in the role of the goddess Diana, Elizabeth's go-to mythological symbol. As Sir Roy Strong once explained, "There could be only one Diana in Elizabethan England, the Virgin Queen herself." Standing before wooded hills in a diaphanous gown embroidered with flowers, grapes, and phoenixes, this Diana/Elizabeth stroked the head of a stag she was crowning with a wreath of pansy and pearl. In this allegory, the stag portrayed Actaeon, the hunter who had happed upon the bathing goddess while she was naked and as punishment was confounded into a stag and ripped to shreds by his own hounds.

Some scholars, including Strong, believed the portrait to be attached to the 1601 Essex Rebellion, an armed uprising against the crown that was started at the Globe Theatre with an illicit production of *Richard II*. The rebellion ended with five courtiers being beheaded and the Fair Youth Earl of Southampton tossed into the Tower. If Strong was correct, that connection to treason might help explain why the picture had been repeatedly altered in strange fantastic ways while residing inside the Royal Collection.

Some less traditional scholars, such as Dr. Paul Altrocchi, claimed this portrait had something to tell us about Shakespeare and that its visual riddle or impresa invoked the playwright in several ways, starting with its cartouched sonnet, a lament of betrayal penned from the sitter's point of view. The portrait likewise depicted the stag as weeping, a possible reference to Jaques's speech in *As You Like It* about a deer shedding tears into a woodland stream. In another perhaps allusion to that comedy, the royal walnut tree behind the goddess, called "the tree of love" in the sonnet, was hung with assorted pleas of love and lament, although its verses were in Latin and did not pine for the fair Rosalind.

But the most amazing detail about the portrait, which had remained identified as Elizabeth I inside the Royal Collection of full-

length sovereigns for almost one hundred years, was its depiction of the Virgin Queen, traditionally painted with a wasplike waistline, as blatantly pregnant—a condition also hinted at inside the sonnet. In 1898 the historian Ernest Law, after identifying the subject as Queen Elizabeth I, wrote, "This curious picture, with its fantastical design, enigmatical mottoes, and quaint verses, doubtless has some allegorical meaning which we are now unable to interpret." Strong called the painting the most complicated of all Elizabethan allegorical portraits. "Such a picture," he added, "cannot have been conceived as anything other than a major statement."

While gazing into this picture that evening, I left the lamp off too long and fell asleep. With my wineglass lagging into my lap, I dreamed about Queen Elizabeth in all her glory in which methought I was among her court, dressed in my best jerkin and slops, an outrageous cartwheel ruff circling my neck, inside a grand ballroom at Hampton Court teeming with beautified courtiers: the earls of Essex and Southampton, the frizzy-haired Mary Sidney, the skullcapped John Dee, the looming Richard Topcliffe, and even wee Robert Cecil, the crookbacked secretary who in his own treacherous way ruled over them all. Only Shakespeare seemed to be missing as the couples performed that annoying palm-mating dance featured in every movie about the Tudors.

I know you all, I thought: the intelligencers, bit players, torturers, thieves, and sorcerers. I knew their ruffs, perms, beards, cuffs, and jewelry, their wants and weaknesses, their shadows, scars, and syphilitic ears. I knew what virtues and horrors these creatures were capable of. Behind the wan smile of a Lord Burghley lay a moat of corpses. I knew their shifting alliances and how they all thwarted against Robert Dudley, the queen's longtime lover said to employ an Italian apothecary for poison on demand. I knew how Dudley's wife had fallen down a staircase right at the moment in history when Dudley had the highest hopes of marrying the queen, and I knew how Elizabeth would have wed Dudley in a heartbeat had not the commoners risen up against that sordid love-triangle murder.

I knew the dancing courtiers by their portraits and their body counts and by the characters they'd inspired in plays, and I walked among them recalling their poems, plays, philosophies, trifles, and pamphlets, all the while trying to grasp the Elizabethan mindset, which at times seemed to me void of conscience, a court filled with a psychosis of fantasticos who might have left no ear unpoisoned or throat unslit had it not been for one courtier's invention of the inward-spiraling soliloquy, that evolutionary reminder that we are cousins in suffering.

I awoke with a wine-soaked crotch, set down my glass, and at that moment noticed something remarkable about the portrait hung on my wall. What I noticed was titillating, impossible yet resolute. Illuminated by candlelight, the queen's bathing gown had dissolved into a gauze that left her naked and exposed. Yet a moment later, after I'd flicked on the lamp, the same gown—that quick—was no longer transparent and the queen was once again respectable.

I kept turning the lamp on and off to test my sanity. What I beheld seemed indisputable, and I began to wonder if I was the first person to notice the queen's nakedness since Mr. Edison had invented the lightbulb. I also began to wonder if I were losing my mind or becoming a fetishist, so I decided to test my theory and a few nights later invited two friends over for drinks, lowered the lights, lit some candles, then pointed to the portrait and asked them what they saw.

"Oh my god, she's naked!" my friend Anna said.

Not only was the queen naked, but this nakedness mirrored the portrait's conceit in which the goddess Diana was spotted bathing nude by the doomed Actaeon. All of which made a sort of sense when you recall that the Elizabethans knew only two lights to view art by: the wick and the sun. Had the gifted painter Gheeraerts devised a way to make his queen clothed by day yet naked by night? Well, by any light the portrait was treasonous enough to beg the question: Why would Gheeraerts have risked torture and death to paint this heresy?

"Here is an impossibility," I told myself. "Here is a portrait that defies all logic. It cannot exist, and yet there she stands, as if alive."

There was one particularly damning detail about the portrait I felt certain would prevent it from ever being X-rayed. A simple magnifying glass held up to the queen revealed two knotted rings dangling from the cord around her neck, and one of those rings was resting directly atop her pregnant belly. It seemed obvious these had to be betrothal rings, and if that were the case then the hidden message was that the child inside Elizabeth's womb was not a bastard but a legitimate heir, a royal Tudor prince or princess who would have been in line for the throne ahead of Scotland's King James.

The real miracle was that the painting hadn't been burned like a screaming witch by royal censors. Not that it had escaped injury. The Royal Collection's 2001 catalog explained the painting "has been extensively rubbed (i.e., erased, extirpated, or blotted out) and, especially in the background, heavily repainted. The outline of the dress down the sitter's left side has been drastically simplified; the overlapping folds of the dress and its fringes have been painted out."

Far from "simplified," the dress had been thwarted from all angles in a likely attempt to make the queen appear less pregnant. At least one of the Latin mottos attached to the tree had been altered. The pond, or lake, in the wooded background had been blotted out along with a building, some birds, and God knows what else. Somebody had not wanted us to know the spot where this painting was set and had gone to a lot of trouble to subvert its message.

Back in 1898, after identifying the sitter as Queen Elizabeth I, the scholar Law had noted the large letter R embroidered inside the queen's headdress. Scholars like Altrocchi had since pointed out that this R would seem to stand for "Regina," a case-closed clue as to the sitter's identity. But after Law recorded this identifying feature, a funny thing happened. While the portrait was still under royal care, the incriminating letter became obscured by added embroidery before vanishing altogether. The most cursory glance today still

revealed the remains of the ghostly veil scrubbed from the picture with no trace of the letter inside it.

Part of the portrait's message should not be controversial. The queen was of course no virgin. Elizabeth and Robert Dudley shared adjoining quarters for years, an arrangement that over time forced Elizabeth to pass a brutal law attempting to prevent the gossip of how she'd given birth to a hive of Dudley's bastards, up to five of them (according to one ambassador in London who sent back reports). Even Shakespeare had poked fun at Elizabeth's celebrated virginity in his suicidal Sonnet 66. While listing off the injustices that made him long for death, he had brazenly included "Maiden virtue rudely strumpeted."

These days no royal curator will admit the portrait depicts Queen Elizabeth (even though her name is still visible on its frame). In fact, they all quite agree it isn't Elizabeth now. Sir Roy Strong, after stating there was only one Diana in England, spun the bottle and declared the portrait to be . . . wait . . . wait . . . Frances Walsingham, the wife of the beheaded Earl of Essex!

Let's have a glance at Strong's theory. Okay, the 2nd Earl of Essex, a former court favorite, had been the leader of the failed rebellion against the crown. In Strong's strange-fantastic scenario, the pregnant Lady Essex, hoping to prevent the beheading of her husband following his arrest, had with great speed commissioned this sexy full-length portrait of herself and sent it to Elizabeth as a plea to spare her husband's life. Strong made no attempt to explain why Lady Essex, who was famously despised by Elizabeth, would have thought it wise to paint herself as the Virgin Queen's pregnant twin—the two women didn't even look alike in real life. We are asked to believe that Lady Essex decided to co-opt the queen's symbol of the goddess Diana in a nearly nude portrait in which the deer, presumably representing her husband Essex, was being crowned by the queen?

"Codswallop," I croaked from my couch.

I refilled my wineglass and raised it to the portrait. "I am the only

living person who has seen you naked," I thought or maybe even said out loud. It was while emptying my glass that I suddenly recalled the fate of Actaeon, the hunter who had spied a goddess naked, after which his own hounds ripped him apart like a baited chimp.

It gave me pause, I'll admit.

That was the winter I fell in love for the first time since my divorce. There was a woman I'd become close friends with. One evening, after an argument with her boyfriend, she called me wanting to have drinks and later that night, after too many margaritas, she started kissing me. Nothing much happened except all hell broke loose inside my heart. Apparently I'd been in love with her for some time without admitting it to myself—bokashi!—and the moment we kissed all that denial met the wrecking ball and I became a slave to someone who was only kissing me to get revenge on a boyfriend. The two of them quickly reconciled, and my life became unbearable.

Unrequited love, however idealized by French troubadours, is nothing less than torture, and small-town heartbreak is the cruelest form of crucifixion. Every time you step outside you hope to glimpse your beloved—and in a town this tiny you often do—so there's hardly a moment's reprieve from lovesickness. You go to a bar and your eyes roam the tables. You enter the post office, the library, the grocery store, and it never stops. Every window becomes a Norman Rockwell painting you scour for the woman who doesn't love you.

One evening I took a copy of the *I Ching* off my bookshelf and read its instructions and asked it some questions about the woman I was in love with and tossed some pennies and pondered some hexagrams, and within a week I was thoroughly addicted to the *I Ching*. Then I started writing love poetry and would occasionally email a poem to the woman I loved. It was insanity, and anyway what kind of fool thinks a woman can be wooed with poetry? Maybe in Shakespeare's time, but these days if you send a woman love poems she assumes you are going to dismember her. Somehow not realizing this—love is the purest madness—I kept emailing her my insipid

poems until she wrote back and asked me to please stop. Reading that email from her stripped me bare and suddenly I saw myself in all my feral patheticness and became so ashamed I stopped going downtown entirely.

How many hundreds of times did I ask those three pennies of fate if she was thinking about me? To escape that compulsion, I took long walks in the woods where I cursed the frozen landscape and flipped off crows and began to pick out the best trees to hang myself from. That became my Tourette's-like relationship with nature. *There's a nice tree limb! Fuck you, crow! Oh, that's a much better limb!* The woods I roamed were strung with corpses, and in this Rockwell shadow box I'd created out of madness, love, Adderall, and bad poetry every dangling corpse I saw was my own.

Suicidal thoughts can be addictive, not to mention genetic, and I spent a lot of time that winter recalling my grandfather and father and their sordid deaths by noose and pill until, finally, one evening, almost three years after I'd moved to Montpelier, I took a forlorn drive that ended at the gun shop at the edge of town—a gun shop as painted by Norman Rockwell—and sat behind the wheel watching the giant snowflakes fall and thought about that first portrait, the one with the emaciated lovesick courtier posing before a wall of fire. I'd become that man. Actually, I'd started off as that man and now I'd come full circle. I imagined my son smoking dope in the candy store with his friends and how somebody would have to tell him the terrible news about his dad. That started me crying in self-pity.

I stayed there I don't know how long before driving back to my condo and walking into my office, where I sat in my ergonomic chair beneath my Manson Family of Shakespeares. I was still there the next morning, but by then two empty wine bottles had joined the still life. As sunlight filled the room, I wiped my eyes and started spinning slow circles in my chair. The office wheeling around me resembled a halfway home for punch-drunk poets: eyes corkscrewed, cheeks scarred, ears cauliflowered, noses boxered. So many mutts: the catfished and drift-eyed, the banana-nosed, poxed, acned, and

apoplectic, a police lineup of jostled bards. As I started spinning faster, the portraits began to blur into one gigantic, inconceivably hideous Shakespeare, the crepuscular Lumley blending into the inebriated Dexter, the Dexter into the Nosferatu-like Staunton, the Staunton into the ill-odour Hunt, into the Pistol Felton, the Bardolph Flower, and finally into the ugliest Shakespeare of them all, the Falstaffian Buttery, his head served up on a bridal-gown-white collar.

All those winters they had been my confidants, my drinking buddies, my band of deformed brothers. When I planted a foot to halt my spin, the office continued to gyroscope as I stood, still wobbly, and one by one took down all my Shakespeares, the whole bedraggled army, scraping off their tape, prying out their thumbtacks, then I stacked them into a cardboard box, carried them out into the snow, threw them into the backseat of my car, and drove them home to Mississippi.

PART TWO

The Great Unknown

13

Southern Shakespeare

Like the automobile, the mind can stray wildly when traveling long distances. My beat-up Honda had one wiper, scant tread, and two days of whiteout weather between it and Mississippi. Provision-wise it claimed a stunted spare, a giant bottle of Adderall, a rusted can of Fix-a-Flat, a second-generation iPod, and a horde of garrulous Shakespeares crowding the backseat. The driver leaned forward, his hands strangling the wheel, riding the grooves, at times slaloming on snow.

"Don't make me stop this car," he kept growling over his shoulder.

In spite of some backseat criticism, I was in command of my vehicle. Not a sparrow crossed the road that my OCD-Adderall eye did not track. You never know about that black ice, though. Suddenly it's there and your world has changed dramatically. Your heart is in your mouth, and you have no idea how this will end.

We were midway through Tennessee when the southern sun swung out like a prison searchlight and caused me to shield my eyes and hiss. After pulling into a rest stop, I left my haggard of bards in the car with the window cracked and plopped down on a wooden bench, a vampire committing suicide by sunlight. A half hour later I opened one eye and noticed a state trooper studying me. I stood and performed a few jumping jacks before walking a semi-straight line back to the snow-crusted Honda, where my Shakespeares were singing obscene sea ditties in the backseat.

"Shut up and act normal," I ordered them.

It was Super Bowl Sunday when we pulled into Oxford, home of William Faulkner, the University of Mississippi, two Confederate statues that needed blowing up, and my favorite bookstore in the world. I parked the car about ten minutes before kickoff and began searching for a bar along the town square Faulkner had immortalized in so many novels I'd never quite finished. A dive called the Blind Pig caught my eye, but its door was locked. Odd, I thought while peering through the tinted glass. Closed? On Super Bowl Sunday?

Then it hit me. Blue laws. Jesus. The Sabbath.

All the bars were closed.

I was home.

Via Craigslist I had arranged to move into a studio apartment built on the side of a house on MLK Jr. Drive, a street that proved far whiter than anticipated. The gentrified backyard included a pool, a Japanese garden with two goldfish ponds, and a Jacuzzi. For five hundred bucks a month I got to share this paradise, plus kitchen rights, the only stipulation being I had to be gay-friendly and open to the occasional naked pool party. The house was owned by a couple in their forties, Doug, an English professor, and Robby, a Web consultant. I assured them I had no problem with their lifestyle and was soon basking poolside. My bard crew quickly shed their collars and jerkins and started sporting about the gardens. They went feral on me. Weeks would pass without me spotting them.

What happened to me in Oxford seemed like a fantasy camp. A decade earlier I'd published a raunchy novel about a teenage drug dealer in south Mississippi. In my eighteen years in Vermont, I'd never met anybody who had read it, but in Oxford things were different and many of my fellow barflies approached me with questions like, "Hey, didn't you write that novel about the kid who fucks watermelons?"

"Yes!" I would reply, beaming, as if I'd been complimented.

I was beyond astonished. Suddenly I had friends and sunshine

and a sort of pathetic fame. So in spite of the fact I was ghosted and addicted to amphetamines I got invited to parties, and there were lots of them. Called "late-nights," these parties began in the homes of drunk people as soon as the bars closed at midnight. All I had to do, it seemed, was bluff my way through countless conversations about the novels of William Faulkner. I felt up to that. Hell, I might even finish one of them.

Then, after a day spent befuddled inside *Absalom, Absalom!*, I would douse into the backyard behind a pint-glass margarita to dwell among the fraternity of potbellied dudes porpoising the pool or lobstering the Jacuzzi. Closing my eyes on sunshine, I listened to them exchange horrors stories about growing up gay in Mississippi and what it had been like to tell their born-again parents and redneck friends the news.

At this point I was still assuming I would return to Vermont at winter's end, but then one night at Murph's beer garden this glow-in-the-dark beautiful woman introduced herself to me as Joey— short for Joey Lauren Adams of *Dazed and Confused* and *Chasing Amy* fame. Oxford was her second home. As we chatted, she told me that for years now she'd been giving away copies of my novel to Hollywood directors in hopes they'd make a movie out of it. I nodded in disbelief while searching the beer garden for hidden cameras.

That was the night I decided to stay in Oxford. I'd have to go back to Vermont and tell my son, and that would be incredibly sad, but Hayden was eighteen now and would be going to college soon. The memory of that Rockwellian gun shop played a hard hand in my decision. I was staying put. I was home.

Back in those days Dean Faulkner Wells, the niece and last blood intimate of the Nobel-winning author she called "Pappy," still lived in Oxford. Dean's father had died young while piloting a plane given to him by his famous brother William, who, guilt-racked, then raised Dean as his own daughter. Dean was in her seventies when I met her and had been married to the novelist and publisher Lawrence Wells for forty years. Larry, a southern gentleman and

Faulkner look-alike, believed the 17th Earl of Oxford, Edward de Vere, had written the works of Shakespeare under a pen name. Dean was also an Oxfordian. The two of them had even taken an Oxfordian tour of England together. Their dogs were named Shakespeare and Queen Elizabeth.

As our interests overlapped, I started getting invites to Falkner House (the home Faulkner bought for his parents, who had retained the original spelling of the family name). By this point, Dean had retired into the small-town condition of reclusiveness. She was not healthy, having smoked out her lungs. A raspy gadfly when she spoke, Dean had a beautiful face framed by a medieval iron-gray haircut once called a Buster Brown and drank white wine mixed with water and sometimes would reach out to pinch my arm to emphasize certain statements, as in, "Damn it, Lee, you ate my last bag of Fritos!"

I was always eating Dean's last bag of Fritos.

Before her reclusiveness set in, Dean and Larry had long held court in their kitchen with the likes of Barry Hannah, Willie Morris, and a stream of celebrities who dropped by to pay homage. Larry enjoyed retelling stories of those days, his favorite being the one about their house catching fire on the night Oxford got hit by forty lightning bolts in ten minutes and a firefighter named Larry Brown, who would later emerge as one of his generation's best writers, ignored the more affluent calls for help to extinguish the attic fire at Falkner House.

Back in those days Dean's kitchen was rowdy with lunatic drunks, but now the old bench was dead from cigs and booze, except for Barry Hannah, who still liked to tool around town on his Harley while breathing oxygen through a tube. Larry Brown had died from a heart attack years earlier. If you ordered a Larry Brown at the bar at Ajax Diner, Phil would serve you a Budweiser and a shot of Cuervo and a lemon wedge on the side for five bucks.

The town mayor when I first moved to Oxford was the bookstore owner Richard Howorth, who, along with his wife, Lisa, a novelist

known locally as "the night mayor," or "nightmare," had transformed Oxford into something anomalous in Mississippi, a beatnik town rife with broke-dick artists. It was too good to last, of course, and within a decade of my arrival all the musicians and writers would be displaced by foodies and MFA teachers.

Once a week I would sit in the kitchen with Dean and Larry talking dead Elizabethans, dipping Fritos, and sniffling into my Four Roses bourbon because I was allergic to their dogs. Some nights I'd bring my laptop and trot out my circus-animal portraits. Unlike everybody else I'd met, Dean and Larry seemed fascinated by the paintings and the sordid scandals attached to them. Dean was then finishing her memoir about growing up Faulkner, and some evenings she'd show us pages or we'd talk about her fear of book tours. One night she handed me a letter she'd just received from Cormac McCarthy complimenting her memoir and advising her to use fewer commas and cut all those damn hyphens.

Week by week Dean started allowing more people to join us and soon her salon sprang back to life. Larry, a natural-born tour guide, would show the newcomers the dining room table at which Faulkner had revised *Absalom, Absalom!* Or he'd show them the impossibly small tweed jacket Faulkner had worn in his sexiest photograph, the one my housemate Robby had hung on his bedroom wall. As Dean's salon revived, what we didn't know was that her lungs were shot and she could go any day. There was nothing the doctors could do, and she was trying to finish her memoir before it happened. Nobody understood this but Larry, the world's most devoted husband.

It was only when the three of us were alone that we discussed the Shakespeare-authorship debate, and I was open to that discussion because of the eccentric mistreatment of so many portraits. As a young man I'd read everything Mark Twain wrote, including his book arguing that the real Shakespeare had been a humanist-educated lawyer well traveled in Europe, well versed in seamanship, in soldiering, and intimate with royalty. Twain's *Is Shakespeare Dead?*

was not a scholarly argument but a passionate book rooted in the idea that the truth about our greatest playwright was self-evident to anyone who approached the subject without confirmation bias. Walt Whitman, another hero, had once described the real Shakespeare as "one of the wolfish earls" with a mind "capable of taking the law in its largest scope, penetrating even its origins . . ."

But it wasn't just Twain and Whitman whispering heresies into my ear, a whole ink spill of geniuses had staked their reputations on the argument that "Will Shake-speare" was one of the hyphenated pen names popular among Elizabethan satirists who didn't fancy being disemboweled in public. The list of gadflies who questioned the official narrative of Shakespeare included Chaplin, Coleridge, Emerson, Gielgud, Hardy, Holmes, Jacobi, James, Joyce, Welles, and of late even Mark Rylance, the first artistic director of Shakespeare's Globe Theatre. Collectively they believed the Stratford businessman to be a front and a fraud. Whatever the truth, it's fair to say the authorship debate had long been divided into two camps, artists vs. academics.

One evening Larry informed me that Mississippi claimed the world's most eccentric authorship gadfly, an heiress named Gertrude C. Ford, who had penned, and self-published, a book-length poem, doggerel and endearingly bad, premised on the theory that Edward de Vere had an affair with Queen Elizabeth I in the early 1570s that resulted in the birth of the Fair Youth 3rd Earl of Southampton. Gertrude Ford even had herself portraited while writing this poem. In the painting, currently displayed on the Ole Miss campus, Ford was seated beside a Tudor rose and poised seductively over a page as she awaited further inspiration.

After finishing her poem, Ford then wrote a play about the love affair between Liz and Eddie. That done, she hired some local actors and rented a theater off Broadway for her play's debut, but the actors were embarrassed by the script and got drunk on the flight and were later booed roundly onstage. Stung by that failure, as well as by the death of her husband, Gertrude moved deeper into her mansion in

Jackson, but before dying gave the University of Mississippi enough money to build the Gertrude C. Ford Center, where Barack Obama would later defeat John McCain in a presidential debate on the same campus where riots and murder had tried to prevent a young black veteran from getting an education.

There was a small room in the back of this theater where Gertrude's library of authorship books was kept alongside copies of her play and book-length poem.

Nobody ever visited this room.

14

Stone Cold Shakespeare

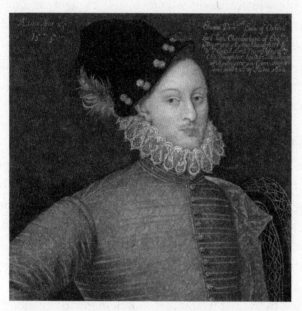

The Welbeck portrait of Edward de Vere, a seventeenth-century copy of a picture, now lost to history, painted in Paris circa 1575. This portrait, artist unknown, is on long-term loan from Welbeck Abbey to London's National Portrait Gallery.

Mark Twain, bedazzled by the poverty of facts surrounding the playwright's life, dubbed Shakespeare "the Great Unknown" and compared him to a museum brontosaurus made from too much plaster and too few bones. In search of some unassailable facts, I turned to Professor Stanley Wells's essay "What Was He Really Like?"

There, I gleaned many insights into at least one of Shakespeare's bones:

As a baby he howled and wept, smiled and laughed. He played games with his siblings and was irritated when they could not keep time in their recorder playing. He walked to and from school with his satchel on his back, he learned to read and write, to swim and to ride a horse, and he struggled with Latin grammar. He went regularly to church, and thought, as any intelligent boy would, about what he heard there. He ate and drank, belched and farted, urinated and defecated . . . As adolescence came on he began to experience erections and to feel desire. He masturbated and, earlier than most of his contemporaries, copulated.

I blinked into that paragraph for some time. Was I dreaming it? Had somebody actually typed out this claptrap in earnestness? The possibility crossed my mind, not for the first time, that the act of studying Shakespeare over the course of a lifetime might pose severe dangers to mental health. Could rabbit-holing Shakespeare trigger something akin to multiple personality disorder? Could the psyche become an inner Globe filled with too many exits and entrances? Maybe Frances Yates was correct, more than she knew, about the connection between Shakespeare and demonic possession. Short of some inner demon, what could possibly have inspired Wells to give voice to the nubile adventures of Shakespeare's putz?

While questioning the sanity of others, I noticed my stash of Adderall had dwindled. This was worrisome in that I couldn't get a new prescription in Mississippi without forking out $500 for an ADHD test. Staring at my last bottle I began to recall a list of withdrawal symptoms not excluding mental inertia, insomnia, nightmares, headaches, irritability, depression, and suicidal thoughts. "Well, that won't happen to me," I chuckled. Side effects were for losers.

Reassured, I broke off half a pill—I was at least rationing now—

and turned my attention back to the authorship debate, which had arisen—for good or bad—out of that black hole of history.

What little we did actually know about Shakespeare's life seemed discouraging: the signature of a hand-dragged corpse, no documentation of education or travel, a famed thespian who shunned acting, a bookend of missing years, a death that went unremarked upon by anyone, and a last will and testament without mention of any valuable books much less the incomparable manuscripts that would later create the First Folio. Perhaps most damning of all, we were asked to believe that the creator of Cleopatra, Juliet, and Rosalind had raised an illiterate daughter.

It was no secret in London that satirical wits hid behind pen names made identifiable by the insertion of hyphens, such as "Cutbert Curry-knave" or "Jocundary Merry-brains." Was the highly suspect name "Will Shake-speare" another such nom de plume? I didn't know, but it seemed to me that anyone who dismissed that possibility out of hand, or outright ridiculed it, was selling something, most likely another biography filled with descriptions of Shakespeare arriving in London as a traveling puppeteer who later acted in such roles as Adam in *As You Like It*, King Duncan in *Macbeth*, and King Hamlet's ghost.

It never happened. They made it all up. As Alexander Waugh stated in the prologue to an Oxfordian book called *Contested Year,* "There is no record of Shakespeare acting that predates his death in April 1616 . . ."

Not a single record existed from Shakespeare's lifetime of him acting in a play written by anyone. No Adam, no Duncan, no King Hamlet's ghost. It's not that the Stratford businessman didn't exist— he did—but nobody gave a damn he existed. Not a single neighbor remembered this great celebrity. Nobody saved a letter he'd written. Twain, who knew a thing or two about celebrity, called bullshit on that parade of fanciful biographies:

"Why, the Supposers, the Perhapsers, the Might-Have-Beeners, the Could-Have-Beeners, the Must-Have-Beeners, the Without-

a-Shadow-of-Doubters, the We-are-Warrented-in-Believingers, and all that funny crop of solemn architects who have taken a good solid foundation of five indisputable and unimportant facts and built upon it a Conjectural Satan thirty miles high."

Back in Twain's day, alternative candidates to the Stratford businessman had existed, they just weren't very convincing. Kit Marlowe had to be dusted off inside a plot twist where he'd faked his own murder. Francis Bacon, though a brilliant essayist with a history of writing plays anonymously, owned a writing style too at odds with Shakespeare's. Even during Bacon's heyday as a candidate, the claims against the Stratford businessman felt stronger than the claims for Bacon.

As Twain put it, "I only *believed* Bacon wrote Shakespeare, whereas I *knew* Shakespeare didn't."

Lacking a worthy replacement, the authorship movement spun its wheels until 1920 when the hat of Edward de Vere came twirling into the ring, at which point the referee was knocked unconscious by a folding chair and all hell broke loose. The folding chair that triggered this mayhem was the publication of *Shakespeare Identified*, a book written by an American schoolteacher with the unforgivable last name of Looney. Championing the long-forgotten 17th Earl of Oxford, the book made it clear that de Vere's biography fit Shakespeare as snuggly as a French codpiece would an Englishman. The world took note via a barrage of headlines. Even Mississippi's *Daily Herald* ran the de Vere story on page one.

Whole *Hamlet*s of books have since been written about the parallels between Shakespeare's works and de Vere's life, the best among them, by far, being Mark Anderson's *"Shakespeare" by Another Name*. As Anderson pointed out, de Vere was a Hamlet of sorts, a prince consumed with literature who owned the oldest title in the land and had spent his childhood inside a great castle housing an acting troupe. When de Vere first pranced into London at age twelve, he did so behind a procession of 140 horses darkly decked in his livery. Fond of words, de Vere was raised by a proces-

146

sion of brilliant tutors and elite schools, trained as a lawyer, traveled widely, and grew up to become one of the most celebrated poets and playwrights of his day.

Even among the nobility, de Vere was considered a living god—that's hardly an exaggeration inside the cult of royal blood he was born into—and he continued to be treated in this manner even after killing one of his own servants—supposedly the two men had been practicing at swordplay, though prior to the fencing accident de Vere had complained about his servants spying on him. Lord Burghley, Elizabeth's right-hand man and de Vere's legal guardian, pulled enough strings to prevent de Vere from losing everything during the subsequent murder inquiry but in return gained a stranglehold on the young earl's fortune and later forced him to marry his daughter, after which Burghley declined to pay the massive marriage dowry he'd promised.

Outraged, de Vere refused to consummate the marriage—or so he claimed—and soon fled the country for his Grand Tour of Europe, but his reasons for leaving might well have been compounded by his rumored dalliances with Queen Elizabeth. A catty letter sent by Mary, Queen of Scots, suggested this royal affair was the real reason de Vere refused to sleep with his young wife. Another letter, this one from the courtier Gilbert Talbot, described how the earl's young wife had "unwisely" grown jealous of the queen and how de Vere remained the apple of Elizabeth's eye.

After fourteen months abroad, spent mostly in Italy, de Vere attempted to return home, but his ship, like Hamlet's, was captured at sea by pirates who deposited de Vere, like Hamlet, naked upon the shore of his native country. After finding new clothes—fashion was extremely important to de Vere—he returned to court to accuse his young wife of adultery and continued to torture the young woman, who, like Ophelia, was being used as a pawn by her Machiavellian father, Lord Burghley. Burghley had long been identified by traditional scholars as the obvious inspiration for *Hamlet*'s Polonius.

The authorship debate was never the same after de Vere stepped

into the ring wearing a Mexican Luchador mask and began taunting the hick Stratford crowd. So convincing was the de Vere argument that the other candidates in the debate were soon forgotten, at which point the contest became a one-on-one cage match: the backwoods businessman verses the rascally earl.

Wanting to hear both sides of this debate, I started reading a book Larry advised me against. *Monstrous Adversary* by Alan Nelson had been described by Oxfordians as a hit piece designed to desiccate de Vere's character while ridiculing his literary juvenilia. And the book did seem mean-spirited to the point where I soon found myself rooting for the bad guy—a nasty habit of mine. What was so terrible, I began to wonder, about a stone-cold bard, especially when the alternative was a Shakespeare-shaped hole in the ground?

Defamation was nothing new to de Vere. While still alive he'd stood accused of being a sodomite, a traitor, a blasphemer, a Catholic, a "spoiler of his cook," a black magician, and, well, a boy-buggering horse fucker. These accusations had rained down upon the earl after he'd been busted as a secret Catholic. When Elizabethans fell, they fell hard, and to lose favor with Her Majesty was to risk having your name, however noble, dragged through the mud like Hector's corpse.

Among the hundreds of pages of slander done de Vere, he'd even been described as a vampire "who would drink my blood rather than wine." One political enemy elaborated:

First, I will detect him of the most impudent and senseless lies that ever passed the mouth of any man . . . His third lie which hath some affinity with the other two is of certain excellent orations he made . . . The second vice, wherewith I mean to touch him though in the first I have included perjury in something [*sic*] is that he is a most notorious drunkard and very seldom sober . . . thirdly I will prove him a buggerer of a boy . . . fifthly to show that the world never brought forth such a villainous monster, and for a parting blow to give him his full payment,

I will prove against him his most horrible and detestable blasphemy in denial of the divinity of Christ . . . that Joseph was a wittold [cuckhold] and the Blessed Virgin a whore. To conclude, he is a beast in all respects and in him no virtue found and no vice wanting.

As Mark Anderson noted in his book, no such crimes were ever proven and there's little reason to suspect these accusations to be anything but typical Elizabethan slander of the type Shakespeare satirized via constable Dogberry in *Much Ado About Nothing*: "Marry, sir, [the accused] have committed false report. Moreover, they have spoken untruths, secondarily, they are slanders, sixth and lastly they have belied a lady, thirdly they have verified unjust things, and to conclude, they are lying knaves.".

De Vere once addressed the slanders done him in a letter to his father-in-law, Burghley, by complaining that "the world is so cunning as of a shadow they can make a substance and of a likelihood a truth." In another letter, this one to his powerful brother-in-law Robert Cecil, de Vere added, "But I hope truth is subject to no prescription, for truth is truth though never so old, and time cannot make that false which was once true."

The slings and arrows didn't stop at de Vere's death, either. John Aubrey's seventeenth-century *Brief Lives* recorded a fictitious incident that would become synonymous with de Vere's name. "This Earle of Oxford," Aubrey wrote, "making of his low obeisance to Queen Elizabeth, happened to let a Fart, at which he was so abashed and ashamed that he went to Travell, 7 yeares. On his returne the Queen welcomed him home, and sayd, My Lord, I had forgott the Fart."

So it came to pass that a man obsessed with literature and immortality had his entire life reduced to a fart joke. Following Aubrey's low blow, de Vere was then allowed to rest in peace until 1920 when the American named Looney proclaimed "Will. Shake-speare" to have been the pseudonym used by the 17th Earl of Oxford. This in

turn inspired all sorts of fresh venom to be slung at de Vere, who, although trained as a lawyer when alive, was no longer in a position to represent himself.

With that in mind, allow me a moment to defend this much-maligned earl, who, although a renowned braggart in his day, never once laid the claim of Shakespeare upon his own shoulders while slaughtering his servants or molesting the livestock or sucking the blood of his enemies, and yet because the Stratford gospels had been attributed to him—rightly or wrongly—it seemed that de Vere's own country, for whom he shed blood and battled armadas, had now transformed their 17th Earl of Oxford into an Elizabethan cockroach.

Scholars used to be much kinder to de Vere. Back in 1916, C. W. Wallace described the earl as: "Himself a university man, musician, lyric poet, and dramatist, another Henry VIII in the love of such pleasures, he [de Vere] brought to the Blackfriars [theater] two kindred university spirits, George Peel and John Lyly, two wild and reckless young fellows like himself."

After stating that de Vere likely collaborated with Lyly, Wallace emphasized the importance of those Blackfriars comedies in creating the first modern five-act plays to "cut loose absolutely" from the old morality plays—morality not being de Vere's strong suit apparently. Such was de Vere's generosity that he even handed over the lease to that theater to his personal secretary John Lyly, the playwright scholars agreed most influenced Shakespeare's comedies. According to Anderson, de Vere also gifted a house to the composer William Byrd and reportedly handed over ten pounds, an enormous sum of money, to an Italian beggar simply because the ruffian had proclaimed that such a sum "would make a man out of me."

Another detail that made me soft on de Vere was his connection to the book *Cardanus Comforte*, a meditation on death known since the nineteenth century as "Hamlet's book." The Italian philosopher Girolamo Cardano penned *Cardanus Comforte* in 1542 as an alter-

native to killing himself. Since then, traditional scholars such as Francis Douce, Joseph Hunter, Lily Campbell, and Hardin Craig had pinpointed Cardano's book as the wellspring of Hamlet's soliloquies, something Dr. Campbell meant literally when she wrote, "I should like to believe that Hamlet was actually reading it or pretending to read it as he carried on his baiting of Polonius."

De Vere was twenty-three when he commissioned the English translation of *Cardanus Comforte*, and his introduction to that translation seemed almost to hint at a future masterpiece, or "monument," based on that work. Unaware that he himself would be buried in an unknown grave without any monument, de Vere wrote:

> Again we see if our friends be dead, we cannot show or declare our affection more than by erecting them of tombs: Whereby when they be dead in deed, yet make we them live, as it were, again through their monument. But with me behold it happeneth far better, for in your lifetime I shall erect you [the translator of *Cardanus*] such a monument that, as I say, [in] your lifetime, you shall see how noble a shadow of your virtuous life shall hereafter remain when you are dead and gone. And in your lifetime, again I say, I shall give you that monument . . .

None of which proved that de Vere was Hamlet, or wrote *Hamlet*, but perhaps we should be more forgiving to a man who gave us the book that sparked Hamlet's suicidal eloquence. Somebody once pointed out the evil men do lives after them while the good is interred with their bones, so be it with de Vere, I suppose, and if I didn't support his being crowned Shakespeare neither did I begrudge him for having lived such an adventurous and literate life that he stood thus accused. Say what you will about de Vere, he must, on occasion—such as when destroying all comers in the tiltyard after lounging the morning away in an orange taffeta tent beneath a tree painted gold to match his armor—have enjoyed the ownership of his too-human

body in ways unimaginable to the average witch-hunting academic. Love or hate him, de Vere was a true Elizabethan, one whose life is best summed up in a line of poetry sometimes attributed to him:

A day, a night, an hour of sweet content,
Is worth a world consumed in fretful care.

In his book about de Vere, Alan Nelson did make the point that none of de Vere's surviving letters or poems screamed of genius. The Oxfordians in turn argued that de Vere's mature work, aside from that published as "Will. Shake-speare," was systematically destroyed by intelligencers under the orders of Burghley and Son. Stated simply, nobody had ever unearthed a work of genius with de Vere's name stamped on it. Nor did we have an ad vivum painted portrait of Edward de Vere, only a seventeenth-century copy of a now lost circa-1575 portrait (artist unknown) that showed the earl posing beneath a wide-brimmed sugarloaf hat. A French cloak of gold braid (a proper dandy changed cloaks three times a day) was thrown over the left shoulder of a gold doublet uniquely tasseled at the wrist. Welbeck Abbey lent this portrait of de Vere to London's National Portrait Gallery back in 1964, and for as long as I kept tabs on it, that portrait remained hidden inside an NPG storehouse in Wimbledon in spite of great public interest in de Vere. Was the NPG worried that tourists might flock like maenads to this dashing portrait of de Vere instead of ogling over the greatly unbeloved Chandos?

While frowning into Nelson's *Monstrous Adversary* one evening, I got a call from Larry asking if I wanted to have dinner with his old friend Charles Beauclerk, who was the collateral descendant of Edward de Vere and heir to the title Duke of St. Albans. Beauclerk's book *Shakespeare's Lost Kingdom* was about to be published, and he was giving a reading at a bookstore in nearby Memphis. He and Larry were having dinner afterward.

Beauclerk, the current Earl of Buford, also had a reputation as a

rogue. In 1999 he had been banned from Westminster for life following a rowdy debate at the House of Lords. Nevertheless, Larry promised me I would like Charles, who was charming and witty and had been an excellent ambassador for the Oxfordians until quite recently when rumors about his forthcoming book, said to embrace some squalid theories about de Vere, had the Oxfordians turning on Charles like cornered rats.

"You want to join us for dinner?" Larry asked.

"You bet," I replied.

15

Hideous Kinky Shakespeare

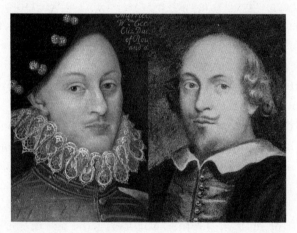

Left: The Welbeck portrait of Edward de Vere (on loan to the National Portrait Gallery, London). *Right*: The Hunt or Stratford portrait (Stratford Birthplace Trust; photograph from Friswell's 1864 *Life Portraits of Shakespeare*).

The good news was I had a girlfriend, a brilliant and beautiful poet who was the visiting writer at Ole Miss for a semester. I'd met Laurel while shooting pool at the Blind Pig during that window of Adderall rationing when the drug was actually working as intended. One morning, about a month after we'd met, she even wrote an amazing poem while camped out on my couch about a poor couple in love and the different ways they dealt with workaday worries. Nobody had ever written me a poem. I read it a hundred times and folded a copy into my wallet, just in case I needed it.

The firstborn daughter of a sonless general, Laurel had been raised to be a wingman and enjoyed downing Scotch with my crime-writer pals on the balcony bar at City Grocery. Oxford was thick with crime writers. On most days the town had more crime writers than it did criminals. Too good to be true, Laurel returned to D.C. on the same week my Adderall stash ran dry, at which point my brain hit a speed trap, blew its tires, pitched into a tar pit, and began sinking into a morass of dinosaur bones.

My first withdrawal symptom was a form of prosopagnosia in which I began vivisecting each new face I encountered into ear type, nose type, eyelid type, etc. I then had to stitch the face back together into a quilt. The amount of coffee and Red Bull I started consuming made me chatter away to myself in public. When I tried to research a portrait now it was with an index finger crawling under the print and drool dotting the page.

One day, puttering about in this fashion, I started boning up on the history of the Oxfordian movement when I came across an episode involving ghost sonnets that gave me pause. During the 1940s a prominent Oxfordian named Percy Allen had suffered a chain of calamities, including financial ruin, the loss of an eye, and the death of his twin brother. This being the age of spiritualism, Allen decided to consult a psychic, and not just any psychic but the famous Hester Dowden, the daughter of the Shakespearian scholar Edward Dowden. This was an intriguing choice, since Hester vehemently opposed all theories of alternative Shakespeares and had once kicked a Baconian out of her home. The Baconians, she proclaimed, had ruined her father's life.

Dowden's go-to method of communicating with the spirit world was to write in automatic script using three fingers of her left hand. In her seventies at the time, her clientele included the literary Wilde and James families as well as W. B. Yeats and Thomas Wolfe. She had repeatedly channeled Oscar Wilde, whose ghost helpfully explained to her how he used the flesh-and-blood eyes

of living people to read with and in this manner had read Joyce's *Ulysses*, which he described as a "great bulk of filth" and "heated vomit."

Percy Allen initially approached Dowden to communicate with his dead twin, but when that conversation turned to the authorship debate, Allen's dead brother promised to fetch Edward de Vere to their next séance. Once fetched, de Vere's amiable ghost confirmed he'd written the works of Shakespeare in collaboration with Francis Bacon and the Stratford businessman. Allen then changed the Oxfordian movement forever by asking de Vere's ghost if by chance he had, well, knocked up the queen.

An honest ghost, apparently, de Vere admitted to having impregnated the Queen of England with their love child, Henry Wriothesley, who would grow up to become the Fair Youth Earl of Southampton.

These conversations, which continued for years, eventually converted the medium Dowden to the Oxfordian camp. Meanwhile de Vere's ghost, ever helpful, suggested the best way to prove his identity might be to trot out a few choice sonnets. He was a bit rusty, he worried, but willing to give it a go. Everyone agreed this was a capital idea, and over the next few sessions Dowden channeled no fewer than four ghost sonnets, the last of which was transcribed by her three fingers in less than an hour and went like this:

> When from the star-strewn heavens I gaze around,
> And mark the narrow compass of the Earth,
> Small as an atom in the sunlight drowned—
> I marvel how within such narrow girth
> My love for thee found sustenance and space;
> The wine too close was housed, too small the cup;
> My precious draught o'erflowed the narrow place,
> Lost all its perfumed flavour, soon dried up.

Now has my love found her true path of grace;
Deep in thy soul she hides herself and me.
Here is no fear of time, of age no trace;
Forever of restraining fetters free—
So we enjoy the glory of the sun,
In sure affinity—for we are one.

Well, case closed you'd think, but did the Stratfordians admit defeat and shut down their Avon amusement park? No, reader, they did not. Cynical as ever, they even suggested the medium Dowden might have fabricated the sonnets in advance of the séance. Percy Allen suffered no such doubts. His Prince Tudor theory confirmed by firsthand testimony, Percy made the mistake of going public with his argument regarding the 3rd Earl of Southampton being the love child of Ed and Eliza. Following the publication of his occult research titled *Talks with Elizabethans*, Percy was forced to resign his post as president of the Shakespeare Fellowship. His Prince Tudor theory, by contrast, began to surge in popularity to the extent it would eventually hijack the original Oxfordian movement after being embraced, and financed, by an eccentric heiress in Mississippi.

When not researching the strange history of Shakespearean spiritualism, I sometimes found myself on hands and knees exploring all the crevices of my life where I might have dropped a stray Adderall and was rooting under my bed with a flashlight on the afternoon Larry pulled into the driveway and honked. I stood, uncrossed my eyes, and spilled into his front seat.

While Memphis bound, the two of us began discussing Charles Beauclerk's new book. Neither of us had yet read *Shakespeare's Lost Kingdom*, but Larry knew it embraced the Prince Tudor theory, which worried him, as he was an old-school Oxfordian. We also talked about the Hollywood biopic coming out soon about de Vere being Shakespeare. Larry was skeptical about that project as well, mostly because the movie, called *Anonymous*, was being directed

by Roland Emmerich, famous for UFO blockbusters and Mayan prophecies.

"I think Emmerich might be a little over his head on this one," he said.

At some point Larry mentioned that Emmerich had hired Beauclerk's girlfriend, Lisa Wilson, to co-direct a documentary about the authorship debate, but by then my mind had shut down again. I kept opening my mouth, forgetting what I had intended to say, and then closing it again, like a fish that needs feeding.

Once inside the strip-mall bookstore I was pleased to note Beauclerk resembled the Welbeck portrait of his ancestor. He had the same earlobes, auburn hair, and piercing eyes. After purchasing his books, we sat on folding chairs among dozens of elderly Oxfordians appearing waxy and pale beneath the fluorescent lighting. Charles, by contrast, looked buoyant and bright, his pitch charismatic, his new hardback slickly produced by Grove Press with eighteen color plates. How I loved colored plates! While admiring them, I came upon an old friend, the Gheeraerts picture of a pregnant Diana petting a doomed deer above a melancholy sonnet. I was showing that plate to Larry when Beauclerk took the podium.

The founder of the De Vere Society and a former president of the Shakespeare Oxford Society, Charles was the very face of the Oxfordian movement, so it was interesting to watch his audience sit enrapt as Charles, their hero, took up his brushes and began to paint for them the ugliest swan ever conspired upon humanity—even I was left stung. He did this by fusing together two sordid theories about Edward de Vere. The first was the Prince Tudor fling in which Elizabeth and Edward were the parents of the 3rd Earl of Southampton. The second theory Beauclerk had embraced, originally put forth by Paul Streitz, was known as the Baby Tudor theory and it argued that Princess Elizabeth, at age fifteen, had secretly given birth to Edward de Vere, whose father had been the soon-to-be-beheaded Tom Seymour.

Both these theories had been floating around Oxfordian circles

for decades, but Beauclerk had sewed them into a singular plotline in which de Vere, the child of Elizabeth and Tom Seymour, was cuckolded as an infant into the Oxford clan and grew up to unwittingly impregnate his own mother the queen, resulting in the birth of Henry Wriothesley, who was likewise cuckolded into the Southampton clan and became their third earl as well as the Fair Youth of the sonnets penned by his father-brother Edward de Vere.

"Questions?" Charles asked the crowd with a sardonic grin.

Although his audience didn't seem disturbed by these theories, I couldn't help but feel sorry for de Vere. First the fart story, and now this? Following the book-signing ritual, the three of us escaped to an Italian restaurant islanded in the parking lot of the strip mall. Not used to dining with earls, I found myself a bit nervous regarding my use of cutlery. And when the waiter distributed finger bowls I had to resist the urge to slurp mine down, which, to my thinking (having been raised on *Monty Python* and *National Lampoon*) would have been hilarious.

Our table conversation soon turned to a book called *The Courtier* that had been written in 1528 by an Italian count named Castiglione. This book of manners, when translated into English, would have a profound effect on Elizabeth's court by creating the zeitgeist trapdoor out of which Shakespeare's characters emerged, ruminated, murdered, suffered, then killed themselves or got married.

"O flesh, flesh, how art thou fishified!"

That's Mercutio describing his friend Romeo. The wiliest character in that tragedy, Mercutio knows his friend has been *fishified* by the pseudo-religious practice of courtly love, an unfortunate cult started in the eleventh century by French troubadours who prescribed a poetic passion toward an unattainable woman as a spiritual tonic (*ahem*). Long before Shakespeare was born, this cult had swept through Europe and transformed the manly knight of lore into a lisping, traipsing peacock. This effeminizing disease (Romeo's words, not mine) was so endemic that a self-help book was deemed necessary to restore testosterone to court. That task fell to Count Castiglione.

Here's how Castiglione described the "fishified" new-school courtiers both he and Shakespeare despised:

> I don't want him to appear soft and feminine as so many try to do, when they not only curl their hair and pluck their eyebrows but also preen themselves like the most wanton and dissolute creatures imaginable . . . Since Nature has not in fact made them the ladies they want to seem to be, they should be treated not as honest women but as common whores and be driven out from all gentlemanly society, let alone the Courts of the great lords.

Castiglione also lamented the lost art of *braggadocio*, which he believed should be delivered with a spontaneous nonchalance known as *sprezzatura*. The ideal courtier should recall, for example, a lance being driven through his leg as resembling a fly's sting. When Mercutio bleeds to death while comparing his wound to a cat scratch, he is personifying sprezzatura. Other braggarts in Fair Verona prove less skillful. For example, the play opens upon a goon named Sampson recalling the joys of raping Montague women. Sampson, who claims to own an endowment worthy of his name, vows "Me they shall feel while I am able to stand, and 'tis known I am a pretty piece of flesh."

So, um, welcome to *Romeo & Juliet*, boys and girls. Enter, by way of contrast, our boy Romeo decked out in French slops and spewing sonnets. Now spitting sonnets was cool to Castiglione—that is, if they were spat with sprezzatura. Castiglione's courtiers were expected to distinguish themselves by spontaneous—and never premeditated—displays of wit. Under Queen Elizabeth such displays became a spectator sport, which explains why throughout the play *Romeo & Juliet* almost every conversation turns into a wit battle filled with filthy puns and allusions. No sooner do the star-crossed lovers meet then they throw down in a rhyme battle that takes the form of a shared sonnet. This freestyle contest ends in a kiss, one of the few wit battles in which there is no winner. They both lose.

It was this conversation about courtly manners that, ironically, caused me to make my first social blunder that evening. Charles had been describing how de Vere had paid for the translation of Castiglione's book when I adroitly corrected him by saying, "You mean *Cardanus Comforte*, right? Isn't that's the book de Vere had translated?"

Noticing my wineglass was empty, I refilled it from the bottle Charles had ordered.

"Actually, de Vere paid for both books," Charles said in his gracious manner.

I was saved further errors by the arrival of our food. I studied Beauclerk's use of his finger bowl, then sighed and dug into my linguini as my brain sank deeper into its tar pit.

Eventually the talk turned to Roland Emmerich's movie when Charles mentioned that *Anonymous* would incorporate the same incestuous plotline put forth in his book. I dropped my fork right as Larry shot me a horror-filled glance. We didn't have to be discreet. Beauclerk knew he was treading on sacred ground. Here the Oxfordians were finally achieving respectability—their tribe had infiltrated academia and even the justices of the Supreme Court had split on whether de Vere wrote Shakespeare—and now this Shakespeare-as-motherfucker movie would be used to ridicule the entire movement.

Larry was mortified, I was amused, Charles was charming. It all made for an entertaining dinner throughout which I kept studying Beauclerk's earlobes, nostrils, and eyelids. He was impossible not to like, and when the bill came I happily reached for my wallet.

Larry and I drove home through a procession of thunderstorms. Unlike me, Larry had come away from the evening under the impression Beauclerk might get me hired as a consultant on the documentary his girlfriend Lisa Wilson was co-directing for Emmerich. That documentary dealt with a controversial portrait known as the Ashbourne. Larry was trying to decide the consulting fees I should charge Emmerich, but I wasn't nearly as optimistic.

Besides, I explained to Larry, I didn't know that much about the Ashbourne portrait.

"What? You don't know the Ashbourne?" Larry asked.

"I know about it," I said. "It's just been a while since I looked into it—and, you know, the Ashbourne's kinda a bottomless pit. Plus, it's already been written about extensively by, uh . . ."

"Barbara Burris."

"Right, her."

The rain kept getting harder. Cars were pulled over under bridges.

"Hey Larry," I asked, "was it you who told me that some Oxfordians believe King James had de Vere murdered?"

"Probably," he replied as he rolled his eyes. "There's all sorts of theories about how he died or didn't die. Some Oxfordians think de Vere was murdered, some think he was banished to an island where he wrote *The Tempest*."

"*Huh*," I replied.

As soon as Larry dropped me off, I dashed inside to brave the keyboard and study up on the Ashbourne portrait in case Hollywood came calling. After opening that folder, I was surprised to find so many jpegs of the portrait in different stages of distress and restoration. I had obviously spent months collecting these photos but, again, had no memory of doing so. I selected one from the Ashbourne's glory days in *Life* magazine, and the moment I saw that image the slot machine in my brain locked into place showing three blue-eyed Macbeths.

"Sir John Parker," I said, pointing at the photograph.

16

Storm Still Shakespeare

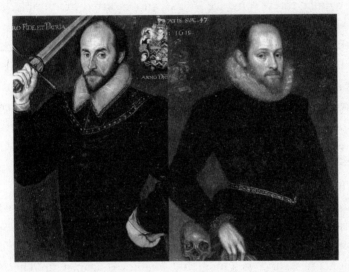

Left: *Sir John Parker*, artist unknown, 1589 (Royal Collection Trust / © Her Majesty Queen Elizabeth II 2021). *Right*: The controversial Ashbourne portrait, artist and date unclear (Folger Shakespeare Library).

As a chain of thunderstorms moved overhead, my eyes slithered back and forth, portrait to portrait. On my right, the *Life* magazine Ashbourne posing with sonnets and Yorick's skull. On my left, my handpicked Macbeth, its artist's signature frozen, tentatively, in the bottom-right corner. The two sitters looked strikingly similar, I felt, but did they really, or was this just another paltry case of confirmation bias? Back and forth my eyes went.

"Yes, they look alike," I decided.

"Or do they?" I challenged myself in Richard III manner.

I am a villain. Yet I lie, I am not. I shall despair.

Then, on a whim, I compared the Ashbourne to my would-be Prospero portrait, and once again the similarities struck me hard. Back and forth my eyes went. Were they all the same overpainted courtier? Could they all be Edward de Vere?

Eventually I retrieved my flashlight and started searching under the bed again. Not finding any answers there, I resorted to Red Bull and tequila, threw some ice into it, and escorted my tumbler onto the back porch, crawled into the Jacuzzi, and sipped my drink beneath the tin roof, flinching every time lightning split the night to reveal the turquoise swimming pool. As I sat there sipping that terrible drink, a part of me, I began to realize, actually wanted lightning to strike the pool. Was there a lobe in the human brain that cheered on the spectacularly catastrophic? As a child hadn't I attempted to lure each new Gulf hurricane toward my hometown?

"Show me the magic," I whispered to the lightning, daring it down.

Instead of striking me dead, the lightning flickered away while the rain increased. I sighed, set the Jacuzzi on full boil, and sunk downward until only my head floated above the water. Mulling over my loneliness, and weighing that loneliness against my checking account, I decided money-be-damned I was going to visit Laurel in D.C. While there I'd also be able to visit the Folger Shakespeare Library and curtsy before the Ashbourne.

All those years I had shunned the Ashbourne portrait. Why? Was there some confirmation bias even in that neglect? In my heart did I not want Edward de Vere to have written Shakespeare? Or maybe I just didn't fancy the Ashbourne sitter? Was he too refined for my taste, too elite, too handsome? Did I not want to admit that my theory had been wrong all along and that Shakespeare was beautiful?

The ginger prince of Shakespeare portraits, the Ashbourne had for decades presided over the Founders' Room in the Folger Library.

Distracted and ultra-aristocratic, but in no way disagreeable, its sitter stood outfitted in what appeared to be a black velvet doublet with ruffled sleeves, the long, delicate fingers of his right hand clasping a gold-plated book—sonnets, obviously. From the left hand, its signet ring turned toward the camera, dangled a glove—likely perfumed and very unlikely to have been cut by this man's father.

Everything about the Ashbourne spat in the face of the Stratford everyman myth. How in hell could anyone think, even for a moment, that this sitter had been raised milking cows in some dung-filled barn? "Here is a nobleman," the portrait sang, and in fact even that dangling glove motif in English portraits had been created to distinguish rank from riffraff: only noblemen posed in that manner. The sitter's face was ethereal, almost regal, as if he were mulling over a line of iambic pentameter or searching for an elusive rhyme.

And yet the Ashbourne sitter clearly had a dark side, too.

It was in 1940 that the paparazzi had caught the Ashbourne sitter with his pants down. Whereas it's true we encourage a little monkey business from our great artists, the behavior of the Ashbourne, captured in photographs and broadcast to a global audience, went beyond anything that could be forgiven by a paying public. This scandal had begun in 1937 when the Folger allowed a gadfly Oxfordian scholar named Charles Wisner Barrell to examine their portrait via the newfangled technologies of X-ray and infrared light. Mr. Barrell hauled in his occult equipment, pierced the portrait's carapace, and then published his conclusions in the pages of *Scientific American*. According to that respected magazine, what lurked beneath the Ashbourne's shell was a creature so hideous that the saga of Shakespeare could scarce be taught in school anymore short of whispering, "Here, children, this is Shakespeare, our greatest artist. If anyone resembling him ever offers you candy . . ."

This Grendel beneath the paint had been known to villagers by the hushed name "the Black Prince." Aye, the Midnight Earl (points of the cross), Edward de Vere, who slept with boys, copulated with ponies, drank blood, farted at queens, and slaughtered servants for

sport. Bolt the doors. Hang the garlic. So it had come to this: Shakespeare, our planet's greatest ambassador, now stood accused of being the one man everybody agreed he should not be, Count de Vere.

Following Barrell's coup, with those headlines still reverberating around the world, London's tourist industry, suddenly finding itself in peril, decided a countermeasure was required, and, following a series of gongs sounding across the Atlantic, the Stratford Armada began to trundle toward the Potomac. The Ashbourne sitter, still searching for that rhyme, had no idea how badly he was about to be vilified.

Inside the pages of *Scientific American*, Barrell had identified the legendary pedophile beneath his trench coat of overpaint via the discovery of the earl's heraldic beast, the boar, embossed, Barrell claimed, on the signet ring. Those same radiographs also revealed the initials CK fashioned in the style of a known monogram from the Dutch painter Cornelis Ketel. In his article, Barrell had cited a letter by Ketel's biographer that proved Ketel had indeed painted de Vere. Barrell then pointed out that the Ashbourne had likely resided for decades at Wentworth Woodhouse in South Yorkshire, where a 1695 will mentioned a portrait of "the earl of Oxford my wife's great grand-father at [full] length."

In 1721 that de Vere portrait was again noted by the antiquarian George Vertue, but by 1782 this framed picture had vanished; yet that year's inventory recorded a new portrait now hung in the main dining hall: an unframed three-quarter-length Will Shakespeare. De Vere full-length with frame disappears, Shakespeare three-quarter-length unframed appears, and all this taking place some thirty-five miles from where the Ashbourne would be discovered.

It was hard to fault Barrell's logic here, I felt, especially since the Folger itself had recorded the Ashbourne as owning no original edges, meaning the picture had been cut down in size at some point. So how was Barrell's article received by that research library? Did

the Folger's staff dispute his facts, sources, or logic? Or did they insinuate Barrell was a liar and a con man? Well, yes, the latter, and in doing so the Folger messed with the wrong gadfly.

According to Barbara Burris, a legendary Oxfordian who published a series of articles exploring the Ashbourne in the newsletter *Shakespeare Matters,* it was the Folger's director Dr. Giles Dawson who stated in a letter that Barrell must have "doctored up" his test results in regard to the CK initials he'd discovered under the paint. Barrell responded to this accusation by suing the library for libel.

Decades would pass before William Pressly, who helped oversee the Folger's 1988 restoration of the Ashbourne (and later cataloged their portraits for Yale University Press), would allow those CK initials had been visible in Barrell's X-rays and also in a subsequent set of X-rays commissioned by the Folger in the wake of Barrell's tests. Yet previously, Pressly had stated that the CK initials were not visible on the second set of X-rays. And Pressly wasn't the only expert who tried to discredit the CK monogram. A Folger-hired restorer named Peter Michaels, who we will soon discuss in grisly detail, speculated that the monogram was a mere illusion created by "a defect or a worn stripping on the canvas."

Scientific American put a foot through Michaels's theory when its editor, Fred McHugh, wrote, "An illusion? A defect in the canvas? It is neither. The hard fact is that the monogram did show at the point Barrell said it did, adjoining the shield, as our *Scientific American* reproductions prove."

The editor then continued to upbraid the Folger:

> Further, it [the monogram] could not possibly have been an accidental "show up" of flaws in the canvas, for no one, seeing the original pictures as I did and studying them in close range during a three-hour presentation by Barrell as I did, could conceive of such a juxtaposition of atoms, molecules, of whole canvas fibers as would make an "accidental," perfectly outlined, artistically de-

signed CK monogram as reproduced in the *Scientific American* half-tones . . . no conjectures of assumptions can write off C. W. Barrell's original monogram "CK," for I saw it clearly in the original X-ray pictures, and it was not—repeat not—a re-touch job!

Not bothering to hide his exasperation, McHugh reiterated the monogram had been "perfectly outlined" and "artistically designed." In the end, the Folger avoided a lawsuit by issuing a public apology to Barrell.

Left: "CK" monogram discovered in Charles Wisner Barrell's X-ray of the Ashbourne portrait. *Right*: Known monograms of the painter Cornelis Ketel. These images first appeared in Barrell's January 1940 *Scientific American* article (*Scientific American*, January 1940).

At this point the Folger was left with no choice but to concede their portrait had been painted by Ketel. Just kidding. No, after stating the initials had turned up in both sets of X-rays, the Folger's go-to man, Pressly, weaved an astonishing theory about the monogram. After finally conceding that both sets of X-rays did reveal the initials CK (cough, cough, fidget, fidget), Pressly then recalled—oh snap!—that the Ashbourne had once belonged to the Reverend Clement Kingston, who had bought the portrait at an art

market in 1847. Pressly speculated, in print, that Kingston had over-painted the picture to fool the public into believing it Shakespeare, but after the counterfeiting was done, the reverend "could not resist initialing his handiwork."

Wait—it gets better!—and it was only after signing his CK initials onto his forgery that the reverend realized—oh double snap!—this was a less-than-brilliant move for a con man and decided to overpaint his initials. It was implied but not stated that the reverend just happened to sign his initials in a style quite similar to the known monograms of Cornelis Ketel.

Later that week Lisa Wilson, the co-director of Emmerich's Oxfordian documentary, called me on Skype and we talked about her documentary. Lisa seemed unquestionably sane and had a great sense of humor. As to the Ashbourne, she knew the portrait inside-out and certainly didn't need to consult me about it. On the day we first spoke, she had just returned to London from D.C., where her documentary crew had been turned away by the Folger. The library had also declined to be interviewed on its research regarding the Ashbourne.

As my own trip to D.C. approached, I kept calling Lisa with questions. One night, just as we were about to hang up, her voice changed as she urged me to be careful in Washington.

"Careful?" said I.

She paused, sighed, then asked if I knew about the . . . well . . . the murder.

"Murder?" I said.

"Yes. The . . . Ashbourne murder," she clarified with a resigned lilt.

"The Ashbourne murder?" I repeated.

Following another sigh, Lisa explained that back in 1982 the conservator Peter Michaels had been murdered while restoring the Ashbourne portrait inside his home. This was the same restorer who once gave a lecture to the Shakespeare Oxford Society in which he explained in detail the methods that should be used in a restoration

of the Ashbourne. A few years later, as fate would have it, Michaels had been hired by the Folger to restore the Ashbourne. During the restoration that ensued, Michaels had repeatedly disagreed with the Folger's director and insisted on returning the portrait to its original state by removing all the overpaint. This restoration ended when Michaels was discovered murdered inside the Baltimore home he shared with the portrait.

"Did the Ashbourne do it?" I asked Lisa.

She laughed and said she didn't know any details, but that murder had caused the portrait to go into seclusion for fourteen years before suddenly reappearing in the Founders' Room in the Folger.

"Wait a minute," I said. "So, when you're telling me to be careful in D.C., you mean, like, be careful I don't get . . ."

She laughed nervously.

I laughed nervously.

"By the way," she added, "I know this other researcher. He seems okay—I don't know him that well. He thinks the Ashbourne's been switched."

"Switched?" said I.

"*Uh-huh.* He thinks that the portrait now on display isn't the original."

After clearing my throat, I told Lisa about the Flower portrait and the German accusations of high switchery in Stratford. It wasn't that Lisa and I believed these conspiracies, it was that we didn't disbelieve them as much as we wanted to.

Intrigued by all this, I called up my crime-writer friend Ace Atkins and asked him to meet me for a beer at City Grocery.

"I'm buying," I told him.

We met at the balcony bar, where I endured his bone-crushing handshake. A photograph of Ace standing over a crumpled quarterback had once graced the cover of *Sports Illustrated* back when Ace played linebacker for the undefeated Auburn Tigers. Ace still looked formidable, muscled and handsome in a hardboiled way, but Ace was far too nice a guy to be a private dick. He just wrote about

them. In a town thick with writers, Ace had probably sold more books than anybody since John Grisham.

I bought a round and told Ace about the Ashbourne. At the mention of murder, his eyebrows perked up and he asked if I wanted him to look into it.

"I get paid in beer," he added.

I scrawled down what few details I knew about the murder onto a bar napkin. Then, after Ace left the bar with that napkin in his shirt pocket, I continued drinking alone and eventually wound my way onto the Ole Miss campus to gaze up at its sexy portrait of Gertrude C. Ford writing her enigmatic love poem about de Vere and Elizabeth. I'd been visiting Gertrude a lot lately and occasionally considered stealing her portrait. There were no surveillance cameras I could detect. But I put off my heist for the time being and wove my way home, where I mixed a drink I'd invented some twenty-five years earlier during my first stint bartending. I'd named the drink a Hawaiian tree climber, but it was essentially a Long Island iced tea with a splash of piña colada mix instead of Coke, and some Grenadine floated on top. I escorted this drink into the backyard garden, which my mind imbibed into a petting zoo of sendaks. But these sendaks looked different, less cuddly. Some of them even had fangs. An hour later I was still sitting in the increasingly malevolent backyard when I spotted him crouched in the darkening crown of a pecan tree, the most animated sendak I had ever seen, cross-eyed and grinning down at me like a cock-headed Cheshire.

After all these years he'd finally found me in my tower of discontent.

"Cheers, Trixie," I said, and raised my glass.

17

Marvelous Heinous Shakespeare

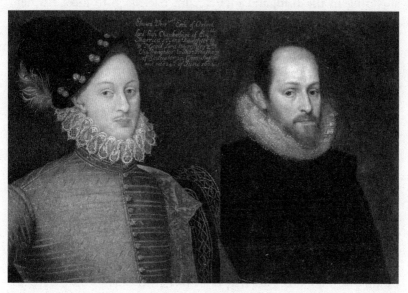

Left: The Welbeck portrait of Edward de Vere (National Portrait Gallery, London). *Right*: The controversial Ashbourne portrait (Folger Shakespeare Library).

Early one morning, a trifle hungover, I phoned Laurel to give her the arrival date for my flight to D.C. Toward the end of our conversation, she mentioned she had a surprise for me.

"Big Boi's going to be in town. I got us tickets."

"No way," I shrieked.

My excitement proved short-lived. The moment we hung up, I glanced down at my scruffy Stan Smiths and realized I would disgrace myself in front of Big Boi at the 9:30 Club. Sure, hanging out

with the legendary OutKast MC seemed unlikely, but I'd once taken my son to a Talib Kweli show in Burlington and the two of us had ended up chilling with Kweli in his dressing room. Hayden was the youngest person in the arena that night while I was easily the oldest. Lucky for us, the DJ noticed Hayden hanging Kilroy-style onto the stage. After the show, with the two of us hovering outside hoping to score an autograph—we were huge fans of Kweli's new album *The Beautiful Struggle*—the DJ stepped out for a smoke, spotted Hayden shivering in the cold, and invited him backstage to meet his hero Kweli, who was incredibly kind and conversed amiably with Hayden for ten minutes while ignoring the throng of beautiful women surrounding his throne.

I put on OutKast's *Aquemini* and began shopping for some respectable shoes. Hours later I homed in on a pair of commemorative Reebok Pumps, gold with white leather insets and green camouflage uppers, the peace-sign monogram offset by a bullet-clip lace divider. I ordered the sneakers to be shipped directly to Laurel's apartment and prayed they would arrive in time.

That done, I decided to do some digging into Charles Beauclerk's "Baby Tudor" theory. Could it be true that England's Virgin Queen had given birth at age fifteen? Few British historians have lingered over Elizabeth's rumored affair with Admiral Tom Seymour, but one book that had not bokashied Seymour, at least not entirely, was Alison Plowden's *The Young Elizabeth*. In it, the author had even described the Seymour scandal as "the first and in some ways the most momentous crisis of her life."

The most momentous crisis of Elizabeth's life? My God, her mother had been slut-shamed to the chop block by her own father. How could a supposed crush on an older man, as this "romance" was typically described, compete with a headless mother?

Inside Plowden's history, mostly a hagiography, I learned that Admiral Seymour had first proposed to Elizabeth when the princess was a mere twelve years old and residing in the Chelsea household of Catherine Parr, the dowager queen of Elizabeth's father,

Henry VIII. When Elizabeth rejected Seymour, via a precocious Dear John letter, the admiral married Catherine Parr instead and moved into their household and started turning up in Elizabeth's bedchamber at odd hours, where he enjoyed pulling the sheets off the young princess and fondling her rump in an "unseemly" manner.

Huh, I thought and turned another page.

Even Kat Ashley, Elizabeth's most loyal servant, confirmed that on one afternoon Seymour had used a knife to slash the black gown Elizabeth was wearing "into a hundred pieces," a bit of S&M fun made kinkier yet by the participation of Catherine Parr, who had held Elizabeth's arms while Seymour slashed the child's gown. In another risqué incident, Ashley described how she'd been forced to intervene after catching Seymour in bed with the princess.

Seymour's downfall began the day his new wife, Catherine, now pregnant, discovered him and the nubile Elizabeth in each other's arms. We don't know what this scene was rated, only that it inspired Parr to cry out for her servants. The two women fell out, and Elizabeth was later shipped to the home of Kat Ashley's sister in the Denny household in secluded Cheshunt. During the nearly five months Elizabeth spent reclused there, she was reported to have fallen ill. Plowden described this long "period of ill-health" as mysterious. It began, according to Ashley, "about mid-summer" but by autumn had worsened to the point the king's physician, a certain "Dr. Bill," was dispatched to attend the princess.

With so many servants about, the inevitable gossip of Elizabeth's "lewd demeanour" began to run wild. A certain Lady Jane Dormer, whose words were recorded by her biographer Henry Clifford, stated that a bastard child was "a chief cause the parliament condemned the Admiral [Seymour]." Dormer described how a blindfolded midwife had been led into a candlelit bedroom of a "very fair [high-bred] young lady. There was a muttering of the Admiral and this lady, who was then between fifteen and sixteen years of age . . . The reason why I write this is to answer the voice of my countrymen in so strangely exalting the lady Elizabeth . . ."

Besieged by Seymour's arrest and the incarceration of her servants, Elizabeth, at her wits' end, decided to take the drastic step of writing to the Lord Protector Somerset, who stood between Elizabeth and her young half brother, King Edward VI. In these two remarkable letters, in which she protested against the accusations she was "with Childe, by my Lord Admiral," Elizabeth was careful never to deny she had given birth to Seymour's child but instead insisted she *was not currently pregnant* and asked to prove this by being allowed to appear at court. Since both letters were written from Hatfield Palace after her sequestering period at Cheshunt had ended, such an appearance would have accomplished nothing, and anyway the request was denied.

In her second letter, Elizabeth even implored the Lord Protector to pass a law that would make gossip about the Seymour scandal a crime. That a daughter of Henry VIII would acknowledge rumors of pregnancy in writing can only be understood as an act of desperation. The investigation into Elizabeth's collusion, pregnancy, and secret marriage fell under the category of treason. Before it was all over at least one head would roll. Elizabeth very much wanted that head not to be her own.

Lord Robert Tyrwhitt was placed in charge of the royal investigation. On the day he arrived to begin his duties, Elizabeth's cofferer, Thomas Parry, reportedly ran into his own quarters, removed all his jewelry, and told his wife he should never have been born. Tyrwhitt's verdict was not ambiguous: "I do verily believe that there hath been some secret promise between my Lady [Elizabeth], Mistress Ashley, and the cofferer never to confess to death . . . I do see it in her [Elizabeth's] face that she is guilty . . ."

During his investigation, Tyrwhitt was unable to question Catherine Parr, who had died less than a week after giving birth to Seymour's daughter. Not long for mourning, the admiral soon sent Elizabeth a message that seemed to me impossible. This message, delivered by his kinsman John Seymour, had inquired of the princess "whether her great buttocks were grown any less or no?"

Let's pause a moment here. Princess Elizabeth was first in line to the throne among Protestant contenders, yet Tom Seymour had the gall to poke fun at the size of her "great buttocks," those same buttocks he was so fond of fondling? How to make sense of that message? To begin, the word *great* was then synonymous with pregnancy, witness a letter written by Elizabeth just months earlier referring to Parr as "great with child." (The glossary *Shakespeare's Words*, prefaced by Stanley Wells, listed "pregnant" as one of the definitions of *great*.) Only in that context did Seymour's question begin to make sense.

More evidence of a royal birth can be found in the strange behavior of Kat Ashley, who began trying to arrange a marriage between the princess and the admiral. Previously Ashley had despised Seymour, but now she was his champion. Plowden could only speculate that Kat had become smitten with the famous rake, but, again, the need for such an unlikely marriage made perfect sense if Elizabeth had given birth to Seymour's child.

Tom Seymour soon began minting money and corralling soldiers in preparation for a royal coup—or so went the official account of his downfall. Although documents recorded that Seymour was arrested one night at Hampton Court during an attempt to kidnap King Edward VI, we don't know if that story was any more or less accurate than Lady Dormer's tale of a midwife delivering Seymour's bastard. Both stories ended the same way, with Seymour's head lopped off. Lucky for Elizabeth, Seymour was denied a trial that might have ended any hope of her becoming England's queen, virgin or otherwise.

Before being denied that trial, Seymour was leveled with thirty-three charges ranging from "High Treason" to "Great Falsehoods" to "Marvelous Heinous Misdeameanours." The most marvelous of these misdemeanors was shooting dead the Boy King's pet dog during the kidnap attempt. Did that actually happen? Did Seymour think it wise to silence a yapping doggie by discharging a flintlock pistol that would have awakened the entire household? Anything's

possible, I suppose, but the accusation of puppy slaughter did conveniently serve to demonize Seymour, who until that night had been extremely popular throughout London.

In what Tom Nashe liked to call "neck verses," traitors almost always swore loyalty to their king before being beheaded. Seymour chose an exit more in line with Mercutio's house-poxing speech. Although Seymour was said to have taken the ax bravely, he was also described by a priest as having died "dangerously, irksomely, and horribly."

Following his execution, Elizabeth, still a child, began a long period of rehabilitation that would include the political deification of herself as a Protestant Virgin Mary. British historians, always eager to help, did their best to erase from history the Seymour scandal that undercut a beloved fairy tale about a virgin queen who married herself to an island in the sea.

Elizabeth continued to collect Seymour's portraits all her life. The writer David Starkey once pointed out, "Almost all of the men that she subsequently loved, or pretended to love, resembled Seymour."

A week before my flight to D.C., I got a call from Laurel to let me know that her father, the general, was currently in Memphis for a conference and had decided to sightsee Oxford the next day.

"The two of you could meet up for a drink," she suggested.

"*Hmm*," I replied.

"No pressure," she added.

I wasn't excited about the idea. The general, I knew, had once served in military intelligence, which made me suspect he might already be spying on me through my television set. But in the end I steeled my nerves and phoned the general and asked if he'd care to meet for a beer at Ajax Diner.

I arrived early at the diner the following evening and ordered a Larry Brown, killed the tequila, then hid the shot glass. When I told Phil, the bartender, why I was there, he laughed and said, "Well, this'll be fun to watch." A few waitresses I knew were drinking at

the far end of the bar—staff beers only cost a buck at Ajax—and Phil must have told them the news because pretty soon they were all grinning at me.

I held out my palm so they could see it trembling.

"You must be Lee," the general said.

He looked young for a retired general. As my mind began jig-sawing his facial features, we shook hands and began to chat about William Faulkner, of all things. After checking to make sure the general was not packing heat, I told him I was a big fan of the short stories and hoped someday to finish *Absalom, Absalom!*

He asked about my portraits, and we touched on that subject before moving on to his own eccentric hobby of collecting guitars originally owned by rock stars now dead. It occurred to me that if portraits could be possessed by the dead then guitars probably could, too. The evening went well, I thought, and when I picked up the tab, Phil gave me a discreet thumbs-up.

A few days later Larry drove me to the airport in Memphis to catch my flight.

"Don't get murdered," he joked when he dropped me off.

"Ha ha ha," I replied.

18

Soulless Shakespeare

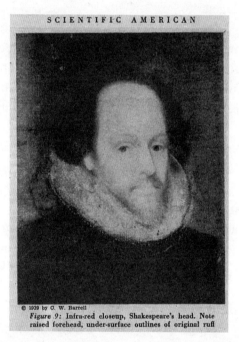

Figure 9: Infra-red closeup, Shakespeare's head. Note raised forehead, under-surface outlines of original ruff

Infrared detail appears to reveal the outline of the Ashbourne's original collar (Charles Wisner Barrell, *Scientific American*, 1940).

Laurel met me at the airport looking lovely with long brown hair and giant brown eyes. Since her knowledge of poetry did not extend to dirty-south hip-hop, it's possible she did not fully appreciate the joy I experienced upon finding my Reebok Pumps awaiting me in her tiny sixth-floor studio overlooking the National Cathedral. I put the sneakers on—Laurel's wince was discreet—and

we hit the town, where I soon forgot about any secret-society assassins the Folger might have dispatched with silencers. Or at least I forgot about them until we were seated inside a Mexican restaurant with a chalkboard list of designer tequilas. At some point inside this blur of añejo, Laurel told me to look around the restaurant, which I did, then she smiled wickedly and whispered, *Everyone here is a spy.*

I searched the room until I came full circle into her eyes.

"Seriously, they're all spies," she said. "In this part of town everybody's in intelligence."

Although she was teasing me—she knew my instilled Elizabethan fear of intelligence agencies—I couldn't help but glance around again to pinpoint the assassin who would slip polonium into my beaker of tequila. Then I shrugged and knocked back my shot. There were far worse ways to go than drinking tequila with a beautiful poet.

The next morning I awoke to a polonium-grade hangover. Today I would finally meet my Wanted wall of drinking buddies, who would likely be every bit as hungover as I was. How perfect, I thought as I struggled out of bed.

After Laurel dropped me off at the Folger, I entered through its gift shop, which carried all things Shakespeare, most notably a bright rack of T-shirts stating, "I Think Shakespeare Wrote Shakespeare!" Well, that's helpful, I thought as I wheelchaired my headache around the displays of postcards, tote bags, mugs, and books. The Cobbe starlet was everywhere—I kept flipping him off—but the disgraced Flower, to my surprise, still exerted a presence in the gift shop. The Ashbourne was nowhere to be found—not a single coffee mug. The Chandos popped up once or twice, and we commiserated on our hangovers.

But where, I wondered, was the library part of the library?

My headache kept getting worse, which caused my stomach to rumble like an approaching storm as I leaned against the sales counter, fought back a belch, and asked the gift-shop lady, "Excuse me, but, um, where's, like, the book part of the library?"

It was here I learned the library itself was closed to the general public and that in order to enter the "library library"—as she described it—you had to apply for a scholar's pass months in advance. Such passes were generally restricted to PhD candidates.

"Are you a PhD candidate?" she asked, glancing down at my shoes.

By then I had a hand clamped over my forehead, which was pounding away like a slowly dribbled basketball in an empty gymnasium. I managed to thank her before staggering outside and throwing up in the Folger's authentic Elizabethan garden. A half hour later, somewhat recovered, I sat on the front steps of the library and pecked out an email to Erin Blake, the helpful Special Collections curator I'd been corresponding with for years. I wasn't sure how Erin felt about me—well, I had a pretty good idea how she felt about me—but at least we'd always remained cordial. I explained my situation and asked for help in getting a scholar's pass. Then I hit the send button and sat there trapped inside the bell tower of my hangover.

An hour later I was still sitting there trying to decide how I was going to frame my incompetence to Laurel. Had I still had my Adderall prescription I would have had three scholar passes plus a bow tie and a pen guard. The thought came to me that I could sneak into the library to at least say hello to my painted comrades. What were a bunch of librarians going to do if they caught me? Murder me? I tested my legs, my gut, my ability to speak, then wandered oh so innocently through the gift shop and slipped down a nearby corridor. Passing an office, I spotted the Staunton portrait hung inside it. The sight of that wan, vampiric swan made me smile. I waved and continued spying into the offices until a woman with short dark hair tapped my shoulder.

"You must be Lee," she said and introduced herself as Erin Blake.

My first impression was that Erin did not appear the type to hire a hit man. She had a pleasant face and a nervous smile, pleasant because that was her nature, nervous because I'd been making her job miserable for years. But Erin also knew me to be the rare intimate of

a portrait collection she also loved. In that spirit she gave me a quick tour of the outer library that ended in the Founders' Room, where a lone portrait dominated the far wall. My brain immediately went to work vivisecting its face.

Holy hell, it was the Ashbourne.

Except it looked . . . different. Like, very different.

Erin and I stood there gazing up at it like the children of Fatima. Like those children, I could make no sense of what I was beholding. The portrait appeared starkly at odds with the Folger-provided high-res photograph I'd been studying on their website for weeks now. That photograph, taken after the Ashbourne's most recent conservation in 1988, looked as if a charwoman had taken steel wool to the portrait's background. Its colors were weak, leeched, but the portrait on the wall appeared pristine and bright.

"Is that a copy of the Ashbourne?" I asked.

Erin assured me that it was the original, and I suppressed a burp to inquire if the picture had been recently restored. She replied that it had not been.

"*Huh*," I said.

We stared at it another minute while I did the fish thing with my mouth. At one point I started to take out my laptop to show her the stark differences between their portrait and their online photograph of it but then changed my mind. The Folger, after all, had just barred Lisa's film crew, or so I'd been told, and I was relying on Erin to get me inside.

That's when I noticed the plaque beneath the portrait.

HUGH HAMERSLEY, it announced.

I was still frowning at that plaque when Erin asked if I were here to study the Ashbourne. On instinct I said no and told her that the Ashbourne was too handsome for my taste and explained my strategy of seeking out only the most hideous portraits of Shakespeare. Erin laughed and seemed to relax. Within an hour she had arranged for me to get a scholar's pass for the following day.

Early the next morning, with Big Boi's "Daddy Fat Sax" still

ringing in my ears, I stood outside the library eager to cram a week's worth of research into a single day. I checked my backpack and was led by Erin into the impressive inner sanctum, to which I paid no attention aside from the two walls lined with familiar faces. I grinned and rubbernecked and resisted the urge to wave. To my disappointment Erin accompanied me on my initial tour of the portraits. Here was the drunk-tank grizzle of diseased swans who had held my hand throughout many a dire winter. Well, not all of my comrades were here. Only a portion of the Folger collection was on display—if *display* is the right word for a museum closed to the general public—but Erin assured me I could fill out request forms for any portraits I desired to be delivered to my workstation.

After she sat me at an otherwise empty table capable of seating six—there were only a handful of scholars in the whole library—I asked Erin if she had a magnifying glass I could borrow. I'd only been allowed to bring in a laptop, paper, and pencils. She said I could use hers and left to retrieve it. Once again, I had to admit Erin was discouragingly likable. I had expected a bête-noire type, a Dark Lady, like Natasha from *Rocky and Bullwinkle*. Then I recalled that Erin hadn't even been employed at the Folger during the controversial Janssen and Ashbourne debunkings.

After she returned, we made small talk as I waited for my first portrait to arrive—my plan being to request the Ashbourne's file as soon as Erin lost interest in me. One thing the two of us quickly agreed on was the superiority of studying high-resolution jpegs. Physical portraits were limited by slants of light or glares off glass. A good jpeg, by contrast, could be abused under an array of filters and zoomed in on almost indefinitely, like landing a module on the moon.

"Yeah, the only thing an actual portrait's good for is X-raying," I added.

Erin made no reply. Many of our emails had centered around my futile attempts to get pictures tested. Only two portraits in their collection of painted bards had ever been X-rayed, and in both cases the portraits, long held to be invaluable Shakespeares, had subse-

quently been debunked and devalued. The Folger was either the most or least honest research library in the world.

The first portrait arrived and was placed on my workstation like a tray of oysters. Here was my old running buddy, the Buttery Shakespeare. *We have heard the chimes at midnight*, I could hear him thinking as his smiling eyes met mine. I wondered how long it had been since any visitor had admired this odd fellow the Folger kept locked in a fireproof box. Erin watched as I began wanding her magnifying glass over the portrait. Was she this curious about everybody's research?

The Buttery's vise-squeezed head, mangled ear, and jigsawed face appeared almost handsome to me that morning. The sitter wore a red jerkin—like the Stratford bust and Hunt portrait—as well as the trademark underpropped collar, which in this case appeared startlingly white and therefore suspect. Lead-white paint, the most popular white pigment of Shakespeare's day, thwarted X-rays and could therefore be used to hide evidence. The portrait had been discovered in 1850 by Queen Victoria's restorer Charles Buttery. A 1902 Sotheby's catalog described the picture as dating from the seventeenth century and explained, "[F]rom its resemblance to the engraving by Droeshout it is conjectured that the painter of this picture and the engraver must both have worked from a common original."

But what about the poet beneath the paint? Did one exist? Well, there were some telltale tide lines, not to mention that lavishly white collar that screamed of overpaint. Erin told me she believed the painting had been conceived as a forgery, but I humbly disagreed. To my mind the sitter's features contained too many inconsistencies with the Droeshout engraving. His mustaches were downward-sloping and asymmetrical and his nose bent to one side like a boxer's. His ear looked glued on. Why would a con man create a forgery from scratch so different from the holy Droeshout template? No, I suspected there was another portrait below this one.

Eventually I told Erin, as gently as I could, that I wished this

portrait were kept anywhere else in the world but the Folger Shakespeare Library. This hurt her feelings, I sensed, but it was true. First the Folger gobbles up all the would-be bards it can buy, then it partitions them away from the public while refusing to allow researchers to gaze into them via spectral technologies. Why purchase a portrait to hide it? Why not display it, alongside its spectral results, in a museum open to the public?

The next portrait served to my table was the Archer, the Evel Knievel of Shakespeare portraits. Although most of the Folger's candidate portraits were described as having been scoured, extirpated, cropped, or inpainted, the Archer was the most abused of them all. Among other insults, it had been "deliberately defaced with very deep scratches, almost destroying the paint layers and ground of the chin, mouth, and beard." The picture had also been cropped into a "fragment" of itself. Somebody had gone to war on a picture that had been painted so skillfully it was once attributed to Federico Zuccaro, the great Italian Mannerist painter who visited England around 1574. The Folger had restored the Archer portrait in 1988, but it had done so without first X-raying it.

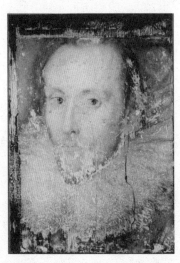

The Archer portrait of Shakespeare during its 1988 restoration, artist and date unknown (Folger Shakespeare Library).

The Archer also bore a noteworthy resemblance to the Droe-shout, but, oddly, somebody had once painted a carnival-barker's mustache above its upper lip. Why strive to make a portrait look less like Shakespeare? What's the percentage? Well, I couldn't ask Erin this question because she had finally left my side. Maybe she'd decided I was harmless. Or maybe the polonium had been discreetly applied to the magnifying glass so that my eyeballs would soon turn to smoke.

After examining the Archer, I stealthed to the desk and filled out a form for the Ashbourne file. Twenty minutes later that file arrived without the portrait itself but with both sets of X-rays and a light box. After looking around for any hunchbacked scholars, I placed the breathing tube into my mouth and fell backward off the boat.

19

Slaughtered Shakespeare

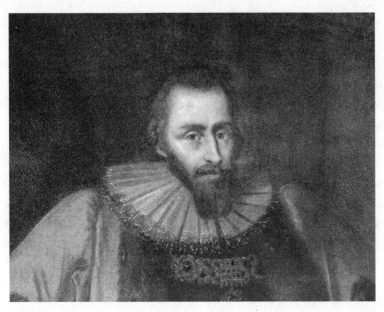

Portrait of Sir Hugh Hamersley kindly sent to me by Mr. David Bartle of Haberdashers' Hall, London.

Before we proceed I will admit there was a part of me, a diseased lobe somewhere in my brain, that wanted the Folger to have assassinated its own restorer. Therefore, as I began pillaging the Ashbourne file that day, I had an agenda, yet knew that researchers with agendas could not be trusted. With that in mind I kept a wary eye on myself, as if I had been divided into two men facing each other across the Ashbourne file: one, a hard-boiled skeptic holding

a magnifying glass; the other, the mad Earl of Anfield who was having Stanley Wells racked in his dungeon by Sir Graeme Souness.

The Ashbourne controversy, for all its complexity, largely revolved around the ambiguous date of the portrait's creation. William Pressly, who helped oversee the portrait's 1988 restoration, and much later identified its sitter as the haberdasher Hugh Hamersley, had based his argument that the picture was painted in 1611, the inscribed date currently visible on the portrait. The two Oxfordians Barbara Burris and Charles Wisner Barrell believed the portrait had been painted no later than 1581, the year the "CK" artist Cornelis Ketel departed England.

Hamersley was sixteen years old in 1581. De Vere was sixty-one in 1611. If the picture was painted in 1581 or earlier it could not depict Hamersley. If painted in 1611 it could not be de Vere, who had died in 1604.

In support of the 1581-or-earlier argument, Barrell had provided *Scientific American* with his radiographs that appeared to reveal an Elizabethan figure-eight cartwheel ruff hidden beneath an inpainted Jacobean collar. Barrell also argued his spectral tests provided evidence that the portrait's original inscribed date, once located beneath the current 1611 inscription, had been extirpated with such zest it had damaged the canvas.

Barbara Burris then supported Barrell's stance with her own argument that costume dating eliminated Hamersley as the sitter. Wrist ruffs, she pointed out, had gone out of style in the early 1580s when cuffs came into fashion. Yet here was the Ashbourne, supposedly painted some thirty years later, sporting wrist ruffs, a fact confirmed by both sets of X-rays. Burris believed somebody had purposely muddied those wrist ruffs with gray paint to conceal evidence.

To confirm these theories, Burris consulted Susan North, the Curator of Fashion and Textile at the Victoria and Albert. North agreed with Burris that the Ashbourne costume was not consistent with 1611 and that wrist ruffs did indeed go out of style in the 1580s:

I would agree that the dress does not appear to date from 1611 . . . The general shape of the doublet with close fitting sleeves and a waistline dipping only slightly below its natural place in front corresponds with men's dress of the 1570s . . . Regarding your comments on the wrist ruffs, I agree that those go out of fashion in the 1580s.

This controversy over costume had actually begun back in 1910. A decade before any Oxfordians walked the earth, the greatly respected Marion Spielmann had described the Ashbourne sitter as dressed like an earl from 1581. Not that he put it in those exact words. Well, actually, yes, he did put it in those exact words.

The Ashbourne was wearing, Spielmann noted, "Just such a dress, belt, and glove as we see in the portrait of James Douglas, Earl of Morton, who died in 1581—that is to say 30 years before the date of this picture."

Spielmann then described the Ashbourne collar as "scamped" and added, "The multifold ruff almost seems to be by another hand . . ."

Two other details irked Spielmann. He thought the Ashbourne sitter looked too young for the inscribed age of forty-seven. While making this observation, Spielmann did not know the sitter had a healthy head of hair beneath the overpaint. Imagine how much younger that hair would have made the sitter appear. Spielmann also believed that the inscribed date of 1611, on which everything hinged, appeared suspect to his eye because it had been applied with the same paint used to scamp both the oval on the book cover and the matrix, or seal, of the signet ring.

And that brings us to another long-standing controversy, one involving a restorer who claimed to have actually removed all the overpaint from the Ashbourne head.

Peter Michaels was found murdered in 1982 at the tail end of his contentious restoration of the Ashbourne. It would take six years before the Folger hired Arthur Page to complete—or perhaps undo—the restoration started by Michaels. However, the library's

relationship with their new hire seemed to get off to a bad start in that a 1988 memo, written by Pressly, sought to reassure the Folger brass that "[a]nything Arthur Page does as regards the ear, the inscription, and the coat of arms can always be changed in the future."

Another memo Pressly wrote that year, this one to the library's new director, Werner Gundersheimer, suggested that "elements of Hamersley" be incorporated onto the Ashbourne sitter, a plan that, according to Barbara Burris, was enacted years before Pressly officially identified the sitter as Hugh Hamersley, haberdasher, in a journal associated with the Folger Library.

As to Pressly's role within the Folger, although the library denied he was their employee, Pressly did help oversee the library's 1988 restoration of the Ashbourne. That same year found Pressly hired to catalog the Folger's portrait collection, which in turn gave him the opportunity to air his strange fantastic theory about how the CK initials arrived on the painting. Finally, in 1993, it was Pressly who identified the sitter as Hugh Hamersley in the Folger's *Shakespeare Quarterly*.

Writing in the Oxfordian journal *Shakespeare Matters*, Barbara Burris stated that, prior to Pressly's identification of the sitter as Hamersley, the Folger, or their hires, had already manipulated the sitter's ear, hairline, and nose to make the sitter more resemble a known 1716 portrait of Hamersley kept at London's Haberdashers' Hall.

"The Folger certainly did incorporate 'elements of Hamersley' into the painting," Burris stated in no uncertain terms.

Burris went on to describe how Michaels, prior to his murder, had wanted to expose the sitter's original head, an action that might well have revealed the (arguably) Elizabethan collar and certainly would have revealed the buried head of hair. Michaels even went so far as to inform an Oxfordian that he had already exposed the head, a task his bosses had ordered him not to do. And if Michaels did expose the head, then who overpainted it again?

While digging into the Ashbourne's file, I came across a note

that had been handwritten by Michaels in 1979 stating that he had discovered a coat of arms buried beneath the overpaint in the area below the current 1611 inscription. To make matters more intriguing, the infamous CK initials had been located inside the flourishes of this coat of arms. What Burris pointed out, and it's hard to fault her here, was that no painter would have ever signed his name or initials in that location; therefore it was Burris's belief that the coat of arms had been added to the portrait at a later date.

Even Peter Michaels, after discovering that coat of arms, became suspicious that the portrait had been selectively extirpated not by a con man but by an earlier conservator. Michaels wrote that "[a]pparently some restorer in the past had scraped off parts of it, possibly to make it less visible under X-ray detection."

As Dr. Paul Altrocchi pointed out in his 2014 book *Moniment*, "This reference to an attempt to evade X-rays is provocative, since X-ray technology was not discovered until 1895 and there was no threat of X-ray examination of the Ashbourne until *after the Folger purchased it* and Barrell had conducted his own X-ray and infrared investigation in 1937."

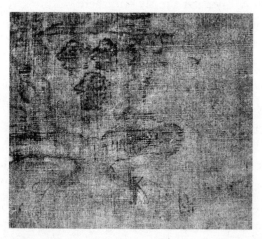

The CK monogram's location inside a scroll at the bottom of the Ashbourne portrait's overpainted and extirpated coat of arms. X-ray by Charles Wisner Barrell (*Scientific American*, January 1940).

Eventually I flicked on my light box and began searching through both sets of X-ray radiographs in the file. I wanted to see what the Ashbourne's head of hair looked like in the Folger's own set of X-rays (the ones made by the library after Barrell's controversial 1937 radiographs). According to Burris, William Pressly had denied the existence of any head of hair beneath the overpaint even after that X-ray had been done:

> Michaels repeatedly said he wanted to uncover the forehead area, and yet the Folger insisted that all the hair had been scraped away and nothing but the overpaint was left. Pressly repeated the Folger claim in his 1988 memo to Gundersheimer and in his 1993 article. Why did they insist that there was no hair under the overpainting and no hairline visible, when even a glance at their own X-rays shows the hair and hairline so clearly and unmistakably?

When I placed that radiograph on the light box, the original head of hair could not have been more obvious, and this was the Folger's own X-ray. First Pressly said there was no CK monogram. Then he unwound his silly story about a reverend signing his own initials on a forgery. And now this.

I was beginning to think Mr. Pressly lacked objectivity.

Suddenly Erin Blake reappeared at my table and caught me red-handed with the Ashbourne X-rays. She did not seem surprised, however, and happily confirmed the existence of the original head of hair and even photographed the hair for me in the X-ray. As far as I know, that was the first time the Folger had allowed their X-ray to be photographed.

After Erin left again, I lost myself in those X-rays, and it was midafternoon before I came up for air to search my laptop for the photograph of the Ashbourne taken after its final restoration in 1988, the same photo that had seemed so at odds with the portrait currently hanging in the Founders' Room. While doing this, I no-

ticed I'd received an email from my crime-writer buddy Ace Atkins that contained two attachments, both of them newspaper articles pertaining to the murder of Peter Michaels.

"Yikes!" Ace had written. "Let me know if you want the police file."

As I only had a few hours left inside the library, I put off reading those articles and dove back into the Ashbourne file. But as I did, I began to wonder if Peter Michaels had been aware of Barrell's theory that the bulk of the now debunked portraits of Shakespeare were all overpainted pictures of Edward de Vere. Was it possible Michaels had started to believe Barrell was correct? And, if so, what would have happened if the expert Michaels had gone public with such a claim?

Well, to start, goodbye Stratford-upon-Avon tourist industry and the millions it raked in annually. Goodbye Royal Shakespeare Company and Shakespeare Birthplace Trust. Goodbye Stanley Wells and goodbye to some 367 well-imagined yet now highly comical Shakespeare biographies. Goodbye to the reputations of countless red-faced academics. And, last but not least, goodbye to the "I Think Shakespeare Wrote Shakespeare!" T-shirt company.

Faced with such a dilemma, the Folger would obviously have had no choice but to snuff out their own restorer, right? Yes, it was all becoming clear to the Earl of Anfield while his skeptical twin glared at him through a magnifying glass.

According to Burris, it was Michaels's request to expose the sitter's upper head that had inspired the higher-ups to call a meeting where they decided to let Michaels proceed. But ten days later that decision was reversed. Had Michaels exposed the head during that ten-day window? Had Michaels subsequently re-overpainted that head when the Folger reversed its decision? Or did the Folger later hire somebody else to repaint the head Michaels had uncovered?

As my final minutes in the library ticked down, I kept searching for a memo Burris had cited as being the last-known reference to Michaels in the Ashbourne file. Burris, who claimed there had

been a gap of nearly a year between this last recorded reference to Michaels and his murder, suspected that gap indicated the Folger might have removed evidence from the file.

I found the memo moments before the library closed.

"Peter Michaels—will do what we want," the note said.

No name or date was currently attached to the memo.

Before leaving the library, I said goodbye to my friends on the walls and sincerely thanked Erin for her many kindnesses and then wandered outside into the Elizabethan garden a bit giddy from the daylong shift I'd pulled without any Adderall. In spite of my fatigue I still felt a healthy respect for Barbara Burris, who had dared to question the behavior of a powerful research library, but at the same time it depressed me to realize how little her findings had mattered. The traditional academics, the powerful white men Twain referred to as "thugs," had simply ignored her findings, which made me wonder if there were even a path to victory here. Could anyone ever hope to rouse the public into questioning the accepted history of an icon like Will Shakespeare?

Had I asked Mark Twain that question he would have laughed in my face.

"And whenever we have been furnished a fetish," Twain wrote, "and have been taught to believe in it, and love it and worship it, and refrain from examining it, there is no evidence, howsoever clear and strong, that can persuade us to withdraw from it our loyalty and our devotion."

There was no hope, it seemed, not when the truth was guarded by men like Stanley Wells, who had once argued, "It is dangerous and immoral to question history."

Dangerous? Immoral? Back in 1951 Josephine Tey (the pen name of Elizabeth MacKintosh) published a detective novel called *The Daughter of Time* that defended Richard III against the accusation he'd slaughtered the lamblike princes locked in the Tower. There had been no reason for him to murder those princes, Tey's detective demonstrated. The Tudor clan, by contrast, had a closetful

of motives to murder those kids. The real Richard III, Tey's evidence cried out, had been brave, capable, and one of the few English monarchs to die in battle. The monster we know and love had been cooked up for propaganda purposes by Tudor historians, aided and abetted by a talented young playwright eager to please his queen.

Following Tey's lead, historians started rising to Richard's defense. Was this questioning of history by Josephine Tey immoral and dangerous?

Late in her novel Tey's detective noted a vexing cultural phenomenon that occurred when people were confronted with hard evidence their historical views had been perverted by propaganda:

> It's an odd thing but when you tell someone the true facts of a mythical tale they are indignant not with the teller but with you. They don't *want* to have their ideas upset. It rouses some vague uneasiness in them, I think, and they resent it. So they reject it and refuse to think about it. If they were merely indifferent it would be natural and understandable. But it is much stronger than that, much more positive. They are annoyed.

"Good ol' Richard III," I muttered to myself while sinking onto my bench outside the library. Then, all at once, I recalled, with a bloom of dread, the two newspaper articles Ace had emailed me. I glanced around the garden, took out my laptop, and began searching for the subject line "Yikes!"

20

Sayonara Shakespeare

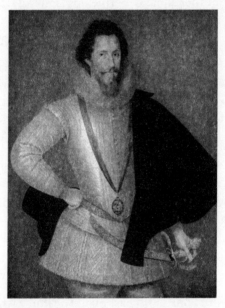

Robert Devereux, the 2nd Earl of Essex, studio of Marcus Gheeraerts the Younger, circa 1600 (National Gallery of Art, Washington, D.C.).

That evening Laurel and I had dinner at a sushi joint with two of her friends, one of whom was a food critic and had just given the restaurant a rave review. As one amazing dish after another was sent to our table, the manager kept checking in to make sure we were happy and contented. I was neither and could hardly speak without mutter-cursing. My only cogent thought was I should stop writing about Elizabethan portraits and start writing about Japanese food.

With every sip of sake, the drums from the Zojo-ji temple boomed louder in my brain and made it impossible to follow the dinner conversation.

Laurel's friends kept asking about my research at the Folger and I kept putting them off with vague responses that tailed into sighs. Having by then read the two articles Ace had emailed me about the murder of the restorer Peter Michaels, I was terrified what might come out of my mouth if I did speak. The crime scene had been repugnant, the murder squalid, perplexing. Peter Michaels, it turned out, had a very dirty secret.

It wasn't until our drive home that I attempted to tell Laurel about that murder and did so with an ironic edge that failed me. Something had changed. I was no longer the morbid kid summoning hurricanes onto his hometown.

One week before his murder, I explained as Laurel veered us through the chaos of D.C. traffic, Peter Michaels had attended a party at the home of "a prominent member of Baltimore society," the "sole purpose" of which had been the procurement of children for sex. Two kids, both male, one seventeen, the other fifteen, were introduced to Michaels at the party.

Laurel shot me a glance: half grimace, half flinch.

"Yeah, it gets worse," I promised. "What's weird, though, is how the murder comes with its own play-by-play commentary."

For a moment I considering asking if she knew what a honey trap was. As a reluctant admirer of intelligence operations, I knew honey traps to be standard operating procedure. You created a brothel, or an illicit party scene, to lure powerful perverts into your lair for the purpose of blackmail. But I didn't say what I was thinking out loud. I was afraid how it might sound.

"Anyway, a week after the party," I continued, "Michaels invites the two underage boys to his home, where he's restoring the Ashbourne." I could almost see the portrait's eyes following the children as they entered. "The kids stay there a couple of days. At one point—it must have been the second day—Michaels calls up a friend of

his, some fellow pervert, and explains that he thinks the boys stole like sixty bucks from him. He tells his friend he's going to confront them about it later that evening. The article didn't give the name of the friend, but, I mean, it's gotta be the rich perv who threw the party, right?"

"Maybe," she said.

"That doesn't hit you as weird, though? I mean, I call you up and say, 'Hey, heads-up, I might be hideously murdered later tonight after I accuse these two children I've been molesting of stealing, so would you mind ringing me up after dinner to make sure my naked body hasn't been bludgeoned to death beneath the controversial Ashbourne portrait of William Shakespeare?"

Laurel's expression gravitated, just for a moment, toward annoyance. I was pretty sure that would be the look she'd use to break up with me when she realized how deeply I'd fallen into my Ashbourne rabbit hole. She kept driving as I experimented with my repertoire of sighs. I am the Charlie Parker of sighs.

"Well, it seems weird to me," I persisted. "Anyway, so Michaels asks his perv friend to call him back later that night to make sure he's okay. That doesn't sound weird to you?"

"Will you please just tell me what happened."

"No," I told her. "It's an old Dan Brown trick. He knows what grisly details your dark heart wants to hear."

More silence. Then, finally, a grim smile.

Any smile in a storm, I say.

"Okay, here goes. It's ugly. His fellow perv calls Michaels back later that night, as promised. 'Hey, have you been hideously murdered yet?' Michaels tells his friend he's okay. Everything's hunky-dory. They hang up. Then, the next day, his car is discovered abandoned, and later some witness claims he can ID one of the boys who abandoned the car, which seems weird in itself."

"Why's that weird?"

"Well, I mean, who remembers somebody getting out of a car? Or maybe it isn't weird—I dunno. Anyway, come Monday morning,

Michaels's assistant shows up at his house and discovers his naked body stabbed repeatedly."

After saying this, I rolled down my window for some air. I liked how they lit up the monuments at night. I liked D.C. I had expected to hate it.

"How many times was he stabbed?" Laurel asked.

"*Hmm*, dunno. All the newspapers said was 'repeatedly.' Anyway, the two boys were brought to trial and plea-bargained. Basically, we got two underage kids standing trial for murdering their molester, right? It makes sense that only one of them did the actual stabbing, but both pled guilty to it. The article quotes the DA as stating he couldn't supply a motive for the murder."

"How horrible."

"Yeah. So how many years in prison do you think those two kids got? I mean, they're children, they killed their molester, then they got talked into plea-bargaining. One of them is only fifteen. How many years in prison? Guess."

After a moment it became clear Laurel had no intention of guessing.

"Thirty," I announced. "Thirty years each. Quite the plea bargain, huh? I mean, what did it save them from, the electric chair?"

I cut myself short, worried I might be sounding shrill.

"That means they're out now," Laurel said.

I stared at her blankly for a moment. Then did some math on my fingers.

"Show-off," I said.

"Maybe you should contact them."

I smiled and sat there imagining all the lovely things that might happen to a writer who investigated child-sex rings used by prominent citizens in the D.C. area. My rabbit hole kept getting deeper and darker, and I wondered if I would ever climb back into sunlight.

Twice during our drive home I almost told Laurel about my suspicions the Ashbourne portrait had been switched, but each time some inner alarm sounded and I kept my mouth shut. Later that

night, inside her studio apartment flooded with ambient light, I sat up in bed watching the white curtain flutter in front of the sliding glass door we'd left open for the breeze. I was thinking about the Flower portrait and the German team of scientists who insisted the Flower had been switched.

Did I really believe the Flower had been switched?

"No," the left side of my brain decided.

"Yeah, you sorta kinda do," my right brain countered.

"No, I don't."

"Liar."

Oh God, I was going Richard III again. At this rate, the ghost of Edward de Vere would come traipsing through the fluttering curtain at any moment. I glanced at Laurel, asleep, her back turned to me. We hadn't argued, not in words, but there had been a unique awkwardness to the evening. How long could I keep this ruse up, this pretense of normalcy, when in fact I was delving into Faustian conspiracies? My instincts said I needed to jettison my portrait fetish or I was going to lose her. Yet my mind could not stop ferreting the Folger's inexplicable behavior and that question of motive, motive, motive . . .

Could the Folger's treatment of their Ashbourne portrait, I asked myself, be connected in some way to what happened with the Flower portrait? Or the Hunt? Was there an invisible chain linking all those enigmas? For a moment I recalled the first time I'd studied a high-resolution jpeg of the restored Flower. While zooming in on its collar, I'd noticed the area around the neck appeared stained, like a seam of blood. That illusion, combined with the newly installed halo, had made me suspect I was looking at a painting of a Catholic martyr, the greatly beheaded Saint Shakespeare.

What if they did kill Shakespeare? I thought. Not the Folger or the Stratford Birthplace Trust, but King James or one of his henchmen? Could that murder explain a portrait cover-up still active some four hundred years later? Did I believe that was possible?

"Absolutely not," I whispered.

"Oh, you so believe that," came an echo.

Hypnotized by the billowing white curtain, I kept discarding the headless-saint theory then picking up that head again, and in this manner began psychoanalyzing myself with such questions as: *Do normal people think such thoughts? Am I a paranoid schizophrenic? Bipolar? Crazy insane? Insane crazy? Hawk? Handsaw?*

Hamlet, I felt, would appreciate my dilemma. Had his father really been murdered? Had he actually seen that ghost? Should he believe the crazy conspiracy theory it told him? Propping a pillow under my shoulder, I recalled the Cobbe portrait's inscription: *Beware the Friendship of Princes!* Had Shakespeare paid the ultimate price for penning his political satires. Then I glanced at Laurel, still sleeping peacefully, and tried to redirect my thoughts to something normal.

Motive, motive, motive my OCD mind kept niggling.

Okay, let's suppose an active cover-up of Shakespeare's murder existed today. If so, then the perpetrators had to be attached to the royal family—who else would have the power to fund and enact such a plan? And if the royal family was involved, then the murder of Shakespeare had likely been tied to the succession intrigue surrounding Elizabeth's death. With that in mind, the question became: Could a transfer of inconceivable wealth and power back in the early seventeenth century still be a factor today? Could that murder explain why the Ashbourne was so befuddled with overpaint and extirpation?

Yes. No. Maybe. On and on it went as my mind roamed the rooms of its haunted house. Here are the eyes that spied Queen Elizabeth naked (peeled grapes), the brains that conceived Othello (spaghetti), the fingers that wrote "To be or not to be" (carrots), and the tongue that cried "My kingdom for a horse!" (ham slice). And here, here (air gun ready), here is the eye-less, tongue-less head of Will Shakespeare that King James cut off for writing *Macbeth* (*phhhhhhht*: exit screaming).

Were my murderous theories really that insane? Hadn't Marlowe

been stabbed dead by intelligencers involved in that same succession intrigue? Hadn't Ben Jonson been imprisoned for his satiric plays? And didn't Tom Nashe flee London in fear of his life? Was it really that farfetched to believe that Shakespeare, who had ridiculed all the power players of his day, and whose play *Richard II* once helped instigate an armed rebellion against the crown, might have gotten himself murdered? And if Shakespeare were murdered, and if the crown had passed to James instead of to a proper Tudor heir, then at what point in our history of horror begetting horror would the royal family have stopped covering up those sordid facts and fessed up to not only having murdered the greatest artists of all time but to stealing the crown of England from the rightful heir to the throne?

Never. They would never admit it. The cover-up would last forever.

Eventually I got out of bed and glided like a shade through the curtain onto the small balcony and stood there staring down at the darkened cathedral. *Motive, motive, motive* gonged the church bells of the mind. Why would people working inside the Folger Library go to such extremes to establish a priceless Shakespeare portrait depicted a worthless haberdasher?

I tried to look at the Ashbourne situation from the Folger's point of view. William Pressly, in his article officially identifying the sitter as Hamersley, emphasized two factors as deciding the issue. The first was the picture's inscribed date of 1611. Yet Barrell had reported the original inscription beneath that 1611 date had been scraped off to such a degree it perforated the canvas. And Spielmann, that most objective of scholars, noted the 1611 inscription was painted with the same pigment used to scamp other parts of the portrait. Why use such a seemingly threadbare argument to devalue a portrait?

The second piece of evidence cited by Pressly had been the coat of arms he argued was attached to the Hamersley clan; yet Michaels had described that coat of arms as having been previously extirpated, and Burris insisted that no painter would ever place his initials within a portrait's coat of arms.

Provenance, that curatorial god, seemed to play no part in Pressly's identification aside from his argument concerning that coat of arms. He hadn't even attributed the portrait to any painter. And nobody inside the Folger had supplied a convincing explanation as to why M. H. Spielmann described the sitter as wearing the costume of an Elizabethan earl from 1581. Provenance and logic apparently didn't matter. No, all that mattered was somebody with the correct degree had published a paper in an academic journal that made everybody else feel better about Will Shakespeare. That done, the gavel came clapping down as the Ashbourne portrait was declared innocent on all charges of depicting Edward de Vere.

I never got any sleep that night but at least no ghosts pushed me off the balcony. The next morning I zombied into the National Cathedral and napped in a pew while the organist practiced his licks. Needing to kill time—Laurel had work to do in her tiny apartment— I decided to visit the National Gallery and for the longest time stood there gesticulating into their portrait of the 2nd Earl of Essex. In *The Quest for Hermes Trismegistus*, the writer Gary Lachman mused that it would be interesting to pinpoint that moment in Western history "when the belief that being able to communicate with nature—the world—which is the essence of animism, is declared a sign of madness." Lachman's observation summed up my relationship with art, I felt. The curators might not like me, but their portraits did.

"Show me the magic," I whispered to my old friend Essex.

On February 7, 1601, about two years before the queen's death, an uprising against the crown had begun at the Globe Theatre with a treasonous production of *Richard II* in which Elizabeth was satirized as the incompetent Richard surrounded by villainous counselors. This rebellion, which would march on London the following morning, was led by two fallen favorites, Robert Devereux, the 2nd Earl of Essex, and Henry Wriothesley, the 3rd Earl of Southampton. We can't be sure of their motive in starting this doomed rebellion, but it seems likely these two hyper-educated earls, symbols of the fast-fading English Renaissance, had been attempting to free

their aged queen from the grasp of her powerful secretary, Sir Robert Cecil, in order to thwart Cecil's plan to control the crown upon Elizabeth's death. But Cecil had proved too smart for them.

After the play ended at the Globe, the rebel crew of some three hundred disgruntled soldiers and discontented Catholics reconvened at Essex House before marching on London's Cheapside. Their revolt seemed desperate, almost suicidal, especially since Cecil, always a step ahead of his rival Essex, had already dispatched town criers into London to declare the rebels traitors. Finding no support in the city, the rebels retreated back to the Strand. Then, with Cecil's cannons pointed at them, Southampton and Essex stood up on the roof of Essex House and vowed grandiloquently to die before surrendering.

Then they surrendered. A show trial damned both earls to be hanged, cut down alive, disemboweled, set alight, quartered, etc. Essex's confession got his sentence reduced to a mere beheading. Southampton, enigmatically spared the chop block, remained imprisoned until Elizabeth died, and the rest was literary history, the consensus being that the Essex Rebellion inspired the angst and beauty of Shakespeare's autobiographical sonnets penned to the Fair Youth Southampton trapped in the Tower with his cross-eyed cat.

Five earls, three barons, and sixteen knights were implicated in the uprising, yet Shakespeare survived that rebellion unremarked upon. He was not summoned before the Star Chamber like Marlowe. He did not have his papers seized or his books burned. He was not punished in any way. Although clearly aligned with the Essex faction, he wasn't even called as a witness.

Who was protecting Shakespeare at this point? The Stratford myth that he was being protected by his dear friend and patron Southampton, a threadbare argument to begin with (Southampton was often out of favor), flies out the window here. Imprisoned in the Tower, Southampton was in no position to protect anybody. So if Southampton wasn't protecting Shakespeare, who was? And how, and why?

For the longest time I stood there muttering questions like these into Essex's portrait. When I finally noticed I was speaking out loud, I glanced around and then backpedaled out of the gallery. I needed more coffee. Three cups later, my mind re-awoke inside a different puzzle, and I began to wonder once again if the Ashbourne portrait had been switched. To solve that mystery I would have to return to the library, and so I did.

After tiptoeing through the gift shop, I skirted down the corridor back into the Founders' Room, where the so-called Ashbourne portrait was hung on the wall above a plaque identifying it as Hugh Hamersley. Moving as fast as an art thief, I opened my laptop to the high-resolution photograph of the Ashbourne supplied on the Folger's website. Back and forth went my eyes from the photograph on my laptop to the portrait on the wall. At first it seemed impossible to reconcile them, but eventually I forced myself to construct a theory that might explain the obvious discrepancies. It seemed feasible, though just barely, that the photograph—which would soon be replaced on the website—might have had its contrast tweaked in such a way as to highlight the scars and scour marks marring its background. That possibility filled me with relief. I desperately did not want to hear myself babbling to Laurel about how the Folger had switched its portraits. For the sake of my relationship, I needed sanity to gain a toehold here.

Maybe, just maybe, the Ashbourne hadn't been switched, I decided, though it was difficult to give the Folger the benefit of the doubt. More than anything, I just wanted to be done with the Ashbourne. All this flirting with madness, my own and others, had taken its toll.

Before leaving I closed my laptop and attempted to commune with the Ashbourne's hybrid sitter, but instead I kept wondering why the Folger continued to display this debunked bard in their Founders' Room as their ambassador? Why showcase a haberdasher in a Shakespeare library, especially when you have so many other bards to choose from?

"Codswallop," I whispered for no particular reason.

After nodding goodbye to the Ashbourne, I walked outside into the Elizabethan garden and sat brooding on the cement steps while recalling all those wasted winters and imagining the life I might have led had I not purchased Hilliard's big red book of portrait miniatures. I could have taken up the biathlon, or ice sculpting, but instead I'd lost myself in an endless labyrinth of snake-doctored portraits.

It was not a beautiful garden I found myself cursing into that morning, but it was at least authentically Elizabethan, meaning its landscape had been designed to protect the garden from the infiltration of witches. Secure in that regard at least, I studied the people reading books or newspapers. They looked so normal. How I envied them that. I who had never been normal, not for a minute, not even by accident. Waves of self-pity rose inside me, and soon the garden began to blur. All I'd wanted to do was find a lost portrait of my hero painted from life, and now I'd become a freak show, something like the Dan Brown of Elizabethan portraiture. I sensed I had not been treated fairly by these professionals who imposed one set of rules on me and quite another on themselves. Provenance was god until it interfered with their priorities. Physical resemblance meant nothing unless it supported their theories. My feeling was I'd been playing an honest hand while everyone else was pulling aces out of their assholes.

"Codswallop," I muttered again.

The sound of my own voice startled me, and I squinted around the garden searching for sendaks. What I most wanted at that moment was to live a normal life. I was tired of all these poets with Klingon heads spying on me at night. I thought about Laurel perhaps writing a poem back in her apartment and remembered that billowing curtain from the previous night and my fear that Shakespeare's ghost might tromp into her bedroom.

Sitting on those steps I knew not what to do with myself, with my hands or eyes, my heart least of all. Needing to do something,

I took out my wallet and unfolded the poem I kept there, the one Laurel had written that sunny morning on my couch, and I read that poem to myself with tears flowing down my cheeks. Then I folded the poem away and realized I was done with this shit—not just the Ashbourne but with the whole dirty lot of them. Fuck a Shakespeare portrait, I thought—and that decision, that unfettering, made me grin into the weak sunlight.

"Done," I said out loud.

Then I flipped off the gnomish spymaster Sir Robert Cecil one last time across the centuries.

"*No mas,*" I whispered to him.

With that, I brushed off my new sneakers, stood almost drunkenly, shouldered my backpack, and walked helter-skelter across the Elizabethan garden striding through all those layers of paint, one after another, back into my own century.

Engraved Portrait of Robert Cecil, First Earl of Salisbury (1563–1612), artist unknown (Fairclough Collection, University of Leicester).

England

On the afternoon I visited the Tower of London I did not throw myself into the Thames, though I contemplated it. To my horror I found the Tower of my imaginings transformed into a hands-on plastic-coated theme park, a perversion of history. Maybe it was naive to expect to travel backward in time and visit the site as it had once been, but the arcade displays with their sound effects made that impossible even with my eyes clenched shut. Everything was geared toward the lowest common denominator, children, with any lingering ghosts racked in anguish at the perpetual shrieking. There was no feel or respect for history. What a miserable day, one of my first in London.

There was one consolation. The Beauchamp Tower, used to incarcerate high-ranking prisoners, wasn't done up like some Tokyo pachinko palace, and its sculptural wall carvings left by former inmates still felt haunted, especially one word attributed to Lady Jane Grey, Queen of England for nine days, who at age seventeen was beheaded. Seeing her first name carved there made history feel close enough to weep over.

I had arrived at the Tower that morning hoping to find the spot where Southampton's portrait had been painted, but none of the employees had any idea which building had housed which prisoners. I stood there turning circles, hoping to spy something familiar, and while doing so began to eavesdrop on a guard who was complaining

to some tourists about the newish memorial structure—it resembled a glass coffee table—that had been placed on the execution site.

"It is inappropriate," he insisted, "an attempt to sanitize history." He then urged the tourists to write letters of complaint, "because they don't listen to those of us who work here."

He was correct about the absurd memorial set on a pitch of grass where dozens of scattered heads would have been visible in any decent X-ray. Yes, far better to have a replica chop block built on the green complete with blood-stained ax and maybe a few fake heads lolling around for the ravens to bicker over. Or let Madame Tussauds take charge of the Tower and fill its corridors with wax dummies of emaciated earls reading sonnets to cats and intelligencers racking Catholic spies. Place a human skull on the wall for every soul who fell here: ninety-three beheaded, twenty-three hanged or hanged-drawn-and-quartered, and three stake-burned. If it must be a kid-friendly amusement park, then, by God, make it a haunted tower. Terrify the bejesus out of those kids. If they have to scream—and apparently they do—then make them scream in horror at history.

My overdue trip to England had begun ominously a few days earlier when a brief layover in Chicago devolved into a nine-hour delay. I was hunkered in a dark corner of O'Hare squinting over maps when Larry called to tell me his wife had died. Dean had suffered a stroke a few days earlier with no chance of recovery. After talking with Larry, I walked into the nearest bar and ordered a whiskey. Just a week earlier Dean and Larry had helped me plot out my trip, and now Dean was dead. Missing her funeral would hurt, but I couldn't afford to cancel my trip.

While planning the trip, I'd felt confident I could navigate England without falling backward into paint and losing another decade trapped inside portraits. It had been over a year since I'd sworn off my bards, and during that time Laurel and I had gone separate ways, our long-distance relationship proving impossible to sustain. I'd quit love, Adderall, and English portraiture. Nothing could make me resume that last obsession, I felt.

I was half drunk by the time I boarded my flight to London and fully hungover by the time I lugged my aluminum-framed backpack to a suburban house in Canfield Gardens. Bonnie, a friend of a friend who had offered to let me stay with her for two weeks, turned out to be an elegant Jewish woman in her seventies, and her beautiful home was filled with books and a piano she played wonderfully. The day I arrived she welcomed me inside, made me lunch, and even helped me secure tickets to a production of *Othello* at the Rose, Shakespeare's first theater.

"I didn't even know there was a Rose any more," I confessed after she'd told me about the production.

"It's not exactly a theater," she explained. "They're still excavating it. You'll see when you get there."

The following afternoon I dragged my jet-lagged psyche to the excavation site and watched the play performed on a wooden platform suspended like a window-washer's plank above the dig. The outline of the original theater glowed eerily beneath us in red lights. The *Othello* I watched on that platform was performed without act breaks, just one extended scene of unfurling horror that made me forget I was sitting on a bleacher without cushion, concession, or loo. The air was dank, and a fog only half theatrical floated across the stage already blood-splattered from previous treacheries.

It's easy to forget that Shakespeare didn't originally divide his plays into acts or scenes. Those delineations began after his productions migrated to the indoor Blackfriars Theatre with its crew of ribald child actors. The need to replace candles demanded that breaks be inserted into the plays, and the rest, for better or worse, was structural history.

Seen in this light, the Rose's *Othello* was a revival of the productions enjoyed at the original Rose, plays built for speed that kowtowed to the weary legs of drunken groundlings. The result was *Othello* on Adderall, a play as unrelenting as its villain. The use of fast exits and surprise entrances lent the production a quick-cut quality. The audience might as well have been sitting in the front cart of a

roller coaster as the play opened upon Iago strapped to a steampunk electric chair. Here was a Iago modeled on Prospero. Climbing the scaffolding, he conducted lightning, music, spells, sound effects, and even invoked trance-bound characters onto the stage to explain to us the improbable machinations of his schemes.

Back at Bonnie's that night, I borrowed a book off the shelf by Julian Barnes called *A History of the World in 10½ Chapters*. One of those chapters concerned Théodore Géricault's *The Raft of the Medusa*. Barnes had analyzed that famous painting of shipwreck survivors while trying to decide if the tiny ship painted on the horizon might be the one that rescued them, but I felt confident that was not the case. The wind was blowing the raft toward a black cloud, and black clouds meant trouble. It had taken Géricault eight months to paint his picture, I learned that night. Before starting, he'd shaved his head and even had a replica raft built by a carpenter who had survived the sinking of the *Medusa*. Géricault placed wax dummies on this raft and then covered his studio with portraits of decapitated heads, just to get the mood right.

It will tell you something about Bonnie that she immediately noticed the small paperback missing from her giant library. The next morning, after I promised to return it to its proper place, we traded our admiration for Barnes's books, after which Bonnie told me about the Globe's upcoming production of Marlowe's *Doctor Faustus*.

On the day of that show I visited dreary Deptford, where Marlowe had been stabbed in the eye. Deptford still felt dangerous and was filled with run-down houses painted garishly as if to fool visitors. "Poor people live here," screamed the bright pigments, shouted the balcony clotheslines, sang the obsolete satellite dishes. I raised a pint to Kit at the Dog & Bell then skedaddled. Deptford was a bit too authentic. Poverty was about as authentic as it gets. Violent crime was extremely authentic.

From the Dog & Bell I headed to Shakespeare's Globe to see its blockbuster *Doctor Faustus* with special effects galore. The play was fantastic yet could not have been less Elizabethan. There were more

actors onstage in the opening scenes than had existed in an entire old-bench troop. These actors were incredible, especially in the bawdy subplot about the rustic who steals a book of magic. We in the audience were pissed on and spat at and roundly abused. Leaning against the runway tongue jutting out from the main stage (not authentic), I had to crank my head upward at times to take in the actors, and what I'll always remember, even more than the fabulous costumes, was that giant O looming in the sky, Shakespeare's O, which even in this theme-park version void of ghosts (the remains of the original Globe were discovered a quarter mile away while this facsimile was under construction) cast a spell within a spell inside a play designed to denounce magic.

The camera-happy pit crowd engulfing me remained festive and involved, especially during those moments when things went awry and the actors had to improvise. A castle-shaped helium balloon that was supposed to soar out of the Globe instead drifted back on the stage just as a foreign regent was complimenting Faustus on his awesome castle-in-the-sky illusion. The balloon was snared by Meph, who stomped off stage with it while Faustus giggled and the groundlings belly-laughed.

After the play I followed the crowd across the Thames (very authentic) and ended up at Shakespeare's Head, where I had a pint, but just one, as I didn't want to show up drunk at Bonnie's house. I already felt as if I were on probation there. Bonnie, bless her heart, seemed torn between hospitality and impatience. I couldn't tell if she wanted me to feel as if I were imposing on her or if she were doing her best to hide that truth. One evening she'd even short-sheeted my bed.

Needing to get out of her hair for a bit, I decided to put off my tour of the National Portrait Gallery to visit Stratford-upon-Avon and ended up at the Salamander Guest House under the care of an archly good-humored French proprietor named Pascal, who was by far the best thing about Stratford. Pascal's routine of mapping out tourist traps for his guests was breathlessly dramatic, as if he would

love to accompany them and their horrid spawn if only he had the time. During breakfast that first morning, the two of us commiserated over the downfall of Muammar Gaddafi, then in progress, and after that we got along splendidly. If Pascal were any indicator, then maybe I would enjoy Stratford, right?

After getting directions, I set off into town hopeful for a little time travel. Many of the houses I passed did not have the thin bricks used by the Elizabethans between timbers, though some of the buildings certainly dated back to Shakespeare, such as the grammar school that Stephen Greenblatt described in his bestselling book *Will in the World*. To Greenblatt's credit, he did point out there was no evidence young Will had even attended that school—or any other.

"But in these details," Greenblatt noted, "as in so much else from Shakespeare's life, there is no absolute certainty."

In his book Greenblatt lingered a bit too long, for my taste, on his belief that Shakespeare's father sold gloves and while doing so Greenblatt tried to demonstrate how these gloves had made cameo appearances in various plays. As I yawned my way through his recollections of damn near every glove donned in the canon, I began to wonder if this type of distraction lent the illusion of history when in fact the facts were few. Far more interesting to me was Greenblatt's list of every class that had been denied young Will in this hypothetical school experience: "no English history or literature; no biology, chemistry, or physics; no economics or sociology; only a smattering of arithmetic . . . all backed up by the threat of violence."

There were no classes in signature signing, either, that is, if we were to judge the grammar school by Shakespeare's hand-dragged penmanship and the way he haphazardly signed his name as "Willm Shakp" and "William Shaksper" and "Wm Shakspe" and "William Shakspere" and "Willm Shakspere." Even Elizabeth's pet henchman Richard Topcliffe owned a signature a thousand times more elegant.

After deciding to skip the tour of the school, I set off for Holy Trinity Church, paid my two-pound donation, and walked down

its aisle like the groom in a shotgun wedding. The putty-faced bust overlooking the stunted grave felt void of life force. As to the tombstone, its lettering was inscribed upside down to the forward-facing pilgrim, a problem somebody had rectified by propping up a shoddy plastic reproduction of its epitaph. The poem itself was the real embarrassment, its rhymes more likely to have been penned by Gertrude Ford than Will Shakespeare:

Good friend for Jesus sake forbeare,
To dig the dust enclosed here.
Blessed be the man that spares these stones,
And cursed be he that moves my bones.

After exiting the church, I followed the river, which I'll concede was lovely, and poked my head into the Dirty Duck pub before entering the Royal Shakespeare Company, owner of the Flower portrait. I had contacted the RSC weeks earlier and was waiting to hear back about an appointment to view the Flower. Finding their box office closed, I meandered through the gift shop flipping off the Cobbe coffee mugs and exited onto a street flooded with pilgrims who swept me along to their next stop, a stable of tourist boats, strange cigarlike craft brightly painted and decorated with potted flowers, like floating pubs. Nearby stood Stratford's statue of Shakespeare flanked by four lesser gods—Falstaff, Prince Hal, Lady Macbeth, and Prince Hamlet. I stood there for ten minutes grinning as obese tourists displayed their beer bellies beneath the statue of Falstaff.

Eventually, and with some trepidation, I entered the lobby of the Shakespeare Birthplace Trust and glanced around, half expecting to find Stanley Wells holding a shiv. After scanning the room I asked the woman selling tickets to a tour of the building if the Hunt portrait was part of the package deal. Following a number of consultations over a crackling walkie-talkie, she confirmed that none of her colleagues knew anything about the Hunt. Other authorities were

summoned but kept confusing the Hunt with the Cobbe portrait, and I had to keep explaining to them that the Hunt was not currently on a rock-star tour of America. In the end a kind woman named Karen vowed to make it her business to find the Hunt for me, if I'd just check back with her in the morning.

I thanked Karen and strolled back outside and eventually ducked into a McDonald's for some authenticity. Sure enough, there were pods of surly teenagers camped out in the booths, and who could blame them for being so authentically surly? Their hometown had been turned into an Elizabethan Disney World with their lives spent weaving between moo-cow tourists. As I chewed down my first English cheeseburger, I could feel the old frustrations mounting, especially my long-seething anger toward Stanley Wells. Back in Mississippi I had convinced myself I would be able to visit my portraits without hope, despair, or rancor, but perhaps I had overestimated myself.

The following morning I sat down in the breakfast room, where Pascal gleefully filled me in on the horrors done to Gaddafi. Pascal served breakfast with aplomb, though I was the only guest who parried with him, the Italian couple post-argument quiet, the British family too kid-fatigued to banter. After breakfast I wandered off to buy a ticket to the RSC production of *Merchant of Venice*, which Pascal had explained starred "our Patrick Stewart" and was set in "your Las Vegas." The play opened with Elvis alone onstage, and I was devastated to learn, upon arriving at the box office, that the last ticket had already been sold.

Cursing inwardly, I decided to punish myself by entering the Shakespeare Birthplace Trust's bookstore, where I was mobbed by the Cobbe creature at every turn and a few minutes later reeled out of the shop like some Hitchcock starlet harried by invisible birds. It took fifteen minutes to calm myself enough to return to their main lobby, where I was told by Karen that the Shakespeare Centre next door was open today and should be able to help me find the Hunt portrait.

While walking there I began to dread meeting their curator, Ann

Donnelly, whom I had bombarded with so many emails. I entered, glanced around for assassins—unless I tell you otherwise I am always glancing around for assassins—then explained my mission, the hunt for the Hunt, and, lo, the secretary phoned upstairs and ten minutes later a nice young chap named Paul, who had just replaced Ann Donnelly, escorted me up the stairs into a private room and said he would be back shortly with the portrait.

Left alone, I found myself staring across a study table at a large broadside of the Cobbe portrait. We squinted at each other like gunslingers until Paul reentered wearing protective gloves and carrying the Hunt, which he placed on the table. I moved closer to stare down into that mud puddle of mysteries.

I have to admit the portrait was more impressive than I'd expected, more broodingly alive, but of course the original portrait, the one that was possibly ad vivum and enlivened, I suspected, by a horseshoe-shaped facial stain, remained buried below. How many years had it been, I wondered, since the SBT had informed me about the delay to the portrait's already scheduled restoration? Had it been tested in any way since I'd kicked my habit? I had no idea.

Paul, the portrait's new guardian—it was his first week on the job—looked to be midtwenties, but I hardly noticed him as I kept gazing into the portrait. There was a funny moment when I placed the Cobbe broadside on the table next to the Hunt and Paul and I slithered our eyes back and forth until I said, "A bit hard to reconcile, eh?"

Following a pause, Paul did the obligatory and said, "Actually they do have some qualities in common."

But in truth, we might as well have been staring at two different species. As Paul and I chatted, it became clear he knew very little about his new charge, so I told him about the portrait's history, after which he stared at me sadly, like a doctor with bad news, then informed me that the Hunt's long-delayed restoration had been canceled altogether.

I took the news well, I think. All that research I had supplied,

all that intrigue, and now the SBT had canceled a restoration that seemed to me centuries overdue. After a few discreet sniffs I told Paul I found that disheartening, then I thanked him for his time and took my leave.

But my day was far from finished. Back at the Salamander I had an email waiting from a certain Catherine of the Royal Shakespeare Company saying she'd be happy to meet me at their warehouse on Wharf Road, where the Flower portrait was currently being stored. I grabbed a cab and fifteen minutes later knocked on the warehouse door.

Catherine opened the door, smiled, ushered me inside, and there, to my surprise, was Paul, and he was holding a gat. Okay, he wasn't holding a gat, but he did look embarrassed as he explained, "I didn't realize it was you seeing the Flower today."

My feeling was I had interrupted a conversation in which I was being discussed, but, regardless, I was led to a far wall inside the warehouse where dozens of portraits were kept on sliding racks. Two or three rows of portraits had to be wheeled backward or forward— I glimpsed an impressive Chandos copy—before the Flower portrait appeared before me in that dim light.

But was this the real Flower or the old switcheroo? I began examining the picture while muttering to Paul and Catherine about the 1979 restoration that had perhaps destroyed the portrait's original background in order to expose the Catholic underportrait.

"Back then the Flower was one of the most famous portraits in the world," I explained. Then I ribbed them about the claims of portrait-switching in such a manner that I sounded less skeptical than I was. That must have won them over as they began asking me questions about various Shakespeare portraits and my view on the Cobbe. Paul even told me a story about the Flower brewery, owned by the family that had donated the portrait to the town of Stratford, and how he had first come to know the Flower via the bottom of a pint glass. It was pleasant to converse with these two young people who for all I knew might take an interest.

After twenty minutes of chitchat, all the while staring at the Flower and trying to decide if it were the real McCoy, I thanked them and returned to the Salamander not sure how I felt about anything other than I had liked both Paul and Catherine. The portrait itself had made no emotional impact—a dud firecracker—and later I would learn, via a close rereading of Professor Hammerschmidt-Hummel's second book, that the picture stored in the warehouse was in her opinion merely a copy of the still at-large original.

That left only one item on my Stratford bucket list. In memory of Dean I wanted to find Bilton Hall, Edward de Vere's country home in Warwickshire. I had learned about Bilton via my partner-in-crime Charles Wisner Barrell. In his essay "'Shake-speare's' Unknown Home on the River Avon Discovered," Barrell had described a fabulous mock battle de Vere once staged on the riverbank to entertain the queen in 1572, back when the young earl was rumored to be her lover.

After constructing a fort made of timber and canvas facing a similarly constructed castle manned by de Vere, the armed actors had exchanged "squibs and balls of fire." Battering rams and mortars were employed to the delight of the crowd as de Vere bravely led his two hundred faux soldiers in an assault on the burning fort. The Grand Guignol ended with a giant dragon stuffed with fireworks being launched into the air.

Barrell, unable to resist a jab, had stated in his essay, "What would not the professional Stratfordians give if they could present a similar piece of attested local history, mentioning 'Will. Shakspere, gent.' as the leading light of such a show?"

In his admiration for de Vere, Barrell failed to note that the fireworks had set at least four homes on fire, one of which was burning to the ground when de Vere and another nobleman rushed inside to rescue the family living there. According to *The Black Book of Warwick*, the couple was given the generous sum of twenty-five pounds to rebuild their lives. Another report claimed two people had died during the fires.

I awoke the next morning with a head cold that caused me to abandon the search for de Vere's home and instead said a nasal-fluted goodbye to Pascal, who implored me not to write anything too disparaging about Stratford and then polished his fists into his eyes in a mimicry of weeping. All I could do was show him my palms uplifted in despair, and that's how we parted. After sneezing my way to the train station, I discovered my return ticket had expired. With my lower back pounding, I trekked to the river to catch a bus to Warwick, where Tourist Information directed me to an economy guest house a mile away. I trudged there and rang the bell and after a ten-minute wait an elderly woman with long white hair opened the door and informed me that no rooms were available.

"I'm afraid my husband just died this morning," she explained.

"Oh," I said.

After a pause I told her I was very sorry to hear that. Not knowing what else to add, I turned and staggered back to town and eventually located a room. There, I popped some Sudafed-type medication that knocked me silly and hunkered down on a too-soft featherbed with a book of poems written by local hero Sir Fulke Greville.

If you were to judge a courtier by his collected rumors, Fulke Greville was a god among men. Not only was Greville rumored to have written the works of Shakespeare, he was unique in having claimed a desire to be remembered as Shakespeare's "master," an odd statement from a man famous for modesty and honor. Greville was quoted as having voiced this desire inside David Lloyd's 1670 *The states-men and favourites of England since the reformation.* The scholar John Buxton, writing in 1954, described Greville's claim to being Shakespeare's master as ". . . as tantalizing a remark as any in all contemporary notes on Shakespeare."

Greville, as I would soon learn, had the perfect résumé for any would-be bard. He had grown up inside Shakespeare's Forest of Arden outside Stratford (where he later served as Town Recorder) to become Queen Elizabeth's closest intimate, and he had lived under the same roof with Southampton in Essex House until just

before the failed rebellion of 1601. It was Greville who had been dispatched to negotiate with the rebels after their retreat, and it was most likely Greville who convinced Elizabeth to spare his friend Southampton's neck.

I learned some of this information that night via a webpage advertising a book called *The Master of Shakespeare* by A. W. L. Saunders (the pen name of Greville's descendant Rene Greville). A Renaissance man in every sense—historian, playwright, poet, essayist, philosopher, soldier, ship commander, patron, tilt champion—Fulke Greville was purportedly the richest man in England when he died, a success he owed in part to his intimacy with Elizabeth—he was said to have had *the longest lease* of all her favorites. Greville's refusal to marry had sealed a bond with Elizabeth born from their mutual love of the Muses, and it was Greville whose company most consoled the queen during her final years of illness and unpopularity.

Following a long and prosperous life, Greville had been murdered at age seventy-three when an irate servant supposedly stabbed him twice while dressing him. The servant then ran into his own quarters and—*ahem*—stabbed himself four times, thereby leaving a crime scene reminiscent of *Macbeth* with the servant slaughtered and his blade smeared with incriminating blood.

My god, I thought, *had somebody murdered Shakespeare with his own plot device?*

We might never know why Greville was murdered, though it's easy to imagine motives, what with him tirelessly revising his plays to vilify the Jacobean court. (One of Greville's plays that he claimed to have destroyed for political reasons had actually been titled *Antony and Cleopatra*.) And Greville's murder did spark cries of conspiracy at the time. As his biographer Ronald Rebholtz noted, "At least one high official saw Greville's murder as part of a frightening pattern" revolving around the royal favorite George Villiers, Duke of Buckingham. Greville's ally at court, Buckingham was believed to have had a demonic hold over the throne due to his patronage of a child-

molesting magician named John Lambe. Buckingham, Lambe, and Greville were all murdered within months of each other.

There was another detail about Fulke Greville worth pondering. Throughout his life he had refused to publish his many plays, poems, and essays—even his famous biography of Sir Philip Sidney wouldn't be printed until twenty-four years after Greville's murder. Greville also made sure history would know that his literary works, if ever published, would be cut and rewritten, scraped and over-painted, little more than "a world of alterations . . . a story of other men's writing, with my name only put to it."

His surviving poetry, which had been circulated in some form or another among the literary set at Wilton Circle, insinuated in bawdy terms that he and Mary Sidney had once been lovers. What were the odds, I wondered, against two poets, both rumored to have written the works of Shakespeare, having been bedfellows? But, then again, Mary Sidney apparently had many lovers. The gossip-monger John Aubrey even published the rumor that Sir Philip Sidney had impregnated his sister Mary. Aubrey further recalled how, when mating season arrived each spring, Mary would have her horses fetched out front so she could watch them sport from her balcony perch. "And then," Aubrey continued, "she would act the like sport herself with her stallions."

Wait, I thought. First de Vere and now Mary Sidney? That made two contenders for the title of Shakespeare who stood publicly accused of having fucked horses. What would Sherlock Holmes have made of such a clue? Well, all I knew for certain, as I sank into my featherbed that night, was that Greville's poetry was first-rate, cynical, funny, modern, and far superior, to my ear, than the celebrated poems of his boon companion Sir Philip Sidney. So why had I never heard of this guy? Why wasn't Greville famous? Why were his wonderful sonnets, years ahead of their time, so overlooked?

Perhaps it was because Greville's poetry had a little too much in common with Shakespeare's? And it wasn't just me who noticed that. The critic Glynne Wickham once argued that Shake-

speare had based his *Love's Labor's Lost* on a play Greville wrote. The Shakespearian Charles Lamb shocked his friends Coleridge and Wordsworth by choosing Greville as the one person from literary history whose ghost he would most like to interrogate. John Baxter observed that Shakespeare and Greville "share remarkably coincidental general intentions." The sonnet-cycle scholar Martha Foote Crow noted Greville's poetry "comes nearer to Shakespeare's philosophical grasp than does the attempt of any other Elizabethan sonneteer." Lytton Sells wrote, "In variety of tone and topic [Greville's] *Caelica* resembles the sonnets of Shakespeare more than any other poet of his time."

Frequently ill, always portraying himself as old beyond his years, obsessed with the passing of time, with the ripenings and witherings of buds and boys, Greville, like Shakespeare, prided himself on a plain-spoken style at war with the chivalric fashion of the day. It's obvious that one of these two Stratford poets must have, at the very least, heavily influenced the other, and Greville was a decade older and had established his style long before Shakespeare's sonnets saw print.

The Master of Shakespeare, by A. W. L. Saunders, after citing many of the above details, hung its hat on those similarities of poetic style while arguing that Greville, a famously amiable patron, had been the master of a long-standing collaboration marketed as "Will Shake-speare," whose contributing members included Mary Sidney, Tom Nashe, Francis Bacon, Kit Marlowe, George Peele, and Samuel Daniel.

The second-best rumor about Fulke Greville claimed he'd been the first grand master of the Rosicrucians, the occult secret society that gave birth to the Freemasons who in turn founded America. The Hermeticist magi Giordano Bruno had even set his book of dialogues inside Greville's banquet house. According to Saunders, a monument designed by Greville inside Warwick's St. Mary's Church is still revered today as England's earliest Rosicrucian temple.

I sank into sleep that night a fan of Greville and awoke the

next morning with my lower back throbbing like a telltale heart. I downed coffee, aspirin, and a few cold pills alongside the various pig parts called breakfast and then made my way to the fabulous castle Fulke Greville had rebuilt from ruins.

Warwick Castle had once been owned by Richard III, which inspired me to halt giddily along its ramparts while gazing down on the Renaissance fair below, where we had face painting and sword dallying as well as archery and shield-painting lessons, all available for a price, but at least there were no plastic consoles blaring *Star Wars* sound effects. I liked Warwick Castle and liked it even more when I discovered wax dummies had been set up inside its various apartments. These dummies, it turned out, had been installed by the Tussauds Group, which had purchased the castle in 1978.

"Sell the Tower!," shouted my inner stockbroker. *"Buy Warwick!"*

Inside the castle I came upon two portraits, one of Sir Philip Sidney, artist unknown, and another of his fellow knight Sir Fulke Greville as painted in 1586 by an unknown painter of the English School. I stood there, under the gravity of cold medication, pondering those two men and their legendary friendship celebrated throughout Europe. Giordano Bruno once described them as brothers, "born and raised together," who even resembled each other physically. I didn't notice that resemblance as I gazed up at the portraits; instead I blew my nose and appeared so disreputable that a nearby employee, dressed as a Jacobean chambermaid, started eyeing me as if I might steal something. Eventually I tried to strike up a conversation by asking her where exactly Greville had been murdered. She didn't know the answer, nor did she much approve the question. And I provoked her further by inquiring if she thought these two famous friends might have been lovers.

"Certainly not," she insisted.

I sighed and turned back to Greville's portrait on the wall. Although I saw no resemblance to Sidney, I did notice some similarities between Greville and the Droeshout engraving. For a long and perilous moment I imagined all the future emails I might send, all

the side-by-side comparisons, all the waiting and worrying. Could my sanity survive just one more Shakespeare portrait? I doubted it could.

After propelling myself through the castle via a gallop of sneezes, I headed to St. Mary's Church to visit the tomb of Robert Dudley, the 1st Earl of Leicester and the closest thing Queen Elizabeth had to a husband. Oxfordians despised Dudley because of his rivalry with de Vere, but I was soft on him, as Dudley had been a great art collector who almost single-handedly inspired the Elizabethan portrait craze. He also owned the deepest closet in England, a true clothes-horse, yet his tomb, to my surprise, appeared relatively humble.

How un-Elizabethan, I thought.

Back in 1581 the Jesuit writer Henry Hawkins had stated that "my Lord Robert hath had five children by the Queen, and she never goeth in progress but to be delivered." Carole Levin, the Willa Cather Professor of History, wrote, "Though from the very beginning of her reign there were rumors about Elizabeth's love affair with Dudley and that she was pregnant by him or had children, the rumors about Elizabeth's illegitimate children became even more intense in the last two decades of [her] reign . . ."

Beguiled by royal bastards and horse-fucking poets, I became suddenly dizzy but could find no place to sit down. Meanwhile my back spasms caused me to finish my tour of the church in the same convulsing manner I'd entered Tokyo during my bout with shingles. While girdling my lower spine with both hands, I got lost inside the church and by accident came upon the funerary monument Fulke Greville had built for himself and Sir Philip Sidney to be buried inside together. This impressive monument featured a giant bed of black marble and was based on the designs of Giordano Bruno and Robert Fludd, two die-hard Neoplatonist magicians. Greville's plan had been for himself and Sidney to be buried on top of each other, with Sidney occupying the upper bier and Fulke taking the lower position, though ultimately the tomb had been left empty after Greville began questioning the Elizabethan obsession with fame.

Throughout his life Greville had been a purveyor of fame, a god maker. It was his gift for propaganda and marketing that had transformed Sidney from an unpopular snob into a Protestant martyr. (As part of that project Greville had even rewritten and published Sidney's poetry.) Likewise Greville had turned his friend Essex into a living god after the earl's one meager naval victory at Cadiz. Greville had also skillfully marketed himself as "the friend of Sidney" and was known even in Europe by that moniker. Since he'd already turned Essex into Mars and Sidney into Jesus, was it possible Greville decided to start a new god from scratch? One thing's for certain: nobody in England was more qualified to foist a collaborative Shakespeare on the public than Fulke Greville.

The emptiness of that monument in front of me was another reason the locals thought Greville wrote Shakespeare. Inside the First Folio, Ben Jonson had called Shakespeare "a monument without a tombe," and here was just such a monument. Jonson had also described Shakespeare as the "Sweet Swan of Avon." Greville's heraldic beast was the swan—he'd even worn a swan-topped helmet into the tilts—and Warwick Castle, where Greville had been living when the First Folio was published, was perched directly over the Avon River.

I found a tour guide and asked her about something I'd read on the internet the previous night. Apparently a tiny radar device had recently been lowered into Greville's tomb and had detected three boxes inside. This in turn roused suspicion that the boxes might contain the uncensored works of Shakespeare or perhaps Greville's lost Elizabethan history. The guide seemed pleased with the inquiry and informed me that a follow-up test had been performed and the resulting trigonometry—"that's the wrong word," she corrected herself—had established the tomb contained only rubble.

I nodded, disappointed, then spasmed my way back to the monument and reread its epitaph:

Fulke Grevill
Servant to Queen Elizabeth

Counselor to King James
And Friend to Sir Philip Sidney
Trophaeum Peccati.

That last bit of Latin lent the monument another mystery. Translated into English, it stated, "a monument of sin."

I left the church and eventually spasmed my way back to London, where Bonnie politely informed me that I would have to vacate in three days as she had friends arriving. I put those days to use by rallying through a blitz of portraits that started with my two favorite Hilliard miniatures at the Victoria and Albert: *An Unknown Man* against a background of fire and Professor Leslie Hotson's *Unknown Man Clasping a Hand from a Cloud*, their beauty still evident inside the dimly lit showcases that protected their pigments. Still sneezing, I failed to notice any resemblance between Sir Fulke Greville and the sitter in Professor Hotson's so-called Shakespeare miniature—and many years would pass before I made that connection.

But those two sitters did resemble each other (see page 16 of the color-plate insert). Greville had marketed himself, even abroad, as "the friend of Sidney." Meanwhile Professor Hotson's *Shakespeare by Hilliard* insisted that his miniature's visual riddle was designed as a tribute to the friendship between two poets, one in heaven, one on earth. Greville, alive, and Sidney, dead, seemed to fit the bill, especially since the miniature had been painted shortly after Sidney's funeral and its unknown sitter, the earthbound poet resembling Greville, was wearing a sugarloaf hat associated with Sidney's followers and funeral. Hotson also identified the second sitter in the miniature, the one inside the cloud, as the god Apollo. Prior to his death, Sidney had famously adopted Apollo as his personal symbol.

Fulke Greville once built a grand monument to be buried beneath his friend Sidney. Might he not also have designed a portrait miniature celebrating the famous friendship he spent his life promoting?

But, due to my cold, or the dim lighting, I didn't notice the re-

semblance between Greville and Hotson's earthbound poet that day in the Victoria and Albert, and thank God I missed it—or I might never have escaped the dark spell of Elizabethan portraits.

A few days later, inside a spate of windy blue-skied weather, I traveled to Windsor Castle, which to my despair I found polluted with van Dycks, his sitters glowing with biblical pomposity. There, displayed in a central position inside an alcove, I gazed up at my so-called Macbeth portrait. To my relief, the elaborate signature of the artist Custodis remained anchored to the bottom-right corner. I kept a wary eye on that signature as I admired the portrait and wondered, once again, if it depicted the same courtier as the Ashbourne. Then for a moment I stood there remembering all the madnesses I'd endured in the past, all the blind-alley and dead-end bards, and after a while I began remonstrating with myself not to fall back into that pit of despair.

One portrait I couldn't visit—it was currently unavailable for viewing—was my pet Prospero, but prior to my trip, the NPG had kindly mailed me a hard copy of their infrared results. That portrait's shipwreck backdrop, you might recall, had revealed a dandy workman repairing the ship while sailors staggered to shore. It had been my suspicion that this worker was added to the portrait at a later date to make it appear as though the ship were being repaired in dock as opposed to having been wrecked on an island beneath a storm cloud. Just as I'd hoped, the reflectogram showed no trace of that worker or his scaffold—all of which proved nothing but indicated I might be correct about the portrait's original conceit alluding to *The Tempest*.

That might seem encouraging, but it was, at best, an optimistic dead end. No more tests were scheduled, and obviously nobody at the NPG gave a damn about my theory, and why should they?

I was healthy again by the time I journeyed to London's Haberdashers' Hall to visit their portrait of Hugh Hamersley, the Folger-endorsed Ashbourne sitter. It was there I met David Bartle, the portrait's caretaker, who mentioned to me on three different occa-

sions that he did not believe the man portrayed in the Ashbourne portrait to be Hamersley.

"They look nothing alike really," he added.

Bartle, a good-natured man, seemed bemused by my interest in the picture and recalled that years earlier another researcher had requested that he measure Hamersley's nose, which he had gamely done using a stepladder.

There was one other portrait I didn't visit in England. The swashbuckling Hampton Court cad had long been a favorite bard of mine, that is, until one morning while doom-scrolling Twitter I'd come across some portraits of Sweden's Gustav II, a king with the endearing habit of posing for his pictures while flaunting his royal belly. To say Gustav looked familiar to me would be an understatement. Some googling confirmed that Gustav's wardrobe, many pieces of which were displayed in Swedish museums, appeared strikingly similar to that vexing bombast-burst outfit worn by the Hampton Court sitter (see page 13 of the color-plate insert). Gustav the Great, as he was known, had died in battle and was a Protestant hero; therefore it made sense that his picture would have wound its way into the art collection at Penshurst Place, home of the Protestant Sidney clan. I dutifully emailed the Royal Collection in London with this information, though it pained me to help debunk my old wingman.

My time running short, I hugged Bonnie goodbye and left London to visit de Vere's ancestral village. While I was Hedingham bound on the 89 bus, an old man shaped like a giant cabbage stood to exit the bus just as the driver accelerated, causing the man to topple backward while pinwheeling his arms. *Oh God*, I thought and stepped into the aisle to break his fall. Following our collision, I semi-guided our joint descent into the rear-most seat and got the wind knocked out of me. The man jumped from my lap, smiled down at me, patted my head as if I were a dog, and then scampered off the bus while I sat there wondering if I'd cracked a rib.

A half hour later, cupping my rib cage with one hand and my lower back with another, I found myself situated in a room above a

pub called the Wheatsheaf owned by a friendly man named Rob. I dry-swallowed some Advil and limped downstairs, where the equally friendly barmaid, Joyce, informed me that her husband was the town historian and might fancy giving me a tour. She'd let me know tomorrow if he had any free time, she promised. I thanked Joyce and headed down Nunnery Street admiring the hilltop keep of Hedingham Castle, its lone-star flag hanging limp in the blue sky. The town was filled with tiny shops that gave way to a tennis club, where I was shoutingly employed to confirm a call and gave them the index-finger "out" sign. I counted three pubs that had the local castle on their signs and had a medicinal pint in each of them.

The next morning I went down for breakfast, a feast of tomatoes, hash browns, sausage, bacon, eggs, deviled meat, baked beans, toast, cereal—everything but a handgun—and while picking my way through the meal was informed that Dickey would drop by to fetch me in thirty minutes.

"Dickey?" said I.

"Dickey Bird," Rob said. "Joyce's husband, the historian."

Well, gosh, that was easy, I thought, amazed at the kindness shown me here. While attempting to put a polite dent into my breakfast, I began to wonder what would happen if the Stratford awfulness invaded Hedingham. It could happen, I realized (taking another bite of a brown cardboardlike meat), yep, one damning manuscript unearthed (shoving two strips of fatty bacon into my mouth) and the lovely hamlet of Hedingham would be barnstormed by bardologists ready to deify de Vere. Stratford had probably looked a lot like Hedingham at one time.

What if that did happen? Well, I mused, Rob would be an instant millionaire, and his pub, renamed the Buggered Pony, would give way to a long line of B&Bs with names like the Black Prince, the Spoiled Cook, or the Midnight Earl. Tourists with the Welbeck portrait of de Vere emblazoned on their T-shirts and tote bags would wait in line at the haggard-horsed tiltyard outside the castle. The neighboring wax museum would enchant children with

its lifelike dioramas of Shakespeare impaling his servants, drinking virgin blood, farting at his mother-mistress the queen, and playing tennis with his brother-son Southampton. Meanwhile, on the outskirts of town, a midway of mechanical monsters would ignite each evening, their octopus arms slewing neon into the night while colored lightbulbs spelled out "The Sodomite" or "The Changeling" or "The Double Entendre," with all those cash registers ringing so loud the din could be heard in the now Dickensian streets of Stratford-upon-Avon, where Stanley Wells sat alone inside the Falstaff's Belly, the worthless Cobbe portrait hung crooked above the dusty step of bottles, muttering to ancient gods.

"Sell Stratford!" yelled my inner stockbroker. *"Buy Hedingham!"*

My reverie gave way to a fantastic day in which the village historian, Charles "Dickey" Bird, shepherded me through a tour of all things de Vere. We started at the church, where Dickey showed me how all the characters in *Edward III* had been cut into the wooden latticework above the pulpit. Then we examined the black marble tomb that held the fifteenth and sixteenth earls, the sixteenth having been dumped beside his father for economy's sake, plunder not being what it used to be. We departed just as a funeral was beginning to an accompaniment of rain.

To avoid the storm, we drove to the castle, where we were admitted for free due to Dickey's status as tour guide, and climbed the stairs into the entrance hall boasting an impressive bronze bust of de Vere fashioned after the Welbeck. There was a Norman arch that had been attacked after the Reformation but had proven impossible to blow up. The second floor of the keep was called the banqueting hall—"quite incorrectly," Dickey pointed out—because it had once held a banquet for a king. Queen Elizabeth had also visited there when de Vere was a boy. This hall was actually the feasting room, Dickey explained, which was where the plays had been performed by Oxford's Men, the acting troupe that resided in the castle when not touring.

Eventually we descended into the dungeon, now a storage room, where a man with two hawks on his padded arm stood by in case

any tourists arrived. The hawks were fierce-looking creatures, more roostery than I'd expected, with great plumage and greater indignation. Their keeper petted them affectionately as they attempted to mangle his gloved hand. Dickey dutifully explained that falconry had been the exclusive sport of kings, yet Shakespeare had known its secrets inside-out.

While waiting out another storm, we stopped for tea and biscuits at Dickey's house. His wife, Joyce, watched our conversation like a tennis match, half interested, half amused, a game she knew not how to score. I used my laptop to show Dickey some portraits and promised to email him some jpegs. After lunch we drove by the historical home of Horatio de Vere, Edward's cousin. The house was now owned by farmers who wouldn't allow any access, though Dickey suspected it contained a treasure trove of old portraits.

"What if I knocked on the door?" I asked.

"I wouldn't advise that," Dickey replied ominously.

As we drove away he announced he had a surprise for me and then parked his car at the edge of some woods. I followed him into the trees until we came upon an ancient ruin that still supported a roof of sorts. The small house was gripped by vines that appeared to be pulling it downward into the earth.

This was the real banqueting hall, Dickey said, the place nobles used to escape the scrutiny of servants and stage risqué plays or exchange subversive manuscripts. We stared in through a missing windowpane. Although these ruins had once belonged to Edward de Vere, the current owner was an elderly man who had neglected its upkeep to the point the small building was now creepered both inside and out. I followed Dickey through a large board he'd pulled back and we walked around inside the hall that felt half man and half nature while we imagined the scandalous plays that might have been staged here by this misfit earl who, if not Shakespeare himself, was so close to that genius as to be his shadow.

Finally we returned to Dickey's house, where he showed me the collection of props he used for his presentations at the castle, the high-

light being a waxen head of Edward de Vere modeled on the Welbeck portrait that Dickey had had created by Madame Tussauds. Its eyes seemed hauntingly alive. As I examined that handsome head, once again recalling the seam along the neck of the Flower portrait, it struck me that Dickey might be guilty of beautifying history in the same manner as the Stratford tourist board. We all want perfect heroes, or at least perfectly beautiful ones, I thought as I gazed into those hazel eyes that seemed to follow me.

De Vere's decapitated head, currently unattached to its waxen torso (under repair at the time) was both creepy and cool, and I grinned like a maniac when Dickey let me hold its sword, which I immediately raised over my head in the fashion of my Macbeth portrait.

After thanking Dickey profusely, I returned to the Wheatsheaf and watched a bit of Spurs versus Hearts before wandering into a nearby pub called the Bell Inn and was eating some nachos at the bar when a man named James, who turned out to be an old friend of Larry and Dean's, struck up a conversation and invited me to join his table outside. There were six of us there, and after I told James the sad news about Dean, we toasted her and Larry. Everyone at the table seemed to accept that de Vere had written Shakespeare in the same way that everyone in America accepted the Stratford argument. But the change was enjoyable, and the portraits I showed them on my laptop ingratiated me to the locals, who saw me as their champion, and I had a vision of living out my life there.

When I returned to the Wheatsheaf, there was a songfest raging that I could still hear while upstairs in bed. All the songs were offspring of "Wind Beneath My Wings" and were being belted with lung-burst enthusiasm and no trace of irony. I fell asleep grinning. The next morning, instead of spending the rest of my life in Hedingham, I returned to London and moved into the Palmers Lodge hostel.

Unlike my memories of backpacking, this current hostel seemed sadly silent, with all the young travelers googling the tourist sites

they would have learned about in earlier years by conversing with new friends from foreign lands. Something vital in the history of travel had been lost, I felt. While sitting there I began reading a book called *The Shakespeare Wars* by the scholar Ron Rosenbaum that delved into the vital question of whether Juliet had been masturbating while reciting her famous "Come, gentle night" soliloquy.

This question had first been posed by a professor named Alexander Leggatt, who believed that Shakespeare had manipulated the rhythm of that speech to insinuate Juliet was pleasuring herself, or at the very least erotically fantasizing about a "world-erasing" firework display of Romeos bursting into the sky. The finger-bang soliloquy in question was the one that began, "Come, gentle night, come, loving, black-brow'd night, give me my Romeo . . ."

Finally, some worthwhile criticism! Having heard those lines employed to that exact purpose in a number of tawdry films, I happily conceded there was both a rhythm and verbiage to this passage that supported Leggatt's interpretation. Who needed to write about the Essex Rebellion when there's so much to say about the adolescent erections and orgasms hidden like Easter eggs throughout the plays? Once again I fell asleep grinning.

For my last full day in London I struck out for Hatfield House (formerly Hatfield Palace) where Princess Elizabeth had lived, on and off, until the age of twenty-five, and where, while standing beneath some fabled tree now lost to history, she had been informed she was the new Queen of England and was well-pleased. My historical nemesis Sir Robert Cecil had torn down most of the original building to rebuild Hatfield House in 1607. Both Cecil men—Lord Burghley, the father, and Robert, the son—had been great supporters of the arts, and my reluctant admiration for those two Machiavellians grew as I strolled through the beautiful rooms before pausing for some twenty minutes before a portrait by Hilliard of Queen Elizabeth posing with a live ermine.

In her book on Hatfield House, Erna Auerbach had documented that the Cecils occasionally paid large sums to have their portraits

altered, which should surprise nobody as they'd done the same thing to English history. Portraits of their family members peopled the house yet there were no pictures of Edward de Vere, the outcast earl who had been forced to marry Cecil's sister.

I was still searching for the unloved Edward when I came upon a portrait, now attributed to Isaac Oliver, that stopped me cold, the stunningly sexy Rainbow portrait of Queen Elizabeth I. As other tourists attempted to elbow me out of the way, I held my ground and gazed at the rainbow clasped in Elizabeth's hand beneath a motto stating in Latin "No Rainbow without the Sun," and after a while, I began to wonder if that portrait's conceit might make sense to us now had the Cecils not paid great sums for the retouching of their pictures.

Aside from the Rainbow portrait, the highlight of my day turned out to be a conversation I had with an elderly tour guide, a keen blue-eyed woman stationed behind a counter that displayed enlarged copies of the two scandalous letters Princess Elizabeth had written from Hatfield House to assure the Lord Protector she had in no way been impregnated by the gadabout Tom Seymour. (The original letters were stored in the Muniment Room of the house.) I struck up the conversation by asking the guide about a mosaic portrait of Sir Robert Cecil hung above the room's mantel. She informed me that in 1608 Cecil had paid to have the picture inlayed with bronze in Venice, the result being something new, and impressive. The portrait had been a favorite of Cecil's, she told me, before adding, "Most people don't even notice it."

We then launched into an increasingly whispered conversation in which, much to my surprise, we concurred on the likelihood of Princess Elizabeth having been made pregnant by Seymour. Then, while still on the subject of scandals, she told me a story about a Jacobean masque in 1606 that had caused some of the players to be put into the stockade. The masque had concerned the Queen of Sheba and included a host of allegorical Virtues played by Jacobean noblewomen before the King of Denmark. Unfortunately for

that king, these noblewomen had gotten staggeringly drunk prior to taking the stage, and their performance deteriorated into a farce of wilting Virtues spilling sauces and drinks upon the Dane as one by one the women cursed, floundered, belched, and vomited onstage before finally attacking one another.

I had to admit the Jacobeans were growing on me.

Our conversation returned to the Cecils when we began discussing the school for wards established by Lord Burghley around 1561 shortly after he'd received a letter berating the paltry education noblemen received in England. Burghley had fixed this problem with his usual efficiency and in doing so gave birth to a school designed to create geniuses of statecraft. The best school in England, and arguably all of Europe, Cecil House had teemed with international scholars who force-fed a library of some seventeen hundred titles into the brains of such spoiled prodigies as Philip Sidney, Edward de Vere, and the earls of Rutland, Southampton, and Essex. Burghley's son Robert, raised hunchbacked in a culture that saw outward deformity as a reflection of inward perversity, also attended this school in his father's house, and it's easy to imagine the resentment he must have felt toward his privileged and perfect classmates.

My admiration for Burghley's school caused the elderly guide to lean closer and work the conversation around to the authorship debate. That shocked me, considering where we were, but I kept my cards close while she voiced her opinion "that rogue Edward de Vere" had written the plays, after which she gave me a brave nod followed by a lingering blue eye, as if daring me to object.

The de Vereians were everywhere, it seemed, and had even infiltrated the enemy camp.

Lowering my voice even more, I agreed that the Oxfordians had an excellent argument and started to tell her some of my own degenerate theories on Shakespeare, but, remembering how everyone despised my theories, I bit my tongue instead. After all these years I still felt the authorship question would remain forever unsolved because it had been hidden from us by Sir Robert Cecil, a genius

of a different sort from Shakespeare but attached to him. What people hated the most about my authorship theory, I'd noticed, was my belief there had been a drafting process to those plays that had likely involved multiple geniuses, one of whom was almost certainly Tom Nashe. Added to this heresy, I couldn't dismiss a woman's role in the plays, especially the comedies. There were times when I even wondered if that collaboration had arisen out of a cabal made up of Elizabeth's bastards, all schooled at Cecil House, and eager to manipulate public opinion at the playhouse.

Over the years I'd come to think of my authorship scenario as the Dread Pirate Roberts Theory of Who Wrote Shakespeare. And now, having just visited Warwick Castle, I couldn't help but wonder what role Fulke Greville and Mary Sidney had played among those collaborative pirates.

Traditional scholars were always calling the Oxfordians snobs for supposing only a nobleman could have written the plays of Shakespeare, but it seemed to me that criticism could easily be reframed into a debate on the merits of the humanist education. It was not fantastical, I felt, to weigh Stratford's medieval grammar school against the scholarly opulence of Cecil House and wonder which of those two educational systems, the medieval or the Renaissance, had produced the world's most complex and learned literary genius.

But I didn't share these theories with my new friend. She had her champion in de Vere, who might well have been that central genius we all desired, and anyway my theory in itself wasn't nearly as important, I felt, as the method I'd use to arrive at it, which I'd done via an invention I'd come to think of as the Shark Tank Test of Truth.

Imagine, if you will, a phone booth suspended by chains above an aquarium filled with great white sharks attacking and buggering one another beneath the trapdoor you are currently standing on. In front of you inside this booth are two buttons: a green YES button and a red NO button. Above these two buttons is a chalkboard on which you will now scrawl the question you wish to know your own true opinion about. For example, say you pick up the chalk and write

"Did Lee Harvey Oswald act alone?" or "Did Jesus raise the dead?" Now, you might have opinions on those subjects, or think you do, but suddenly you find yourself confronting the questions above a frothing tank of giant sharks and perhaps you are not so certain anymore. That's because the question on the chalkboard has been stripped of its cultural trappings. Suddenly it doesn't matter if your boss might laugh at your opinion. It doesn't matter if you want to score chicks or fit in with the cool set at the water bubbler at work.

Only now, perched above those sharks, can you force yourself to dismiss your culture and arrive at your own opinion, be it JFK being shot by CIA henchmen or us living inside a universe in which dead people by definition remained steadfastly dead. The point being, you have a battle raging inside you between your cultural ambassador and your true opinion, and only at this moment, with the help of my patented shark tank, will you dare to free yourself from a lifetime of childlike superstition, mythology, and indoctrination.

George Orwell once pointed out that the average man will do most anything, even shoot a harmless elephant, to avoid being laughed at, but while standing above those sharks being laughed at won't matter. All that matters is that if you push the wrong button, the trapdoor beneath you will spring open and you will be decimated by teeth the size of Cherokee arrowheads. Here and only here is the moment in which you begin to understand your own mind. Until now you might have accepted that Oswald acted alone, or that Jesus raised the dead, because that made you seem normal and impressed your boss and whoever it was you wanted to have sex with. Your opinions, after all, are a huge part of what makes you employable and fuckable inside any culture. And nobody enjoys being laughed at.

But now you don't care about those things. Now all you care about is not being devoured by sharks. Therefore the first thing you will do in that situation is to eliminate the impossible. Did Jesus do the impossible? Did Oswald? Did some backwater businessman from Stratford?

Wow, those sharks sure do look hungry.

Green button YES. Red button NO. Which one do you push? And how certain are you as you raise that index finger? Are your eyes clenched shut as you push the Stratford YES button? Mine sure would be. "I think Shakespeare wrote Shakespeare!" doesn't seem particularly applicable while contemplating great white sharks.

The button I wanted to push inside that booth said "I don't know who wrote Shakespeare." That, I would argue, is the humble button we should all push, but selecting that button won't move product or get you laid or impress your boss. You can't write a bestselling biography called *I Don't Know Who the Hell Wrote Shakespeare and Neither Do You* nor can you print up a sellable T-shirt or coffee mug on that theme. But it's the truth, you don't know, and neither do you, or you, or you, but as a culture we won't admit we don't know who wrote Shakespeare. We desperately want to know. But we don't. And likely never will.

I didn't tell my new friend about my Shark Tank Test of Truth. Instead, since the copies of Elizabeth's two letters were displayed on the counter separating us, I asked what she thought about the theory of de Vere being the love child of Seymour and Elizabeth. I did not ask this in a serious manner, and I fully expected to be censured, but instead she pinned me with that trademark look of raised eyebrows above lowered reading glasses. Then, while holding my gaze in this manner, she lifted her index finger to her lips and tapped it there.

I laughed and told her I thought that only Americans believed such things.

Before parting company, I asked directions to Robert Cecil's tomb and confessed I had a soft spot for Elizabeth's "gnome." She instructed me to go outside and look to my left for the parish church. I thanked her and wandered off in search of Cecil's famously salacious monument.

St. Etheldreda's Church hit me as shabby and woebegone, and I could not help but wish the eternal resting spot of my archenemy a

more regal shrine. Under the ambivalent rule of James I, Cecil had been the real king, one famous for his sexual appetites and mistresses, which might explain the provocative monument he designed to celebrate his life. This monument displayed Cecil's white-marbled effigy in repose surrounded by scantily dressed statues more resembling Vargas girls than the four cardinal virtues of Justice, Prudence, Temperance, and Fortitude. Erna Auerbach was dealing in understatement when she described the curvatures of these kneeling Virtues as "clearly articulated—the breasts bare in the case of Prudence and covered but projecting in that of Temperance."

Seeing those statues made me recall that Jacobean masque of wilted Virtues as I sat in a pew and soon lost myself in reverie while staring brazenly at Temperance. A half hour later, following a brief nap, I stood and glanced around to make sure I was not being spied on—a fitting response to Cecil's tomb—and while gazing at his monument again I tried to commune with the man I had been forced to surrender to in our greatly mismatched battle of wits in which my only advantage had been a prescription for Adderall.

It wasn't surprising I'd lost that battle considering I'd attended public schools in Mississippi, whereas Cecil had to contend with brutal scholars instilling his mind with the secrets of the Renaissance. As a child, Cecil's school day had begun at 7 a.m. with dance, then French, then Latin, prayer, writing and drawing, cosmology, more Latin, more French, calligraphy, and yet more prayer. But it had been cosmology, that hodgepodge described by Mark Anderson as containing history, economics, geology, astronomy, linguistics, philosophy, and oration—in short, the Greek humanities—that had likely sparked the Machiavellian genius of Robert Cecil.

I strongly suspected it had sparked the poetic genius of William Shakespeare as well. In some ways these two men were sides of the same coin, a Janus figure, both occult creatures of the Renaissance who might well have sat in the same classroom. One would take over the country, the other the world.

The tomb I kept gazing at that day resembled a bunk bed cre-

ated from two black marble plinths. The greatly bosomed Virtues served as bedposts on whose shoulders rested the bier containing the beautified effigy of Cecil, his face modeled on his favorite portrait of himself painted by de Critz the Elder. Recumbent in white marble and wearing his garter robe, Cecil clasped the thin staff of state beneath which, in the bottom bunk, lurked a far more honest effigy also done in white marble depicting Cecil's ghastly skeleton, with ribs abloom, reposed upon a bed of straw.

I walked closer to examine both versions of the man I suspected had hidden Shakespeare from us, but, predictably, my eyes preferred the monster below to the fairy tale above and eventually came to rest on that skull. Say what you will about skulls, they make for convivial guests and always get your jokes. I stared at Cecil's skull for five minutes before clearing my throat to speak.

"Well played," I whispered into that nest of horrors.

Then I saluted, turned, and left the church.

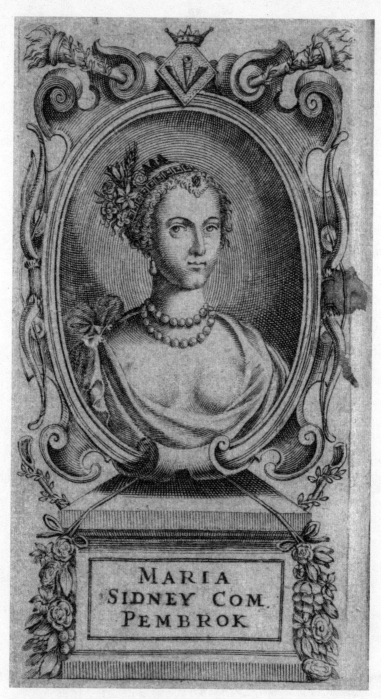

MARIA
SIDNEY COM.
PEMBROK

Frontispiece portrait of Mary Sidney, Countess of Pembroke. Dell'Arcadia della contessa di Pembroch, Portata dal Francese Dal Signor Livio Alessandri, 1659 (Folger Shakespeare Library).

Sir Fulke Greville, First Lord Brooke, from his original portrait kept at Warwick Castle and owned by Lord Willoughby de Broke. This engraving was created in the late eighteenth century by the printmaker Burnet Reading (Folger Shakespeare Library).

Mʳ WILLIAM SHAKESPEARE

For ever live thy fame, the world to tell
Thy like, no age, shall ever paralell.

Mostly an etching but partially engraved, this unique likeness depicts Shakespeare posing in a caricature of melancholy. I discovered this image inside a rogue copy of Shakespeare's 1640 *Poems*. In that one copy, which originated at Warwick Castle (home of Fulke Greville), the standard Marshall engraving (see the frontispiece of this book) had been replaced with this melancholy swan (Folger Shakespeare Library).

Acknowledgments

The author is grateful to the people at Creative Commons for their vast help in making so many portrait images available, and also wishes to thank the Folger Shakespeare Library for providing so many photographs of their portraits. Additional thanks go to the Japan-United States Friendship Commission, the National Endowment for the Arts, and the Mississippi Arts Commission. Special thanks to Emily Polson, Dan Kirschen, Colin Harrison, Sarah Goldberg, Ace Atkins, George Singleton, and also to Lawrence Wells and George Saunders. Thank you in Vermont to the Mills family and to Forrest Cochran for employing me behind the bar all those years. In Oxford thank you to Jack Pendarvis, Richard and Lisa Howorth, Wright Thompson, Mary Miller, Al Morse, Mark Yacovone, William Boyle, everyone at Square Books, Doug Branch, Robby Seitz, Chris Offutt, Melissa Ginsburg, Tom Franklin, Beth Ann Fennelly, and Theresa Starkey.

The author would also like to express his gratitude to everyone employed by the following museums and collections in England: the Royal Collection, the National Portrait Gallery, the Victoria and Albert Museum, the British Museum, the Museum of London, the Royal Shakespeare Company, the Stratford Birthplace Trust, and the Bodleian Library. Thank you to Lord Willoughby de Broke for

the use of his portrait of Sir Fulke Greville and to Rene Greville for the scholarship that helped fuel the Greville portions of this book. Many thanks to Hildegard Hammerschmidt-Hummel for her years of research, and endless thanks to Mark Anderson for his scholarship on the life of Edward de Vere.

Additional thanks to Lisa Wilson, Charles Beauclerk, Robin Simon, Hank Whittemore, Dr. Paul Altrocchi, Paul Cox, Pamela Bromley, and David Bartle. Thank you Alex Buck, Vanessa Remington, Erin Blake, Estie Berkowitz, Andrianna Yeatts, and Anna Baker Smith. In closing, the author would like to recall some friends lost during the travails of this book: Tom Freeland, Ron Shapiro, Bonnie Capes, Jim Warren, John McMurry, and Dean Faulkner Wells.

Bibliography

Akrigg, G. P. V. *Shakespeare and the Earl of Southampton*. Cambridge: Harvard University Press, 1968.

Altrocchi, Paul Hemenway, and Whittemore, Hank. *Nothing Truer Than Truth*. New York: iUniverse, 2009.

Anderson, Mark. *"Shakespeare" by Another Name: The Life of Edward de Vere, Earl of Oxford, the Man Who Was Shakespeare*. New York: Gotham; London: Turnaround, 2005.

Arnold, Janet. *Patterns of Fashion 3: The Cut and Construction of Clothes for Men and Women c. 1560–1620*. London: Macmillan, 1985.

Ashelford, Jane. *Dress in the Age of Elizabeth I*. London: Batsford; New York: Holmes & Meier, 1988.

Asquith, Clare. *Shadowplay: The Hidden Beliefs and Coded Politics of William Shakespeare*. New York: PublicAffairs, 2006.

Auerbach, Erna. *Nicholas Hilliard*. Boston: Boston Book & Art Shop, 1964.

Auerbach, Erna, and Adams, Charles Kingsley. *Paintings and Sculpture at Hatfield House*. London: Constable, 1971.

Barroll, Leeds. *Politics, Plague, and Shakespeare's Theater: The Stuart Years*. Ithaca, NY: Cornell University Press, 1991.

Beauclerk, Charles. *Shakespeare's Lost Kingdom: The True History of Shakespeare and Elizabeth*. New York: Grove Press, 2010.

Bill, Alfred Hoyt. *Astrophel: The Life and Death of the Renowned Sir Philip Sidney*. New York; Toronto: Farrar & Rinehart, 1937.

Bloom, Harold. *Shakespeare: The Invention of the Human.* New York: Riverhead Books, 1999.

Budiansky, Stephen. *Her Majesty's Spymaster.* New York: Viking, 2005.

Burt, Richard. *Unspeakable ShaXXXspeares: Queer Theory and American Kiddie Culture.* New York: St. Martin's Press, 1999.

Cooper, Tarnya. *Searching for Shakespeare.* London: National Portrait Gallery, 2006.

Crewe, Jonathan V. *Unredeemed Rhetoric: Thomas Nashe and the Scandal of Authorship.* Baltimore: Johns Hopkins University Press, 1982.

Crystal, David, and Crystal, Ben. *Shakespeare's Words: A Glossary and Language Companion.* London: Penguin Books, 2004.

Cunnington, Willett C., and Cunnington, Phillis. *Handbook of English Costume in the Sixteenth Century.* London: Faber and Faber, 1970.

Downing, Sarah Jane. *Fashion in the Time of William Shakespeare.* Oxford: Shire Publications, 2014.

Duncan-Jones, Katherine. *Sir Philip Sidney: Courtier Poet.* London: Hamish Hamilton, 1991.

Edmond, Mary. *Hilliard and Oliver: The Lives and Works of Two Great Miniaturists.* London: R. Hale, 1983.

Fox, Levi. *The Correspondence of the Reverend Joseph Green: Parson, Schoolmaster, and Antiquary, 1712–1790.* London: Her Majesty's Stationary Office, 1965.

Friswell, James Hain. *Life Portraits of William Shakespeare.* London: S. Low, Son & Marston, 1864.

Garber, Marjorie. *Shakespeare After All.* New York: Anchor Books, 2005.

Gililov, Ilya. *The Shakespeare Game: The Mystery of the Great Phoenix.* New York: Algora Publishing, 2003.

Goldring, Elizabeth. *Nicholas Hilliard: Life of an Artist.* London: Yale University Press, 2019.

Green, Dominic. *The Double Life of Doctor Lopez: Spies, Shakespeare, and the Plot to Poison Elizabeth I.* London: Century, 2003.

Greenblatt, Stephen. *Will in the World: How Shakespeare became Shakespeare.* New York: W. W. Norton, 2016.

Hammerschmidt-Hummel, Hildegard. *And the Flower Portrait of William Shakespeare Is Genuine After All.* Hildesheim; Zurich; New York: G. Olms, 2010

———. *The True Face of William Shakespeare*. Hildesheim; Zurich; New York: G. Olms, 2010.

Harrison, G. B. *The Life and Death of Robert Devereux Earl of Essex*. London: Cassell, 1937.

Hotson, Leslie. *Shakespeare by Hilliard*. Berkeley: University of California Press, 1977.

Ingleby, C. M. *Shakespeare's Bones: The Proposal To Disinter Them, Considered In Relation To Their Possible Bearing on his Portraiture: Illustrated By Instances of Visits of the Living and the Dead*. London: Trubner, 1883.

Jimenez, Ramon. *Shakespeare's Apprenticeship: Identifying the Real Playwright's Earliest Work*. Jefferson, NC: McFarland, 2018.

Kahan, Jeffrey. *Shakespiritualism: Shakespeare and the Occult: 1850–1950*. New York: Palgrave Macmillan, 2013.

Kiernan, Pauline. *Filthy Shakespeare: Shakespeare's Most Outrageous Sexual Puns*. New York: Gotham Books, 2007.

Kirsh, Andrea, and Levenson, Rustin S. *Seeing Through Paint*. New Haven; London: Yale University Press, 2000.

Lachman, Gary. *The Quest for Hermes Trismegistus: From Ancient Egypt to the Modern World*. Edinburgh: Floris Books, 2011.

Lamonica, Mark. *Renaissance Porn Star: The Saga of Pietro Aretino, the World's Greatest Hustler*. North Charleston, SC: CreateSpace, 2012.

Larson, Charles Howard. *Fulke Greville*. Boston: Twayne Publishers, 1980.

Looney, J. Thomas. *"Shakespeare" Identified in Edward de Vere, the Seventeenth Earl of Oxford*. New York: Duell, Sloan, and Pearce, 1949.

Maurier, Daphne du. *Golden Lads: A Study of Anthony Bacon, Francis and Their Friends*. London: Gollancz, 1975.

Nicholl, Charles. *A Cup of News: The Life of Thomas Nashe*. London: Routledge & Kegan Paul, 1984.

———. *The Reckoning*. New York: Harcourt Brace, 1994.

Nicolson, Adam. *Quarrel with the King: The Story of an English Family on the High Road to Civil War*. New York: HarperCollins, 2008.

Norris, Joseph Parker. *The Portraits of Shakespeare*. Philadelphia: Robert M. Lindsay, Press of Globe Printing House, 1885.

Plowden, Alison. *The Young Elizabeth*. London: Pan Books, 1973.

Pressly, William L. *A Catalogue of Paintings in the Folger Shakespeare Library.* New Haven: Yale University Press, 1993.

Rabone, John. "A Lecture on Some Portraits of Shakespeare's, and Shakespeare's Brooch." *Birmingham Daily Gazette,* November 20, 1883.

Read, Conyers. *Lord Burghley and Queen Elizabeth.* London: Cape, 1960.

Rebholtz, Ronald A. *The Life of Fulke Greville First Lord Brooke.* Oxford: Clarendon Press, 1971.

Rees, Joan. *The Selected Writings of Fulke Greville.* London: Athlone Press, 1973.

Roe, Richard Paul. *The Shakespeare Guide to Italy: Retracing the Bards Unknown Travels.* New York: Harper Perennial, 2011.

Ronald, Susan. *The Pirate Queen: Queen Elizabeth I, Her Pirate Adventurers, and the Dawn of Empire.* Old Saybrook, CT: Tantor Media, 2007.

Rosenbaum, Ron. *The Shakespeare Wars: Clashing Scholars, Public Fiascoes, Palace Coups.* New York: Random House, 2006.

Saunders, A. W. L. *The Master of Shakespeare: Volume I. The Sonnets.* London: MoS Publishing Ltd, 2007.

Schoenbaum, Samuel. *Shakespeare's Lives.* Oxford: Oxford University Press, 1993.

Sears, Elisabeth. *Shakespeare and the Tudor Rose.* Seattle: Consolidated Press Printing, 1991.

Shapiro, James. *The Year of Lear: Shakespeare in 1606.* New York: Simon & Schuster, 2015.

Starkey, David. *Elizabeth: The Struggle for the Throne.* New York: Perennial, 2001.

Stewart, Alan. *Philip Sidney: A Double Life.* London: Pimlico, 2001.

Strachey, Giles Lytton. *Elizabeth and Essex.* New York: C. Gaige; London: Chatto & Windus, 1928.

Streitz, Paul. *Oxford, Son of Queen Elizabeth I.* Darien, CT: Oxford Institute Press, 2001.

Strong, Roy. *Lost Treasures of Britain.* London: Guild Publishing, 1990.

———. *The Cult of Elizabeth: Elizabethan Portraiture and Pageantry.* London, Pimlico, 1999.

———. *The Elizabethan Image: An Introduction of English Portraiture, 1558–1603.* New Haven: Yale University Press, 2019.

———. *The English Icon: Elizabethan & Jacobean Portraiture.* London: Routledge and Kegan Paul; New York: Pantheon Books, 1969.

Szonyi, Gyorgy Endre. *John Dee's Occultism.* Albany: State University of New York Press, 2004.

Twain, Mark. *"Is Shakespeare Dead?": The Complete Essays of Mark Twain Now Collected for the First Time.* Editor: Charles Neider. Garden City, NY: Doubleday, 1963.

Varlow, Sally. *The Lady Penelope: The Lost Tale of Love and Politics in the Court of Elizabeth I.* London: Andre Deutsch, 2007.

Wells, Stanley. *Shakespeare & Co.: Christopher Marlowe, Thomas Dekker, Ben Johnson, Thomas Middleton, John Fletcher, and the Other Players in His Story.* New York: Pantheon Books, 2007.

Whittemore, Hank. *The Monument.* Marshfield Hills, MA: Meadow Geese Press, 2005.

Williamson, George C. *How to Identify Portrait Miniatures.* London: George Bell and Sons, 1905.

Yates, Frances Amelia. *Giordano Bruno and the Hermetic Tradition.* London; New York: Routledge, 1999.

———. *Majesty* and *Magic in Shakespeare's Last Plays: A New Approach to Cymbeline, Henry VIII and the Tempest.* Boulder, CO: Shambhala, 1975.

———. *The Art of Memory.* London: Bodley Head, 2014.

———. *The Occult Philosophy in the Elizabethan Age.* London; New York: Routledge, 2002.

———. *The Rosicrucian Enlightenment.* London; New York: Routledge, 2002.

Additional Image Credits

Printed [by E. Allde] for Philip Scarlet. London, 1597. Call # STC 12906.

Page 57. Anonymous. Janssen Portrait of Shakespeare. Early 1610s, altered before 1770. Call # FPs17 (before conservation).

Page 165. Artist unknown. Ashbourne portrait. 1612 with nineteenth-century alterations. Call # FPs1.

Page 189. Anonymous. Portrait of an unknown man (the Zuccaro Shakespeare; also called Bath Portrait and Archer Portrait), circa 1615–20. Photographed by Folger Library during the portrait's 1988 restoration. Call # FPs29.

Page 248. Sidney, Philip, Sir, 1554–1586. Engraving of Mary Sidney. Dell'Arcadia della contessa di Pembroch, Portata dal Francese Dal Signor Livio Alessandri. Presso Combi, and La Noù. In Venetia, 1659. Call # 261475 vol.1.

Page 249. Reading, Burnet, 1749 or 50-1838, printmaker. Fulke Greville, First Lord Brooke, from the original in the collection of . . . Lord Willoughby de Broke / Bt. Reading, sc. England: s.n., late 18th century? Call # ART File B871.5 no.4 (size XS).

Page 250. Unknown artist. [Poems. 1640] Poems/vvritten by Wil. Shake-speare. Gent. Printed in London. Warwick Castle (England), former owner. Call # STC 22344 copy 4.

The following color-plate images are used by permission of the Folger Shakespeare Library under a Creative Commons 4.0 License:

CP 4. Anonymous. Lumley Portrait of Shakespeare. Eighteenth century. Call # FPs23.

CP 10. Anonymous. Portrait of an unknown man (the Zuccaro Shakespeare; also called Bath Portrait and Archer Portrait). Ca. 1615-20. Photographed by Folger Library during portrait's 1988 restoration. Call # FPs29.

CP 12. Artist unknown. Ashbourne portrait. 1612, with nineteenth-century alterations. Call # FPs1.

CP 13. Anonymous. Buttery Portrait of Shakespeare. Nineteenth century. Call # FPs3.

About the Author

Lee Durkee is the author of *The Last Taxi Driver*, named a *Kirkus Reviews* Best Book of 2020, and *Rides of the Midway*. His stories and essays have appeared in *Harper's Magazine*, *The Sun*, *Oxford American*, *Zoetrope: All Story*, and *Mississippi Noir*. He lives in North Mississippi.